The Communicating Vessels

Two Portraits of Grief

The Communicating Vessels

Two Portraits of Grief

Friederike Mayröcker

translated from the German
by Alexander Booth

A Public Space Books

A Public Space Books
PO Box B
New York, NY 10159

A Public Space gratefully acknowledges the generous support of the
Drue and H. J. Heinz II Charitable Trust, the Chisholm Foundation, the
National Endowment for the Arts, the New York State Council on the Arts,
the Amazon Literary Partnership, and the corporations, foundations, and
individuals whose contributions have helped to make this book possible.

Library of Congress Control Number: 2020931549
ISBN: 978-0-9982675-8-6
eISBN: 978-1-7345907-2-2

www.apublicspace.org

9 8 7 6 5 4 3 2 1

The Communicating Vessels

1

And I Shook Myself a Beloved

83

The
Communicating
Vessels

 and then cuddling shoulder to shoulder we were (my shoulder brushing his shoulder brushing mine) at the jazz concert, most of the time in the back, otherwise it was too loud. I'd say to him, please get seats farther in the back, but sometimes it was even too loud for him and we'd leave the hall in the middle of the *take* and flee. Why am I interweaving my text with stenography? At the machine I always mean to type shorthand abbreviations but that kind of 1 machine hasn't been invented yet or typing would go even more quickly. Last night I dreamed of 1 group of loud academics, 1 whole group of no, not groupies, 1 group of nice people but I didn't trust myself to descend the staircase : with the fat newspaper under my arm, it was 1 turbulent dream, over and over up and down stairs, 1 Greek backdrop, hypostyle halls, but with something like villages surrounding us too, Peter Weibel was there, he had 1 yng. cat in his open shirt but it looked like 1 penis on his bare skin, etc., I had to change as I was completely soaked, I changed in front of the whole crowd but without any feelings of shame, rolled the wet bundle together brought it home and realized it was fresh bread, still warm and 1 little moist. Peter Weibel opened his pants, grabbed about inside while continuing to write explanations on the board, I was extremely curious / attentive and asked him whether the lit. cat he was carrying on his body scratched him, he said no and went on underlining quotes on the blackboard, I was 1 of the listeners in his class, 1 metal partridge like 1 weather vane in 1 old *hovel*, everything completely run-down, EJ wasn't there. Yesterday 1 black-haired groupie visited me, her clothes stank, she probably hadn't changed them in 1 long time, she kept on crying in between, I slipped her some money so she could take better care of herself, 1 member of

the group carried the various bags, baskets, and backpacks I always have with me. But I wanted to draw how we sat *shoulder to shoulder* at the concert:

How lovely it was, this mutual brushing of shoulders, it gave me such 1 great feeling of intimate connection. I almost fell out of bed, I was already hanging halfway over the side, the powerful lamp there so I can read and write without straining, without glasses even. Last night I had to get up pretty often, not to mention 2-3 sweaty hours awake in bed, it would be nice if I could call this text "How Sweet Intelligible Words"—how do you like that, honored reader, treasured listener? No, without the feminine address, the *INNEN*, attached to the masculine form, it's absurd, I come, e.g., across *writer* and *INNEN*—what are you all doing with the poor German language? I went home with the bundle of wet clothes, I don't know what else I dreamed, or I was unable to imagine finding the words, it was 1 *special* view from the hills, fruit and leaves, dark, oily leaves like in the Mediterranean, Asia at your hand. While writing in bed I was propped up on my left side, while Peter Weibel was instructing his listeners (with the help of 1 panel painting!) he reached into his open shirt numerous times where he had 1 woman's breast, we had OPPORTUNITIESTOSNACK, I wondered what consequences there'd be if, upon my visit, I saw her unconscious on the kitchen floor—smallest incidents : excruciating consequences, or if, e.g., I'd left the keys to my apartment inside, in other words, locked myself out, what kind of consequences wouldn't have surged forward

sweet intelligible words, I say, but, I say, there should be 1 little experimentation in there too, I say, the salt of the earth, as the expression goes. Without 1 hitch, it occurs to me, I mean, the utensils I use have to function without any fuss, e.g., the record player, vacuum cleaner, ink ribbon, pedal trash can, correcting pen, sewing machine, the screw top on the jar of honey, etc. Peter Weibel has the yng. cat somewhere on his bare skin, that's a good feeling, abbreviations requested, too many Americanisms, eventually you start to speak that way yourself, the former German expressions are disappearing, in the end seem dated, indeed, where did our lovely German language go? So, I can no longer visit the places we used to visit together : never again at UBL (restaurant with summers : little rose garden!), no more to the PRATER (amusement park), never again in GRADO (August / September '98)… somnambulant, no more in APFELSTRUDL (café)…ach, the woods of the central cemetery, dark leaves, mountains of headstones, damp moss (reverence), no little bench by his grave, the eternal difficulty of lighting 1 candle at his grave, the bouquet held together by wire, my fingers bleeding already, blood dripping onto the gravel path, someone cleans it up *on the spot*. In the morning I can feel that the little dog I mean the pillow is soaked, I mean all this isn't supposed to be capricious! : it wrings my heart. *To paint is easier than to copy*, the wooden cross on his grave softened up by the damp, I urgently need 1 proper headstone, 1 stele perhaps, in the morning 1 performance of frogs. How I always sink immediately sink into the ground, sitting across from *nothingness*, I adopt the color of the person across from me, the way of speaking, the diction, the violin key, the cypress grove. Burned my mouth with boiling hot soup, the skin hung out of my mouth in shreds, drops of rain tapping against the window, 1 winter's day, namely, 1 day wrapped up in 1

dough, etc., foggy-doughy oh what a wonderful morning!—
I have definitively BROKEN OFF 1 ENGAGEMENT, I
mean I have definitively cast off the apartment I was engaged
to for decades. Nevertheless now and again I go inside and
am seized by the urge to urinate and by chills and I begin
to declaim : recite everything I wrote in that apartment by
heart that is *repeat* : 1 revolution after the other, *1 continuous
sneeze*, to eventually clamp itself into the cracks of 1 *frizzy
head of hair*, etc.

The landscape migrates into my mind as soon as I drive up
the COBENZL, and everything looks like 1 book, like
sm. books, inside Elisabeth von Samsonow's flowerlike
handwriting, somehow related to me, 5 x too many words or
what, in the photo that's in the lit. book : her face causes 1 stir,
I write in 1 letter to her : "I'd have nothing against it all being
done and over with, I've had it all already (this life consumed)
I'm standing before 1 NOTHING, it's complicated, whiling
away our nerves…"—: (Must've been 1 bad day!). Just 1 bit
of congestion, I ask EJ, what are you thinking what were
you thinking about? I'm not thinking of anything, I wasn't
thinking about anything.

Every day more of 1 *master of blindness*, I am more of 1 master
of blindness every day, etc., I am already using the strongest
glasses I can for small type, for the totally normal printed
page of 1 book, I'm amazed at how *bluish*, indeed, bluish not
blue, the sky serves itself up to me, etc., blue'd be 1 summer
sky, bluish is for winter when it's icy and sweeping cutting
wind cuts my cheeks and eyes, I look out the window, would
like to wipe away the piercing bluishness, the sky should wrap
itself in doughy clouds and fog, properly clothed, rightly
adjusted, isn't that so, I'm waiting for these cloudy foggy

days, doughy sky, and me, *shoulder to shoulder with the day* like this :

Visual power, namely : the blackbirds fell off the roof when I arrived with 1 bouquet, began to look for a vase in 1 knee-high cupboard : CALFCUPBOARD, and it reminded me of all the hospital visits I've made throughout my life, you barely make it into the room to greet the patient before the question's impossible to suppress anymore : where should the flowers go? Instructed by 1 nurse to look for a suitable vase in 1 of the cupboards in the hall, etc. 1 waste of time, namely, *it's Sunday just like in the hospital, etc.* Glances scattered like seeds, what would they yield… I've reread this all over again and the WILDFEVER took hold of me anew, and I realize that I should have written 1 WOOLIER day (instead of cloudy). How I jumped through the woods, I say, useless to the world and any form of order, waking up I thought about *Frau Röder*, the language teacher who lives over at Castelligasse 12 and the film *The Piano* where the pianist's jealous husband cuts off 1 of her fingers (on 1 cutting board) and how she eventually throws her piano into the sea, etc. Later I come across Per Kirkeby, Danish painter, sculptor, architect, and author, *in the Bull Years in the '60s* involved in the Happening and Fluxus scenes… somehow or other you've got to keep going for as long as you can until the traces of water become clear, etc., namely, until this movable sky of doves swoops onto the plantation, until the WORD-LAMB (lilac bush) sacrifices itself, and suddenly, starting today, Sunday, it's less fun for me to allow you, honored reader, treasured reader, to divine

my stenographic frills, perhaps you've already noticed how pointless it's all become in the meantime, etc., but to get back to the language teacher Frau Röder, she flutters before my enchanted eye, I can see her, with her little flabby cheeks and sly little eyes (field mouse?) : like this :

smiling welcoming her private students to her tiny home and immediately beginning to speak in English or French or Italian, etc.

That we cuddled and sprawled out shoulder to shoulder at the jazz concert, that I didn't always like it but looked to him to read how it was. It occurred to me that we sat away from the regulars, namely, *all the young people*, etc., in any event had decided on single tickets, as it was never entirely clear if I would actually be able to come because of my circulation because of my heart.

The daily kitten (minou) we'd go to 1 concert almost every day I hardly possessed any power of judgment, I had to take my direction from reading his face, that's what I needed to clap, isn't that so. Early this morning I suddenly wanted someone to *kiss the part of my hair*, strange enough, immense happiness. It was already ¼ past 2 in the morning and I hadn't yet slept, in fact I'd been going through old manuscripts and writing my nerve (andantino) stenographies on their backs, Hemingway was at the concert too. I was already

feeling ill from all the angels sprouting up throughout the program, took DEMETRIN in the hopes of being able to sleep, *perhaps humanity's first feast* (Sigmund Freud). Was it the terrible cold last night that completely threw my heart OUT OF WHACK, etc., in any event I finished off the evening (disgust) in this state-of-heart, agitated and afraid : no one there who could have stood by me as with hollowed cheeks and inhospitable enclosure of self I walked back and forth, bloodhound, measuring my blood pressure, counting my pulse, everything in the utmost isolation, distortion. I was more comfortable with the soft voices coming out of the little box and moving about my skull in light garlands (FLORA) whispering, take heart, we are with you, etc., had the *rehearsal-nerves* hooked themselves in, I wonder—choose hooked because, overall, I felt altogether unthoughtful and pathetic—namely, completely abandoned, and so I prayed for the morning light to hurry, rush on its way, 1 time I could call my doctor for help, but that night was long, and in the end I shook 1 handful of pills onto my tongue, drank bottle after bottle of water, and wrote under tears (favored…). At risk of drowning throughout the night's hours of water I thought verbatim : "do you all, you, the dead, sometimes slip into the form of, e.g., 1 butterfly, 1 cricket, in order to try and greet us, those of us still living, through your swish and swing across our world?" (in order to while away our nerves, the same : "while away the time")… 1 man was sitting on the bus, hair tinged with gray, but in reality simply dusted with snow, *1 swallow's hair*, etc., the snow of the Lord and Master, and of such peppercorn.

Whenever I shift my PUPIL, I suddenly see the word PEPPERCORN from the penultimate line appear in the center of the next empty line, probably the beginning

of 1 *squinting-period (method)*, which easily connects to the stuttering-period (method), as well as with the *tongue-kick-period, 1 method as well*, Mario Simmel, e.g., whose books I do not read, appears to be 1 extremely kind person in his interviews, and I'd like to catch sight of him while his tongue is kicking, it's the same with me and people who stutter, I not only want to hear but see their stutter-tools, then everything inside me smokes in delight, or 1 BUNCHOFLITTLEBLOOMS sprouts up out of my fantasies, well now, mother camping on her throne *Thonet*.

To use for all rabbit forms

I set out in the middle of the night to find 1 doctor, *and leafy anguish : naked mourning*.

From day to day and shoulder to shoulder

that's how we sat there, at the jazz concerts

and looked at each other, 1 mirror of the other, 1 mind-comfort, this roaring life, such mortality of language, etc. In this ash-tree distance, *such hemorrhaging*.

From day to day and hour to hour, this is how we sat there, this is how we cuddled shoulder to shoulder, sprawled shoulder to shoulder, like this :

with various mind-thistles (states of mind), and when the penetrating trumpet solos began to hurt, while we were at the jazz concert, shoulder to shoulder, and the whole big band was at it, I'd lay my hands flat across my ears or stick the fingertips of both index fingers into my ears so that it would be tolerable, *namely, from out of the silk-gymnastics, etc.*, or "cry me a river" : *weine mir 1 Fluß*, and then this rose tortured ME as 1 cobweb on my left cheek, 1 crumbling of hair, or I remember going back to my lair with my shower cap on, while, utmost test, we were sitting in the back of the car on the way to the airport, in other words, in the sand, driver stepping on the gas, and taking the exit always : you've nodded off, I say to EJ, and when the airport would appear, namely emerge from out of the morning mist, I'd say to him softly, we're there, I'd say, *time to Gävle up*, I'd say, your luggage, gather our energy... *it's 1 Sunday in boots, etc.*, early this morning in the driving snow the two doves SLID off the slanted window and while sliding fluttered and I thought, these two as well : 1 greeting from him, their claws tore at the sunshade on the outer window, and for 1 moment I stopped drinking and paused in order to observe the two birds better, they were engaged, I supposed, like one of my poet friends who, when we ran into each other by chance one day, whispered to me, I've gotten together with... *we're*

1 pair! He didn't say we're 1 couple but, he said, 1 pair, etc.

As the branches and willow-tree hair, the wide wash of the willow's soft strands quivered in summer's breath, out in Hans Haimerl's garden, we sat out in deck chairs under the tree, and I could feel my fringe sticking to my forehead so that I moved back and forth uncomfortably, I mean, *the 1 thousand ant-feet within the meadows*, namely, devout and fell into 1 half-sleep : sleep-of-seconds.

Death and thousands of howls, I cried into his pen case, 18 months after his death, I cried into his pen case, the pencil sharpener next to the colorful pens and nibs, he'd raised himself in 1 forest : emotional-thinker and *furiosi*, on the 3. and silver moon, etc., and today was another earthquake-morning, I mean everything moved on its own without me touching or mixing 1 thing, the camping table, e.g., where I type, trembling unceasingly so that I had to think that, the very next moment, it'd fall *on all fours*, its legs are indeed retractable, rather practical, I tortured myself out of bed, in other words I left my morning-lair and *beat* myself over to the large table (the one with fixed legs) and sank onto one of the few empty chairs (all the others covered or cramped with silverware, etc.), in other words I fell onto one of the only (usable) chairs my middle snapping and propping my head onto my hands, I was being pulled downward and felt that my forehead would soon touch the floor, I had to think of St. Stephen in my downfall (doubt) and how the hackney-carriage horses stand around for hours in the snow-rain hanging their heads, and someone inside me sternly said *enough with the self-pity, etc.*

I'd like to draw how I buckled in my chair like this :

this is 1 shaman's foot, 1 thought-prophecy, 1 thought-purple, and 1 DEARREADER of my books wrote me the following letter : "and I'd be eternally very (more) grateful to you, I'd be eternally grateful to you, if you'd just write 1 lit. message, 1 lit. piece of *wisdom* for my future, etc." Is this some kind of breakdown or what, some kind of techno, 1 daredevil-deer beneath the EMBROIDERED clouds, pitiless the suburbs will wing.

I fevered then myself took wing, in my turquoise, in my apartment's gloom, while the pink afternoon sky, I mean the condensation trails over the December street, oracle-red, orange-red, namely, *along the little puff of my work*, etc., and she, the doctor I'd phoned, said, "cough into the mouthpiece so I can hear if you're sick," and I coughed into the phone and between the contrived attacks said in 1 croak, I'm 1 pilgrimage type, completely hunched over and holed up, I was 1 green February, 1 France-of-my-own, and I caught myself once again beginning to write down parts of this text in shorthand in my head, it was fun, it made it easier for me to stay in rhythm, and I heard EJ say to me : "as you only ever speak to yourself, it's immensely stressful for you to even engage in small talk, 1 single conversation with your friends is taxing, and all you want to do is run away, your monologue has been interrupted,

it leads to 1 jam, BLOODJAM, and soon enough you're sick and broken, etc."

And, naturally, AS I TEND TO TRANSFERENCE, when E.S.'s left incisor erupted, I immediately had the *physical sensation* of having lost my top-left incisor, and with my tongue kept probing the space where it'd been, in reality where it continued to be, but in the steadfast belief I'd lost it, etc. The airline said : "my little boy" to me and I rushed around my house and sipping again and again from the piece of paper affixed to the machine, wrote words and sentences in smaller and larger spaces, it broke inside me outright wedged. My very own woods / forests visited me too, I mean hardly had 1 notebook popped up somewhere than 1 string of hair coiled itself around another on top, on DRESSES and clothing too, pieces of laundry and handkerchiefs, so that I grudgingly cleaned everything and *blew* the air in order to have 1 clean start again. I literally had to SUCK myself AWAY from the machine in order to wash, dress, and comb my hair, like this :

ach, this hunter-language, I yell, rush through my shower and dive-orgies in order to get right back to typing, etc., this fuchsia-language, this hunter's heart, I devour the language typing as if it were candy, and so be 1 candy type, says B., only *clutching at desires*, etc.

As far as I'm concerned, I say to B., the little fern cushion is still 1 foreign body in my bed, or I still need 1 little time before I can rest my right cheek on it, I mean, I know nothing but how much of 1 STRANGER it is, it's almost too big to be 1 cushion and maybe it's overfilled and has too colorful 1 case… all in all it's 1 bit too loud for a pillow, quietly everything has to happen really quietly, that's how it was back when you came to see me, I say to B., the 1. time, and lay next to me the whole night long, nothing happened or was it that everything happened so quietly, it was that white night, as we called it, do you remember? and I needed only 1 little time to lay my cheek upon yours and I knew nothing but how much of 1 STRANGER you appeared as, etc.

The storm raged, it was glorious *with the sparkling sky*, and once again I had 1 X such 1 memory day and before me I saw that coiled path in Bad Ischl (namely, "from the year of snow," like someone just whispered to me on the telephone, who?) from the hospital window, and I saw someone wandering down the path, somewhere to the west, and my glance came back to EJ, who was sitting in his hospital trolley and wanted to be rolled down the hallway, etc., and whenever I wanted to be proud of something, I'd say to him: "caress me across my scalp," (no, not : "caress my scalp" but "caress me across my scalp," etc.) and he'd caress me across my scalp, *by the kilo*. HOLIDAYKILO, I dreamed last night, but I don't know what it means, and MANY HUNGRY THANKS and HAVING GROWN FRAYED I SAT THERE WITH THE RASCAL JACKET, etc., also SOMETHING BETWEEN LECTURER AND CHECK.

Today the currents of air like currents of water, mild / cold mild / cold, and they seeped into me and took hold of me

and pulled me inside, and my legs brought me somewhere, I had no idea where, in myself imprisoned : determined and 1 x it took me by the back 1 x by the heart, I let myself be carried away as when, at night, the words would come like flakes on 1 winter's day, touch me cover me until completely snowed in by flakes and words, at night I'd write down what I did not want to forget in the morning but then my hand would droop 1 little as I'd be right about to fall asleep again.

I've always wanted to write 1 whole book of *footnotes*, I'd leave them there, the notes, having stripped them off my feet, soft woolen winter slippers, namely, I've always liked writing in winter, isn't that so, footnotes : 1 whole series made up only of footnotes, glossaries, explanatory-style, etc. In February already 1 *tiny fox* surprised me, little rock pillow butterfly, Georg Kierdorf-Traut, fleeing across 1 frozen and snow-covered lake in South Tyrol, writes, now the wild violets are blooming and giving off their scent around the trees of life, my clock soon to stop, was it 1 paltry was it 1 dazzling life, he writes, was it enough?—1 disposition-still-life, 2 MANUsize hemlocks up out of the ground to float knee-high so that I can touch them without having to bend down, LIKE MANUSCRIPT. How I cry it how I cried it with what rudders and rods but anyway when cooking the milk the TEMPERA CONVICTION occurs to me again but anyway I was amazed that I managed to make it to the tears, *coughing 1 lot as well, heartorgy*. It whipped me to write and I learned that everything has to flash and steal your breath,

and I still don't know—despite being so close—whence the impulse adoration exploitation (originally it meant "unfold") arrest : *of this scirocco* and whether it really happened or is only my imagination, namely, as Alberto Sánchez Pérez 1933 writes : "even though my rapture may toss me off the steep slopes, even though my body may change into mud from all the rising and falling, I would gladly sense beforehand what it is like to choke in the depths of the sludge and meet the reptiles of my dreams upon its ground..."

It was around 12 o'clock noon, all my pages on the floor, having fallen out of the folder, and scattered fanlike across the floor, and I gathered them up, and looked at the clock and saw that it was noon, and I reordered the pages according to their numbers and saw that they were already 1 bundle of *manuscripts*, and so I sat myself down on the floor and began to read my *manuscript* from the beginning, and I began to tremble and kept jumping up and completed the last, half-written pages of the manuscript in my head, and I calculated how many days it still would take to bring my work to an end, or rather, to have to, for it's supposed to be 28 pages exactly, but ultimately I've always wanted to keep on writing, for ever and ever to keep on writing, namely on account of this sweetness, etc.

And nights, before I went to bed, I'd lay the folder with my manuscripts down on 1 empty chair or on 1 corner of the table and would beg to find them in exactly the same order the following morning, etc. And it always had to do with this WORDLANDSCAPE or WORD WOODLANDSCAPE, and in the evening someone came with 1 book of glass, Giuseppe Zigaina had written it and dedicated it to me, *all the eyes*. Then 1 snowflash, nature's polishedness, etc., I long for my as-of-yet-unwritten books

as-of-yet-unwritten lines, pages, *strings and strands*, wild and wolflike, from the kitchen window I saw 1 coffeepot with 1 blue edge, 1 bouquet of flowers inside, vis-à-vis, throughout the months and days always the fresh bouquet, dahlias, red lilies, jasmine, *like gondoliers*, the candyknots of my head, WHERE IT'S SAD, happily at home in the thicket.

Early in the morning the telephone rang, and 1 voice that I didn't immediately recognize wished me "1 quiet and peaceful holiday season"—No, I screamed inside myself in 1 terrible uproar, no quiet and peaceful holiday, but storm-like unsettling coming over me in massive waves, tattered, tousled, disheveled, fiery and soft, no nails, Alma says, and nightingale, where are the torrent the tears and the Danube current, I incorporated *1 blazing breakfast* into myself, brand new, namely too hot, etc., and Mother says, You shouldn't eat things when they're so hot, great longing acres, shrubs and wood, cypress trees, soft ferns, the trees along the avenues touching each other with their tops, isn't that so, 1 opening in the rocks over there, 1 opening at the edges of the wood, how odd concave nature, etc. Ach, Mother said, back when we were engaged I was so in love I wanted to kiss HIS feet every single day, that's how it was, I saw the word *foot-prayer* before me in 1 dream, I say to Mother, and then as if off 1 board I read : *patriotically shoed and shod, the side this man sleeps on, Jean Paul, he was given 1 little hour of PE for eternity, bread of tears and of heaven*, etc.

Writing, crying on today's program, carrying 1 lilac on my arm (in the crook of my arm), and feathers ruffled I ruffled fuchsia-like and said to myself, now everything's out! , : *as the coal merchant was closing* and I was afraid that, in the middle of winter, I wouldn't be able to heat my apartment anymore, and feathers ruffled I ruffled fuchsia-like it MELTEDTHROUGH

me when I glimpsed the little urn with the little violet coat in which my mother's ashes and with 1 sob I thought, *that is all that's left of her, etc.*, felt like I'd been hit with a bolt of electricity—she cannulaed herself into the ground at the feet of her husband : my father, and you downright heard 1 tugging trembling and tearing, 1 creaking at the man's feet, at the feet of her husband that she constantly wanted to kiss, BACK THEN, 1 sharp scratching like the blade of 1 knife on the inside of 1 earthenware dish, 1 glass plate.—

1 spreading of wings : she, Alma, has 1 *job at the post office* and therefore is unable to make our long fixed appointment, on the other hand, I can come visit her whenever I like, if I want ("the feces cut off simply cut off because the bowels empty themselves too slowly…" according to Alma).

Going to find Alma that afternoon I was shocked : the apartment was musty and this abominable sunshine came dazzling through the roller blinds and my eyes started to tear immediately. I saw the water bottle on the sideboard, next to it 1 empty glass, and I remembered asking Alma not to make any fuss on my behalf, and so I was waiting for Alma to offer me 1 glass of water, but our conversation was so lively and intense that neither of us thought about 1 drink but getting ready to leave I saw the water bottle and empty glass standing on the dresser. Once I'd left Alma and was on my way down

the stairs to the supermarket, 1 Japanese girl came toward me : she was hopping up the stairs and opening her *automatic umbrella* and I thought, I've got to preserve this delightful little image in my memory... the price corrections were piling up / were implemented at irregular intervals, etc., 1 dream perhaps : I'd swallowed fly-mushroom powder, I could fly, I spread my wings swung over to the window and out, touched down on the stone ground of the inner courtyard, Frau Nagl sitting at home *unaware* with 1 yellow hair dryer and 1 white comb:

and I think I'll let my arms dangle so as to catch myself before 1 fall, in other words, not stick them into my coat pockets while out taking 1 *stroll*, just like EJ now I lay the dirty hankie into the open drawer / onto the dining table, and over and over I want to say something show HIM something ask HIM a question, spend most of my time alone at the desk with my ghosts, *most of the time against the current*. EJ says during his time in the other sphere he has observed how all the angels stick out their tongues at one another.

I tidied up the wastepaper strewn across the floor, picked up the dirty and torn little scraps (notes) piece by piece and placed them in 1 big box then happily sat down for dinner thinking the text, the one I'd worked on for months, etc., at last complete, I made 1 *sign of the cross* (Tàpies) over the folder with the draft and

planned to get started the following morning with the clean copy while at Tàpies's feet. Throughout all the wild months he'd become my favorite painter, he accompanied me day and night, I dreamed of him and his works and thought about him as soon as 1 sentence did not want to come, at the same time, at his feet, Jacques Derrida's *POST CARD*, which I'd returned to after 20 years and whose complicated style once again drove a shivering fit across my body, with these two props (crutches : Dalí's favorite image) months earlier I'd added myself to the text and had finally finished.

All of 1 sudden the story with the earworm came to me, namely, taking the creature out of his ear in pieces with the tweezers, same thing with the bench in the forest on one of the KOGEL mountains near Winterbach where we were resting after having gone for 1 walk. And all of 1 sudden from out of the bushes my

mother's form, she *broke* out of the bushes, broke through the bushes and was standing in front of us, perhaps she'd wanted to eavesdrop, the suspicion wasn't too far-fetched, maybe she was embarrassed about having wanted to eavesdrop, wings beating, on the words and translations, on what was being read, the games of adolescence, walking, and *the hun*t, etc.

Thanks to the *Odyssey* I haven't been to the mountains as much this year, but 1 time the way once again led through the privet grove in Allitz, up to the Rimpf Höfen, past 1 sky, past 1 herd of deer to Rötalm, Siegfried Höllrigl writes, then on past the shepherdess with her dog, straight up and onto the *Schneid* and still higher and higher with the beautiful view onto the Ortlergruppe, and the privet of Kortsch-Allitz always reminds him of EJ, of when, though sick, he was still alive, etc., but here we have 1 box of colored markers, it's just 1 sofa farther, I have grown completely attuned to Antoni Tàpies's work, their unsophisticated forms :

1 cord, 1 cane, cross, heart, diamond, spade, that way almost every day will have been ablaze, I say to EJ, the gray sky, in it 1 bird of Mary, 2 red mosquitoes, 1 shower of blooms, 1 great weakness of limbs and laundry, *I've just about finished 1 text, 6 o'clock in the morning and the air of firs*, 1 young siskin (twig) flits into the car (which I catch) and, in general, huge hawks' nests of journeys in my head, I notice that my handwriting has become similar to his now, in general there are a lot of things I now want to do just like he'd always done. In the lecture hall I felt someone's glance from behind, turned around and looked into the shapeless pale face of 1 old woman, after some time, softly, she said, CORA, CORA, she said, and I immediately perceived her earlier, beautiful face in the present old and haunted 1.

Because I could not understand the Spanish descriptions below the pictures by Antoni Tàpies, I bought myself 1 two-volume edition of Langenscheidt's pocket dictionary SPANISH / GERMAN : GERMAN / SPANISH (I have hundreds of things to tell you, and it's like spring outside, sweet and ready to burst, so sad so blessed, I let my eyes drift, most of the time it has to do with events in the soul, I can feel it in the energy of my creations, etc.).

Having come to 1 halt, I went looking for Gerard Manley Hopkins's JOURNAL, dreamed : broken dishes, 1 sewing machine, spilled morning earth and glue on the kitchen floor, I am like plywood, 1 thing for daily use, 1 simple humble thing, and avoid my eyes in the mirror. Tàpies paints the picture *Black Marks and Fan*, he paints the pictures *Brown and*

Blinder as well as *Brown and Floorcloth*—this picture is completely wrung out, this thirsting picture is completely wrung out, on the inside of my hands that are wringing out the cloth I can feel how raw this picture is, I mean, *monument*, footsteps, the streaks of bloody fingers on the picture, I have cold and red fingers, that's how cold it is today, I'm wringing out my soul, I look into CORA's by now aged face, CORA, I say, is that you? Yes, you too, your soul so wrung out too, I caress her cheeks with my hand, I say, I wrote you so many letters, did you ever receive my letters? 1 emphasis on letters, *in the heart of the void*, etc.

The postcard Elisabeth von Samsonow has written me is 1 encrypted letter, impossible to decipher, I'm afraid of metal objects, I'm afraid for my life.

His talismanic strength resides in his, that is, Tàpies's, paintings and objects, and all the mountains and islands are being moved from their places, I already believed that language, my language, language as 1 whole : DISSOLVED

: blotting paper in the rain, namely, 1 *forestattempt*, and this word will accompany me for 1 long time now, I say to EJ, this is how I'll consume myself, I listen to Maria Callas somnambulant, keep changing doctors. I think, I say to EJ, that only 1 single sunrise continues to keep us apart, in the meantime I make my way through this alphabet world like 1 breeze, when you go hunting LIKE 1 DOG, EJ says, you have to howl LIKE 1 DOG, and so you howl when you write, you're hunting the language, namely, as soon as the heart begins to beat irregularly, the throat is tied, the tears flow : *then 1 wonderful vegetation and fever prevail.*

On the dust jacket the bandaged arm, the bandaged foot of Antoni Tàpies, I say to EJ, and *as I'm always 1 little too early / overly punctual / I always need 1 little piece of plafond, etc.*, indeed, as I am always 1 little too early, I take the way to the physical therapist 2 times, then ring just as the big hand meets the little 1, up and down the street, my eye in the slant of the painful afternoon sun, completely on its own the bottle stopper loosened up and shot into the air with 1 dull crack, and as soon as I hear 1 poet friend reading, I follow step by step, that is, in my head I hear the echo of the language they're reading, listening, I experience 1 kind of counterfeit writing, you should listen to Webern's short pieces, EJ says, in the little juniper grove in the cemetery, all the crosses in the sylvan and mountain flora, the little crosses for sex in Schumann's diaries, on 16 August 1852 about Schumann Jenny Lind says the following : "We eat and drink your songs..." 1 foreign object in my left eye, in my left ear, 1 rush of cloths, an attack of puns that makes me vomit, etc.

By all means the reader wants to *peep* behind the curtain of words, otherwise no allure at all, 1 coin or rather cloud on

the floor or 1 sm. spot of sun, stones from Corsica and Crete on my desk so that various bits and pieces of paper won't be blown away, Hopkins's JOURNAL is one of the few books that I can find at night, I mean, AS IF IN 1 DREAM, on my shelves, after surviving 1 high-blood-pressure crisis today lean and at work again. EJ says, if you die before me, I will desperately look for 1 of your hairs, tuft of hair, 1 few days before his death I cut 1 lock of hair from his temples, Tàpies says to see God's work in the simplest and basest things, the most modest of forms, 1 cord, 1 cane, 1 footprint, the streaks of red fingers, cross, heart, diamond, spade—poor objects human beings need to use every day, forks and pots, table, wardrobe, chair and bedstead, towels, black glasses on 1 leather book next to 1 iron bed with engraved soles, the impressions of body parts, armpit and foot, the tick,

numbers, letters, circles, coils, triangle and intersection, initials.

I start off the day by attempting to verbalize the smallest performances, every movement, this is 1 writing behind the writing, I say, everything dissolves into language, but sometimes I also ask myself where I find the physical (material) aspect of my texts, Dalí's edible sparks, probably. Recently,

at 3 o'clock in the morning, suddenly wide awake with the memory of EJ giving me Sartre's *The Age of Reason* on my 40. birthday, or 1 element of the shoulder (love as rebellious bird, etc.).

I get confused 1 lot now, I open the little Allibert cabinet in the bathroom when I actually meant to open my mouth to check if my gumboil had grown, which is what I feared. Tàpies, his favorite words, asks me in which hand I keep the needle and thread, do you hold the needle in your left, the thread in your right, he says, or the other way around? He helps me into my coat and at first I slip my left arm in, which surprises him, the dough on the shoulders, he says, the resurrection of the feet, magical body research.

After the jazz concert we drag ourselves to the SOFITEL, where for 1 long time no one pays attention to us : waits on us, we sit there, frozen, hungry, and wait for 1 server who doesn't come, I say to EJ, there was also 1 SOFITEL in Venice, it rained 1 lot and you had to make your way across huge puddles, I bought him 1 pin in 1 souvenir shop, 1 tiny red heart as 1 souvenir of Venice, but he asked me to keep it, I pinned it tight to the neck of my T-shirt but at 1 certain point it got lost, never to be found again.

And something makes me howl, our imagination, as far as the phenomenon of memory is concerned, I say to Alma, is not just matter (*Elbow Matter*, Tàpies, 1975) but the excessively felt emotion, the taste, the smell, the touching of the past moment, lying how many years, how many decades back, as fresh as peonies and the apple of paradise. It shimmers in the heart, while bathing, it glistens in the sky, *the sun jubilant somehow* (as invisible), I see, hear myself calling out : "with

the bad foot first, the crucifixion foot," EJ groping, bent over, clinging to my right hip, clutching his cane with the rubber stopper, feeling out 1 step beforehand with his cane, going over the doorstep and down, 1 ascension or strand of hair between our kisses on the temples, while his thinning hair frames his skull in long white curls, etc.

And will anyone even read this, I wonder, and is my apartment maybe 1 little like 1 Beuys installation? (Exhibition "Joseph Beuys… any old noose") Galerie Schmela, Düsseldorf 1965, find pictures of Beuys's objects : object *Snowfall*, object *The Abandoned Sleep of Me and My Loves*, *90-Degree Tent-Covered Felt*, *Rubberized Box*. Today I am doing everything really quietly, deliberately, every sound disturbs me, I say to Alma, my hand trembles while writing, 2 apple seeds in 1 cup *slide* toward each other, strange individual movement, I say, I cry 1 lot and vilify the sunny days, think of the title *Green November*, the poetry collection of 1 poet friend (A.O.), huge cobwebs envelop me at the breakfast table, which is simply made up of 1 foldable board, I've burned my upper lip, at the same time to TORPEDO comes to mind, why, Theo Rommerskirchen calls, he gets up, measures his blood pressure, swallows 1 tablet, sits down at the piano and fantasizes the whole morning long, the idea brings me to tears, sometimes I try to guess which composer it could be when I turn on the radio in the middle of 1 piece, have discovered my passion for *overstamping*, convincing myself my letter will receive more rapid and careful treatment, 1 eye slit out of my chamber, I open the bottle of Odol mouthwash with the special opener, tiny bird as sunlight blazed right across the tilted pane, I spin myself out of the slag like one of Antoni Tàpies's COILS, and in the nursery I see from my window, the red flames, wingbeating woods, I am 1 lamb, I have 1 sword on my back, Robert Schumann writes

in his diary, I have the feeling of having crouched, buckled into myself, out of fear of something I cannot name, whose form and power I do not know, I see no goal, everything I touch, take up, after 1 short time seems flat and plain, it's the same with the people around me, clearly provisional style from Antoni Tàpies, *Two Blankets Full of Straw*, 1969, as 1 backrest on 1 chair with armrests, like the ones we had at home when I was 1 child, that is, CANADIAN / easy chair, as I called it, rounded furniture from the 30s, it could be flipped open into 1 bed, no one wanted to sleep there, woe to those whose lot it was to spend the night there, mattress straw pinewood chips, the following morning back pain intense, a longing appearance (you rolled from 1 side to the other, hardly finding any sleep in 1 martyr's chair like that, bent, shrunk, the COILS like bones poking out all over the place, 1 lolling, cycling, noises), Mother in the seagrass, "hot canvas with diamond patch," etc., little piece of deerskin leather as 1 bookmark in my favorite book, that too won't last, I had 1 lot of favorite books, they were always changing, yes, I mixed myself into their physical matter as 1 protagonist, I was among them, I was 1 little wheel in their clockwork, *the rapturous man of moonshine*, and walking by 1 body of water and tossing the blue ring inside, etc., like you I always jump from laughing to crying, I say to Alma, no hand arrives from out of the clouds, the wispy red-blond-dyed hair, which nestled itself in waves on his neck (A.O.), seemed to want to reveal 1 secret, but as I knew the secret, my observations confirmed reality, ach, little composer's house, *it's just 1 sofa away*, 1 fly buzzes over my skull, everything is complicated and obvious at the same time, I see the color green, I should have sent the *Münster-Arias* to C.F. 1 long time ago already, as she wants to come to the reading, etc., continuous nervous anxious agitation in my head, or nervous coincidences in my head,

or I imagine I'm suffering such burning sensations, no, I'm happy because it drives me to write, isn't that so, attacks of nerve-vertigo, on the street, e.g., when out walking I lose my sense of direction when cars rush past me and in my head I notice that I'm *rushing along with them*, which leads to 1 new feeling of vertigo, piano envelope, 1 album of lieder, Alma at the table piano, Saturdays, Sundays intolerable as there is no mail, letters, postcards, comforting connection to the outside world, weekdays leaving the house to pretend to yourself and the world that you're busy with important things, tolerable only when Saturdays, Sundays, *driving up the Cobenzl with Edith*, sunlight like 1 weight : judgment into the living room, I almost fell unconscious, began 1 great chronicle, I read through my wild books, EJ was 1 moralist, his admonishing voice : "you can't do that! you can't do that!"—at times I ignored it and did what in his eyes was unjust, immoral, etc., drop in temperature, lots of rain, *head book, copybook at my feet*, the communicating vessels. And we had lots of birch leaves on the side, the soul, resounding laundry. I welcome the specification of 1 theme, it guides me, I say to EJ, 6 o'clock in the morning outside in the dewy air, beautiful blooms in the early air, *the Rhine shimmers (it's grown)*, Schumann notes in his diary, I'm impelled to do things only halfway, I say, no : in the middle and over, I correct (myself), something like 1 aria. Honeylipped impression on the paper napkin, cheeks full of food, how unattractive, onions already sprouting in the dark kitchen, 1 suite, I say, I kissed her for the very 1. time on the cheeks when she came up to greet me after the reading, she looked delighted, I mean, as I write this down I chew on 1 word, which doesn't want to justify what happened, I am on the search for 1 particular word, 1 password, it is, I think, one of the poet A.O.'s emotive words, one we talked about frequently, if you inflate the pages, you never get to the end,

They say that it's refreshing to souls when we light 1 candle here, yesterday I lit 1 candle for the 8. anniversary of Mother's death but it almost caused 1 fire in my apartment, a hell-like hissing because I saved myself with buckets of water, I'd slept long that morning, cried 1 lot when I understood how careless I'd been the night before, then everything yellow, Sahara sand across the city, listened to "Pleasures of Youth" from Anton Diabelli's sonatinas for four hands, cry into the morning, hounded by memories, in 1 minor key in the restaurant, the waterfall pleated, the torrent of tears over swollen eyelids, unless I'm *high* I cannot write, I say to Alma, would so gladly have said to myself : "I am completely cocooned within my work," would like to go "outside," A.O. writes, and on the white paper napkin I work out the so-and-so-many anniversary of Mother's death, the thinning bar of soap between her hands where there still was foam, that's how life steps are translated into words, I say, that's how life is metamorphosed into language, the old gnarled pear tree in the untended garden, I say to EJ, the one we sat beneath, I was 1 little cold, for it's easier to be cold in summer than in winter, or is it rather 1 shivering as soon as you step out of the sun's warmth, etc., this body that shall later surrender to writing's sensuality, I have always written with my body, "blossoms" brushed over, beautiful summer days : the naked roses, my current way of working : *in accordance with the kitchen chairs*, *in accordance with the kitchen chairs*, the shimmering of the Rhine will tear the heart, Schumann writes in his diary, the wandering plantations, the mulberry groves, it screams in me, in 1 curve, black, the mulberry fruit burst apart on the loamy soil, 8 years old, face fringed, in the pushcart with my legs tucked up under me, in the park drawing Ariadne's thread with chalk, is the child allowed to listen for the nightingale, the sounds of the wind through the trees, those are tears on the

that they *jungled into* the printed text, isn't that so, I'd lay the book next to my pillow, sleep for days on the open pages so that in the morning not only my cheeks but the pages of the book would also be creased, the book as seemingly devoted to me as I to it. The morning ocher colored or inaccessible or TABOO or incontrovertible, the feet growing dark, then waking dreams, in 1 terrible hurry *scurrying over* one another, through light-green treetops, glimpses into 1 pale blue sky, once again the heart so relaxed, raging laundry, and the word that hides from one what it can say to another, like desert rose, gazelle, carpets of autumn crocuses, something, 1 scent, lotus flower, narcissus, today for the 1. time I listened to Jessye Norman. Our imagination, as far as the phenomenon of memory is concerned, I say to EJ, back then with Daniel, I say, these things could have grown, I say, Daniel wrapping his leg around mine under the table, 1 pleasurable heat began to spread out within me, or my entire body experienced 1 wave of arousal (rapture), and, as if seeing myself in 1 mirror, from out of my innermost eye the lightning flashed and I was afraid of going under in 1 storm of tears ("it was the same town and yet 1 different town, think about it, this wisteria town, I say to Daniel, as I lingered with you there, and in 1 period of 2 years I was there again but alone, and it was 1 different town, but I was tearless essentially completely indifferent, indeed, sullen, I went to the same places but did not recognize them as the ones we had visited together, they were foreign, unfamiliar alleys, ugly buildings, once again the wisteria or laburnum bloomed, but I was excluded, and it didn't bother me in the least…").

1 great Mendelssohn, I had already emptied (and spooned out) the jar of honey, fruit flies over the cup of tea, on the breakfast table, got out of bed late and bumbled about the

living room and the kitchen on tiptoe, although no one was there to wake, was afraid ("sunbeam") in particular of spring weather : temperatures, was afraid of the postman or really packages, because I was still in my bathrobe, I'd had long-haired dreams, they had completely dissolved, leaving only the taste and scent, or mood, I sat there and stenographed with 1 red marker while soaking my feet in hot water, everything was still burned (charred) from the candle, outside wonderfully damp-blurry landscape, *in other words, good beginning of the week, one of his favorite words*. I spring like that (something) from laughing to crying, climb mountains of notes, wavelike hills of paper, namely, "up the rugged mountains," *temple* actually means *the thin*, thinnest skin of the skull, this rapture : one sees with the temple, one sleeps on one's temple, I sleep on my right temple, I curl up on my right temple, on the sm. pillow, head- or templerest, really thin, that's where dreams begin, I think, from the right temple, that's where the good dreams come from, from the left temple, that's where the terrible dreams come from, I lie 1 entire night upon your heart, I say to EJ, I lie 1 entire night upon your heart with my right temple, with my right temple I quiet upon your heart, I say, in other words the resurrection of the feet, then the suffocation fit, I couldn't get any more air, you have to give yourself time when drinking, the doctor says, press your head down when you swallow, the doctor says, in other words you have to drink with your head down, like animals do, and as for the dizzy spells, the doctor says, you have to take very conscious steps, you have to imagine sources of light affixed to your knees, your knees must always face forward, etc.

I'm dreaming this prose's flesh, I say, longing for it passionately, doing all I can, white and streaming red, or window with streaming red, Tàpies, etc., thus I have lost my life writing, but perhaps it was the most I could do with this, my long damn life, I have no idea where I should *send all this to the devil*. Delusion stained, I feel like the two hands on the large wall clock, 1 stranger to myself, I observe everything that happens to this stranger, tears of 1 collaboration between the stranger and me, I'm 1 sloppy person, Hemingway was at the concert too, I already felt ill from all the angels sprouting up throughout the program, beginning with the moon up through the final angel-figure and back again, in the snow-white room my nervenotations, andantino, *to overcharge* the exit from the body, I mean, when, how will that happen, when one exits the body, exit with 1 flashy car, and the like, I tell Alma about my miserable thoughts (speculations), she nods understandingly, whispers some words, the large stone from the coast of Crete that Edith brought me is jiggling on the wobbly camping table where I write, whenever I strike the keys too hard, take heart, we are with you, Alma whispers, no no, I counter, driving out of the divine body is extremely intimate, no one should be 1 witness, whatever I shall experience (suffer), etc. At ½ past 2 in the morning, feeling awful, my body stamina activated, I prayed for the speedy approach of the morning light when I could ask my numerous doctors for help, but the night was long, in the end I shook 1 handful of tablets into my throat, the *thin window*. Then *this rose tortures me*, I mean, as a cobweb on my left cheek and Alma calls : "*you, your variable system of thought!*" etc. This state of mind (thistle), these traces of 1 sm. reptile on the bedspread, this head-high crimson parrot perched on 1 beam, next to my pillow the little bouquet of thyme, woven into 1 etamine pouch, *and did our blood arrive just yesterday*, call Sara Barni, itinerant cloud, you write

DONZELLI with 1 Z like zephyr, I dream that I tell Sara
Barni, EJ makes everything 1 secret although he is 1 really
open person, etc., cannot hide 1 thing, he doesn't hold back
with harsh opinions either, which often hurt the person he's
speaking with, I attempt to soften him, his fury immediately
turns against me, I dream of him telling me during dinner that
he slept with Alma hardly 10 minutes after I'd left the house…
I drag his books over, resurrection of the flesh. At the pub where
we eat dinner, from the neighboring table I suddenly hear the
words : "Look, my Heimat!"—with the inflection from T. S.
Eliot's *WASTE LAND*, I almost burst into tears, the sound
of this voice is so beautiful, on the way home I look into the
blinding sky, it's blinding though there is no sun, I say, we
spoke about literature least of all, I say, can you imagine, as
it was constantly happening in both of us, and in constant
growth, it was hardly 1 thing, he preferred to speak with me
about music, jazz music in particular, about world politics,
about getting 1 pet, about travel plans, or he'd show me the
Polaroids he'd taken (of himself) the night before when he
couldn't sleep, *Berlin asparagus spears and May*, they belong
together, he says, and soon we need to make up our minds
whether to go to Berlin or Meran, he says, what do you think?

I can feel the little dog : the pillow is drenched with sweat,
Moni grabs me in greeting on the left arm, winces, cries out
: that feels thin, you eat too little, how I always race and raise
my levels at once (blood pressure levels, I say), as soon as I am
sitting across from someone who expects me to speak, I hear
myself say to EJ : "this is 1 real pain," I say, "I hardly dare
get together with friends anymore," the landscape migrates
into my brain, I would like to go into the autumnal halls, but
alone, and I was excited yet grew afraid of being so all alone in
the autumnal woods, *inauguration / gooseflesh*, etc. The leaves

in long rows of tears and tines on the wooden branches and perennial wood, Hopkins, reading Hopkins's JOURNAL is my favorite, I had 2 delights while reading or 1 attachment, viz., in point of fact, I got stuck on 1 formulation, got myself some Styrofoam plates in order to nail up my notes, namely, my REMARKINGSTYLE, my bed chestnut colored with engraved legs, Tàpies, I lay down flat on my back and lifted my legs up against the wall, nestled the soles of my feet against the wall hanging, propellered into dreams, which most of the time I don't remember in the morning. When I got back the book I'd lent 1 horrible smell of cigarette smoke streamed off it, namely cloudy sight, etc.

The Leonid meteor shower plummeted stormed rushed shot down my spine, and cutting my fingertips over and over on the tablets' metal foil so that they bled, 1 long time, down the hall and over the laundry, I mean HAIRBREADTH, it's always so easy for me to get sidetracked, I say to Alma, everything, anything at all and everywhere, whatever you designate turns into 1 artwork, "you dog shoe," says EJ on 12 December 1998, the cross and the foot and the table and the hand and the bed and the cord, Tàpies, *out on the field during the sermon.*

The ginkgo leaves fell out of 1 letter onto the floor, strewn, in autumnal colors, "the poet's concern," says EJ, "must be to see into the interior of things," the color-brothers (wings) with glowing silk (soul), this rough and choppy sky full of doves, the shadow of a crow's flight in the corner of the window, my furrowed dreams match the confused pain of my waking

hours so much, dull and foolish, without any order or sense
or dignity.

I have been excerpting the whole morning already in bed from
Jacques Derrida's *POST CARD*, and everything seems to
match my own life situation, then 1 footbath and drying my
feet with 1 terry- cloth hand towel, after all these years I find 1
sm. scar on my left wrist (from childhood?), read through 1 old
manuscript, "Mia Williams Heartwaves," I don't recognize
the title as one of my own, everything's overflowing here, my
wardrobes, shelves, boxes, and baskets : books, newspapers,
complimentary copies, memos, and little notes, not 1 single
drawer in the whole house, that pains me, 1 drawer is 1 very
practical thing, etc. I'm afraid I won't be able to bring this
book to 1 end, if 1 unending piece of paper existed, everything
would be easier, but having to start 1 new piece is oppressive,
I think I've always only ever done things *halfway* with my
terrible, typical carelessness, superficiality, relativity, and
all the same, the pulse flies away, blood pressure in rapid
succession, the stomach, my heart-hang heavy in the center
of my body, well, I'll never be able to finish 1 thing.

Yes, I know, he, EJ, had this tattered T-shirt ("*night pullover*"),
etc., on, clean but completely kaput, I say to Alma, 1 couple
strands of hair wisped my lips while I was lying down, "barred
mouth" (Tàpies), or sewn mouth. Barred mouth, sewn mouth
: corresponds to 1 life's desire, 1 life's aspiration of mine :
to no longer speak, to no longer explain, to no longer have
to confess, for all that is unwritten, oversimplified—*ach*,
alphabet delirium, etc., and Mother in the last months of her
life complained, oh, when you don't speak with me, I forget
the entire language and with it my means of thinking, isn't
that so.

And I made an effort not to fall, my friend's firm friendly glance and smile stayed on the lines of my face, that's how I could feel it, as I sent it back, his smile, I mean, in my memory it's remained my own, and then 1 rushing wind blew through this music coming out of the speakers ("silence and stupor, storms across the globe, sparkling treasures and skin"), Rimbaud, just like me in my skid across the forest floor, 1 woodland bird there belting it out in the silence, and as I skid downward, I constantly thought about that sound, this music from the pine trees (needles) covering the forest floor, I spread my toes to gain 1 foothold and made 1 effort not to fall, I say to EJ, the plummeting mountain views, etc., it was as if the needles : the fallen needles of the pine were emitting 1 sound, 1 sound and 1 smell, a*nd for weeks*. Ach, this wood intercourse, I fail to find too many memories now, but I can remember reading him 1 freshly written poem over the phone 1 day when we couldn't see each other, unsatisfying to the both of us, I couldn't impart all the symbols, he probably could not really imagine what I'd written, *but it was 1 thrill*.

I bounced about so much in my childhood : 1 goat girl, looking back now, I think, who always kept me from going astray? Tàpies so tender, so gentle in his painting *Great White without Matter*, 1965, 1 sink with wall mirror, the wall mirror's anchor accented in black, the fixture for the toothbrush glass, etc. blinding white basin with drain, next to it 1 bar for dirty-gray hand towel, tender act. Or his *Object in Relief*, 1976,

with pliers scissors keys cross knife and eyeglasses, or his painting *White and Malva*, 1973, or *Collage with Envelope*, 1966, the fact that Tàpies works with poor *miserable* materials : strings, rags, dust, sand, straw, ash, fur, mesh, ruptures, thread, pillows, rubble, footprints, knots, broken dishes, sheets, impressions of the human body, holes, earth, mud, streaks of rain, the wall, refuse, newspaper, paper trays, vomit, quilt, rice : it's moving, drawing boards, chalk, crucifix, feet in relief, naked, gaunt, moved namely moving to be able to move one must oneself be moved, etc., quite 1 achievement, but over and over the ruinous doubts during work, the deadly hours of dozing, howling, of self-incrimination, self-evisceration, the screaming and raging, the unproductive path, not 1 single word or sentence at hand, the absolute collapse of the mind, the absolute skeletonization of soul, that folding up and bend of the body until nothing's left, extension no longer possible, my being shrunk to 1 dirty naked POINT, 1 negligible POINT on 1 greasy sheet of paper, etc. Me myself 1 insignificant, impoverished thing, and that shimmering in the heart (*while bathing*), this eternal dislocation... we can only write when disposed, as if in 1 time-lapse : buds breaking into fragrant blooms, seeds on fruit, perhaps man is 1 swindler, 1 charlatan, says EJ, everything faked, perhaps, everything 1 scam, etc.

Tad lion nosed, says Alma, this cat of ours, says Alma, really does have expressions, today reproachful, unsettled, through the little fur, through this piece of fur on her face, moods, emotions are subdued, isn't that so, the soul ostensibly beneath the collarbone.

(Just like that, because nothing else heals me up either, I say, for days, indeed weeks, running here and there with open

bleeding wounds, my fingertips in particular, I can only type on the machine in pain...)

Sitting comfortably I start to critically observe the stuff *I have hitherto scribbled down*, I mean registered with raging heart, but it doesn't really come off, which is to say, I don't get any palpitations while proofing it, I write, yes, I copy from Derrida, out of Derrida's *POST CARD*, the pieces so tiny one can barely notice, I copy tiny pieces because it is the most beautiful book I own, because it is the book in which certain emotions are not expressed but simply implied, just like I always envisioned, etc., and while sitting and reading through all this stuff, with 1 SCRAPER (knife) : like Socrates on the sm. cover, I would like to do away with everything I have written, here, up to here, isn't that so, and I remember that like Socrates (on the sm. cover of this favorite book of mine), EJ writes *with both hands*—if you can say so, in reality he writes with two fingers, *types* with his two index fingers, and that goes really fast, etc., and I say to EJ, you're being sent to the dove, who will give you the responses of 1 judge to so many questions, while I sit here and wait for you to give your account. Pressed close to your heart, these two excerpts written over the last few weeks, it's 1 strange thing, envisioning 1 old text in its present form, most of the time I break free, make something completely different out of it, *the clean copy doesn't recognize the original anymore, and the other way round*.

These weekends are hell, I say to EJ, and when I think about how long it will take until the publishers get my corrections, the swearing starts all over again, or the invocation of more *Ignatii* (plural of Ignatius), over and over the transferences of love, everything I hear, experience, observe, I relate to myself, I have to try and stop, once again to your typing on

the machine, I say to EJ, for 1 few moments I imagine you not writing—: once again the transference : that I am not writing, why aren't you writing, why aren't I writing at the moment, because you are incapable of writing this second, because I am incapable of writing this second, because you can't, you're tired, too little sleep, etc., because I am tired, barely slept at all last night, forever only the thoughts about this text, etc., because you are sitting on the corrections of 1 book that forbids me from dedicating myself to 1 new text, which fills me with great curiosity, etc., viz., I'm anxious about what I will write, I have no idea what I will write, what I will be capable of writing, on top of it all, in the near future sadly I'm going to be away 1 lot, readings and the like, which is to say, I don't know if I'll manage to keep all this up, as it is only when I'm in my familiar home environment that I'm *all here*, as you know, I won't travel so much anymore, Marcel Beyer says on the phone, I mean, this *raging* poesy, Marcel Beyer says, *as if* in your open hand, the ant clan, I mean, the tiny anthill is moving, in my hand, I say, namely, undirected thought, like Tristan Tzara writes, that is, the unrestrained and how it whips you out into the storm, which actually means VALORIZATION OF THE IRRATIONAL, isn't that so.

I set off howling, had 1 sudden memory of one of those eye phenomena, eye irritations, when the blue, red, green rectangles, rhombuses, and circles appeared and I began to panic, thinking I'd go blind, but as I didn't complain and just continued to stare straight ahead no one noticed 1 thing about my episode, but then it broke loose, I was rocked by crying fits and at that point everyone noticed what was going on and tried to quiet me down—ach, these *Matisse flights*, as I used to call these frightening appearances back then, flights and firs,

and my hand, my right hand full of crawling ants, they covered the lines of my hand that show how long my life will last, etc., I close my hand, I open my hand, behind the roller blinds the glowing ball, every morning the usual weather, the ball of the sun falls into the corner of the window, blinds me, bothers me while I'm writing, by now I've looked through and read all of Antoni Tàpies's catalogs, in reality *skimmed*, so that one could say I've even read the unread books, too many kilos on the scale in the morning, not really memory, but something else, as if I were reliving the past once more, for weeks now I haven't seen anyone, once 1 week *Edith* comes by, we go for 1 walk together. EJ asks me, what day is it today? He asks, do we have 1 reading today? I'm afraid I won't be able to read, one could be led to think, he says, that it'd be better to turn your back on everyone and everything, simply sit down in 1 chair and stare into the emptiness, namely, 1 chair suspended in the middle of the white of endless space. I dream his room as if he, EJ, had only gone off for 1 moment, his damp towel on the rack, his writing utensils in good order on his desk, the ceiling light on, the oven still warm, the pipe stuffed full in the ashtray, FORNICATION IN THE BRAIN, says EJ, spirit as 1 function of matter, I have it in my notebook, he says this on 13 December 1989, and he says, *I'm speaking to you from the water*.

1 lot of tears this morning simply because I wanted to prepare myself to keep writing, I find 1 scrap of paper in all my notes where I've written : "I'm having a love affair with this voice,"

perhaps 1 premonition. I peeled the black overripe banana, it was mushy and had no flavor, I tried to stretch myself up straight while standing, just like the physiotherapist had shown me, find 1 *blood sphere* : reproduction of 1 painting by Wolfgang Herzig, caption "FLY," showing 1 no longer young woman, sitting, her red hair tied up into 1 bun with 1 black bow, orange-colored bustier, loincloth, orange gloves up to her elbows (plastic?), between the naked legs 1 black box with a yellow edge : 1 little crooked, curved body, *all the affects of a frivolous heart*, etc. I rummage about through old letters, find 1 from Hans Haimerl, write to him : "the CLOUD is 1 masterpiece, I remember well, back then, on the occasion of my visit, seeing it, marveling. Your CLOUD is now before me on my desk, and there it will stay as long as I'm alive, no more shall we part. If I had ever been able to work in the visual arts, I would have wished to be the one to paint the CLOUD." I remember that sunny afternoon in your garden, was it in '66? I was both carried away and tense, and you said : "your writing is the continual talking of your body..." and all the mummified mosquitoes, flies, scorpions in these old letters, drawings, notes, faded animals and blooms, etc.

As far as writing is concerned, I say to EJ, I have the feeling that these pages are probably being *prompted*, *sent* to me from you, namely, the complex of the thread of the ongoing writing—this is 1 midday darkness, and I look into the gray of the sky, which enchants me, 1 strand of hair across my paper like 1 question mark, the yellow hedgerows, when I let my eyes wander out my window, completely in the gray, surrounded by the gray background of sky, on the chimney across the way 1 jackdaw, ach, I write to Georg Kierdorf-Traut, I like being melancholic because it makes the writing

go better : 1 flood of tears!, 1 attack of vertigo, 1 nervous anxious commotion, then 1 great assault by means of music too, 1 burning sensation at the back of my head, I prop myself up in bed on my left side and write with my right hand, the twisted position hurts and I try to sit up and keep on writing while bent forward, I hear Picasso say he would never stop wanting to paint, even in jail, in 1 concentration camp he would be almighty in his own world of art, and even if I had to paint my pictures with my wet tongue on the dusty floor of my cell, he cries, I would not give up.

Suggestion, to be able to inhale madness, isn't that so. And then, early this morning, cursed everything again everything cursed and I cried for you and shied away from putting on the Maria Callas record *Scenes of Madness* as I'd already heard all the portions in my head beforehand as if I had composed them myself, that is, no longer any comfort then, no pleasure anymore, etc. I caught myself setting the voice *on minor* before calling you, strange enough, I always see this image, I say to EJ, I see you coming from far away, in the city, coming across AM HOF with an open coat, beautiful movements, straight toward me, and I begin to walk toward you while over the whole square my voice rings out from multiple loudspeakers and, almost ashamed, I duck down 1 bit, but then you grab my arm and together we walk to the next wine bar, etc.

And I told him, the eye doctor, that you are dead, I say to EJ, and that I cry 1 lot, he said : that is the best thing you can do for your eyes, that's what he said, 1 taunt, you should not, however, rub your eyes or press them—and then he told me awful stories about widows who had *cried their eyes out*, etc.

I also catch myself, I say, closing my eyes when I talk with you on the phone, then tell you that when I read (for the how manieth time?) the *POST CARD* through to the end, I will start over again. The feeling then grows so strong that I can imagine having written the book myself.

On the telephone 1 note : "correction : skin *wrinkled*," written at midnight, instruction for the morning work, yawning I open my ears again, 1 bit mislaid upon awaking, my eyes crusty after sleeping so long, etc., too few tables, shelves, I say to Alma, even using my knees as 1 provisional desk, not feverish enough today, I say to Alma, no real writing fever, the ants crawling in my right hand, I think BUÑUEL, AN ANDALUSIAN DOG, EJ often told me how as 1 child he loved to rummage through anthills with 1 little stick and was happy when the ants began to panic. Is it 1 angstmontage or what, I say to Alma, 1 obliteration : destruction of self, I say, while the *sewing garden of my dreams*, I mean, the STALKSOFMEADOWGRASS.

1 STALKOFMEADOWGRASS, back then, do you remember, in the 1. dew in the spring meadow, everything was still excessive, 1 frolicking, 1 warbling wind about, between the flowers, behind us someone called out HELIOS, *clattering meadowgreen, etc.*, this orange-red cloud skein in the sky, annunciation, the clouds in view of utmost clairvoyance, there, the little creeks come in plaits, I say to EJ, but I had lost sight of myself.

I practice the piano, walk up Mount Calvary, I had nothing left, no small fleck of floor *for me to spit*, calligraphic age shift, my hand trembles when I write, calligraphic age, I say, hallucination and TEMPEST, I could recognize the inside of my body on the monitor, had nightmares, my snow-covered stutter, e.g., up to 15 strophes of my going wild, and

I didn't know what day it was. Mother, I say to Alma, suffered the most terrible anxiety all her life and gave me the worst of it (for the most part unwarranted)… there is everything with hair : washing table, nightstand, bookshelves, wild nests disgusting dirty, *when I am dying, here in bed, you will refuse to believe it, you have always repressed everything, he says, you have never faced up to reality, etc.*, Alma, who brings food by in 1 tied-up tureen, while outside the roaring trees bow down to the windowpanes, ach, ineffable!, no touch, profane monuments, everything that surrounds us every day : 1 table 1 chair 1 cane 1 blanket 1 pair of eyeglasses 1 *half-decomposed man*, etc., 1 bale of hay, the creases of a wool blanket (wild dove). Pain and misery laid bare, I say, in the upper back part of my skull there was 1 really strong *harried* pulse, in reality pansy, bed impression, I don't want to have to explain everything, it should be possible to understand each other without too many words, it's *1 sign of old age, wanting to explain everything*, I entangle my foot : green kind of splits, cords and cables throughout my apartment, like snake tracks, but sometimes I yank everything with me, floor lamp, footstool, little tables, and FETISH.

(Fetisch)

On the train 1 young woman's laugh like breaking dishes, etc., I had the flower lady explain to me why roses no longer give off 1 smell : she says, it's too stressful for the plant, 1 crumpled slip of ART-ON-PAPER (rattling) torn out

of the newspaper, with my penciled note : "won't be there tomorrow." Lying down to write the pen stops working, *it can't write upward*, I should not forget scissors ballpoint pen pads of paper clothespins eyeglasses watch stones and paperweight, pocketknife and pocket tissue, gabled eye. Trembling gait, the fir tree on the blotting paper, bustling in my brain. I see 1 wickerwork of roses, rotunda, on my piece of paper while, lying on my back, I stare at the ceiling, complementary colors in view, etc. On certain days, I say to Alma, paralyzed sensations, pitilessly lackluster, unstrung, under tears sensing the tedium of an ever more cumbersome life, I begin the day with curse-orgies, cannot imagine any BEYOND HIERARCHY, etc.

Ach, pleasant chaos, dear reader, in this, my TRAVELROOM, the meadowcreak, the broken shafts of buzzard, springbok tracks, my memory tells me that Paloma Picasso made 1 rather suggestive, round, fair-skinned and flat piece of soap with 1 nipple in the middle so that with my finger over and over...
 Maria Callas : 1 few spoken words, melting, then her MADNESSARIA sinking into water—

Massive dreams... we're crossing the *Hauptstraße*, it's tough for me to keep up with EJ, he's walking without 1 cane, it's noon. We're with Christian Wanek, the head chef at RUDI's inn, EJ says, I'm going to my girlfriend's for lunch, at first I show surprise, then timidly say, I've known since yesterday, he says, I'm open with you, I don't have anything to hide, that's how we've always been, we buy *glittering* compression socks, loud Christmas stars, I feel like crying, he's going to win the Nobel Prize, says Christian Wanek, we are still crossing the *Hauptstraße*, I don't understand why it's taking so long to cross this street, earlier we were in 1 shop with

all kinds of junk from the empire, up on the shop sign : K
and K House Specialties, I say, this evening I'll come to
yours, will you be home. Then I wake up and my blood
pressure is elevated, I'm trembling and drenched with sweat,
it was 1 upsetting dream, in reality it's hard for me to find
my bearings, I sense 1 illness like back then, when he told
me about his meeting with Alma, I want to ask him how
everything came about but wait for him to begin his account
on his own. He says again, you know that I'm open, in truth
it'd be better for *you* to win the Nobel Prize, but you have
to wear your POLARHAT and the glittering stockings. 1
agonizing double dream, perhaps 1 hint that, where he's
gone, he's doing well. He can move more quickly than I can,
he's got his old energy back, full of energy indeed, etc., yes,
my doctor says, even while asleep, while dreaming, you can
have 1 heart attack or stroke.

I make typos constantly, I come to the machine with wet hands
and try to fix everything. I put my swim cap on and go to
the toilet, there is 1 flood. I abstain from my early morning
footbath, too little time, this DEODORANT I mean it flew
out of my feather, something that runs after, etc., namely,
what's *edible*. Who gave me the word, "*every once in a while
your absence will become sweeter…*" (Derrida).

I read over so many beautiful things, on the hunt alone for
those sentences, words, paragraphs I can ADOPT, how
pitiful, squalid, what 1 sin. Essentially I only continue to
read through the *POST CARD* now in order to extract, on
the search for sections that move me, isn't that so, EJ says,
1 halting style is often more exciting than 1 harmonious
one, *morbus*, I hang the sweaty little body on the floor lamp,
want to be able to go on with my dream, I am so involved in

my text that I have not really grasped reality, for example, today's HAVINGTOVOTE, I stuff my passport into my coat pocket so that I can GIVE MY VOICE, etc., should put 1 bit of rouge on my cheekbones, come back, leave my fur-lined shoes on, as it didn't warm up at all in my quarters, I cannot completely forget TÀPIES. (The ballot box...)

And back then, at your spa, where the road led up to the hotel in sharp curves and where you felt really awful on your 1. day, I bathed you, washed your feet, but you made me cry, do you remember, I say to EJ, you said almost threateningly : now or never!, and I walked off, up into the woods, right by the building, and the tension between us was almost unbearable, I say, 1 fierce duel, these ordeals, only around evening bit by bit 1 calming down, sm. walk in the woods, which opened themselves up like 1 dark dangerous cave immediately behind the hotel, I remember everything perfectly, *even when called upon*, etc.

Only rarely do I have 1 duplicate of my letters, at the most when they contain something that seems important, particular, strange, curious to me, some dazzling formulations, bold connection. My right shoulder-blade hurts, 1 pain that distracts me, disturbs, which I'd like to get rid of, have someone wipe away, sometimes I attempt to press it down with my left hand. I have borrowed so much, I mean, all of literature, *wanted to do it* with feelings of longing and firm intent, isn't that so, I cannot ignore TÀPIES.

After EJ's death, Sara Barni telegraphs : "I am trying not to be too strong but to save you..."

Crying the few words before she began to grow dramatic : Maria Callas, *in the present nights* : we can think more than we

can say, 1 end is something you do not see at all, it walks away from you, no natural movement, no created reality, etc., my typewriter has the tendency to drift to the left, always more and more determined to slide to the left, while the camping table, I mean, trembles, or flown away through the landscape, in 1 *whirlofnerves*, EJ's photograph devastates me.

1 foot too many, hardly time, hardly gave myself enough time to dry this 2. still wet foot after taking my footbath, I run, half-wet, I run out of the shower and over to my *littletouristtable*, *littleterminaltable*, with the machine, upon which the machine, etc., 1 old dog, I sit in the *colorful* kitchen, *consider certain relationships*, incessantly repeat, more in order to test myself than out of conviction, wail : "I can't go I can't go on," prop my head onto my hand, write with half-closed eyes, 2 unopened letters on the floor in front of me, do not have the energy to open them right now, drag myself over to the writing room, there is so much I want to say to you, I write to EJ, I did not want to be disturbed, back then, when you called me from the intercom, now I hold it against myself, after so many months, years, constantly mistype, have to decipher everything now, my general mission at the moment, to decipher everything, everything incomprehensible, especially in the morning, because I am utterly weak, no energy to see through everything, fathom truth, reality, isn't that so, I have absolutely no idea what's hiding behind what's concealed, what's hidden itself, I understand so little of what's happening, what's happening around me, my heart is taking huge leaps, I have to calm myself down 1 bit again.

During the burial service for Mia Williams when they were opening the crypt 1 crack to place the urn with Mia's ashes inside my glance fell onto 1 nearby gravestone with the

inscription : LENAU. : that period after the name churned up everything inside me, that huge black point : LENAU.

I leaf through the pages of next year's calendar, 3 March, the feast of spring and spikes, I am obsessed with abbreviations, shorthand for thought and script, dot in 1 circle with eyelash clusters for : upcoming trip to the eye doctor, sm. snail spiral for : order cake, 1 single battered lace-up shoe : bring your shoes to be repaired, stretched-out pair of wings : book your trip. 1 body's insignia, I say, bluish-green lemon skin becoming moldy next to other fruit, I'm 1 geriatric sitting at my writing place, then, looking in the mirror, notice thin discolored furrowed facial skin, rustling like old blotting paper in 1 draft of air, on the paper in the machine in front of me in large letters WASTED LIFE 1 gurgling in the box of paints, places of nostalgia, early childhood, affection, on the desk my notebook, so many pages with the bent corners, dirty, as if underneath there'd be 1 squashed insect or bug, you turn language on its head, I say to EJ, 1 angstmontage, blurring, obliteration of self, I say, like the most exquisite and distant sewing gardens of my dreams.

That was Tàpies's 1. bed, it looked like it had been stretched out, his perspective skewed, spatial orientation impeded by 1 multitude of covers and cloths, with 2 cavities at the bottom end, engraving of the feet, back then at that hotel, do you remember, I say to Daniel, my bed untouched the whole night long, we slept in your room, and in the morning I walked over and made an effort to make my bed (imitation) look messy, in order to avoid arousing any suspicion, it was the huge matter of papers, etc., or *Ocher with 6 Collages*, *Collage with Comb on Cardboard*, everything Tàpies, tossed-off birds.

"England is 1 huge oak surprise," writes Sabine Hassinger, "ach, the sun scribbled away, what 1 relief," isn't that so, on horseback leaning against the bed, *Body of Matter and Orange Marks* : red-brown stain, a play on menstruation or excrement, traces of 1 sofa with crosses, ribbons, and corners, suggestions of ears, mouths, noses, phalli, swollen faces, ruby-red *brainchapel* (as resumé), etc.

My knees are my little tables, in the dream real clear : 1 broken dish, old sewing machine, brown and floorcloth, "one day I attempted to reach silence directly" (Tàpies)... the word SÌ (Tàpies) : lonely as 1 giraffe (graffito), streaks of run-down paint, the smell of mold on the street, mostly simple everyday things, writes Tàpies, fundamental situations of being, crosses of every kind, arrows, diagonals, brackets, hatched lines, whispered letters : A and T and M and X, line for line, names, knots, symbols of eternity, words :

amor love, fol fool, body fragments, head and torso, arms and legs, hands and feet, the traces of impressions, skull, flying hands, ach, how delightful : *Ovid bastardized with Jelinek*, etc.

1 young shoot of 1 letter, I say to EJ, where have all of the innumerable letters you once wrote me gone, these letters of yours, classic talismans, isn't that so, then my deeply snow-covered stutter, when I wanted to speak while thinking of something else, it was 1 real stuttering, 1 repetition of the same words over and over, 1 omission of syllables, 1 mistyping on the machine, 1 going silent when one wanted to speak,

to myself, *the eternal transferences*, icy sunshine, feel the stage fright of my poet friend reading, this is all too much, that's how you use up your reserves, the raging sheen in my pupils, windows of running red, says Tàpies, streaming red, dusty red : 4 fingers instead of 5, Picasso says : "if we hold 1 mirror up to 1 true piece of art, it will become fogged," incorporated 1 syncope into the text as threshold, says EJ, the poet's concern must be to see into the interior of things, says EJ, 1 elegiac foot, brooding on dirt, etc., this raging poetry, something chirps while I'm typing, the broken feet of the camping table, probably, *I have to write the condolence letter to Heimrad Bäcker, Gertrude Stein spoke with her dog in the middle of things and incorporated it into her text*, and when he returned after years, DANIEL, and I remembered how much I was attached to him, how much even the tiniest bit of clothing, every movement, every word, every glance almost made me lose my mind, back then, I mean, how great the net of enchantment he threw over me was, day and night, had me spellbound, DISPELLED, I floundered beneath it, but it was also 1 sweet kind of agony from which I was unable to free myself, did not want to, 1 tender undertow that engulfed me, isn't that so, so that I *idolized* even the tiniest thing, every bit of clothing he used, wore, etc. I mean, his shirt collar, his coat pockets, the arms of his suit jacket, and I observed his white arm, and his arms suddenly entangled me and we fell into each other's arms, and I touched his neck and I stuck myself to his neck, the neck of both 1 boy and 1 old man. And while succumbing to such enchantments in my imagination and called everything back to mind and in those days met up with him once again, once again observed his neck, his arms, his hands, and was prepared for the earlier magic to once again possess me, WHICH DID NOT HOWEVER OCCUR, *or not immediately*, I wondered if it hadn't really

been something like the *fantasy* of 1 love to which I'd been in thrall, and I could hardly find any understanding for my former frenzy, etc., namely, that former exclusivity of feeling, but then, once we began to meet each other again more often, with 1 feeling of confusion I thought that the virus was still inside me, that this virus was still alive inside me, though weakened, though not without the power of resistance, etc.

Dogs of time, and without permission, because 1 lisping, within rockets, I say to EJ, wood and mountainflames, I say, firtreepiles, hardwood, or where we climbed around the mountains, everything clear to my eye, 1 thinking of effects, Barthes, or to endure the soul's suffering with constancy, *1 holy umbrella of air*, says EJ, *1 magical investigation of the body*, *that's what writing is*, says EJ, *Feed bag*, *Painting with an Ironing Board*, (Tàpies), I could hardly move away from the machine anymore, I had to wonder myself away, I had to force myself to take care of my body, e.g., poured 1 basin with hot water onto my head, over my head, while the telephone rang unceasingly, at the same time I was thinking about your paintings, I say to Antoni Tàpies, and about Hölderlin ("the fire in the eye"), I picked at my eyes, stretched my back, was already back at my little table, it was already just about noon, but chapter for chapter, *barking, more and more*.

Whenever you feel 1 certain LACK, that is, the absence of 1 particular object : 1 very particular book, 1 very particular thing, 1 very particular person, here's what you need to do in order to satisfy the lack IMMEDIATELY, this is what you have to do, I say to Alma, in order to then and there get satisfaction, this is 1 great relief, this is 1 great excitement too, this acquisition of the immediate fulfillment of 1 desire. Like *flying hands*, *body scratch work*, *great material*, *little*

pleasure woods. Or the material with papers, it is 1 faring into fulfillment, 1 stilling of hunger, 1 cover : wrapping with charity.

Woke up at 11 o'clock at night, thought it was morning already, I'd only been asleep for 1 hour, EJ says : while I was walking between Freyung and Hof, I thought of you, with 1 kind of boiling back-and-forth rhythm, there were such waves in my head, such 1 close feeling, that oppressed me and made me happy at the same time, where the sm. clover typically bloomed, I say to EJ, I discovered this sm. spider, namely, on 1 particular whitewashed wall of the room in the KUNSTHALLE where the Spanish painter Oscar Domínguez's object is : sm. gentle horse, trotting, worming its way through 1 old bike frame, etc., I fantasize that it's my dead mother who wants to greet me as 1 sm. spider, the thing I am most dependent on is color, Barnett Newman writes, over and over Barnett Newman reports on admirers of his work weeping before his paintings (pine tree horizon).

Your externality, says EJ, when you are dealing with people, that's why you prefer to be alone, because even people who are close to you confuse you, says EJ, you cannot indulge in your natural thoughts because they are constantly being frustrated by the people in front of you, those who want to communicate with you, so that you can barely find your way back to your earlier inner positions, etc.

Flakes of syntax, I look in my other quarters for Bataille, related reading, I surmise (after Derrida), in the café, at the next table, Sloterdijk working on 3 books, excerpting from 3 books, *has 1 effect of poetry on me*, I say to Alma, What is your blood type? Alma asks, I have to think about it for 1

long time, I think A and something else, I say, what can it be? I say, is it positive or negative, Alma asks, oh right, I say, it's A+, Then I will look into what, says Alma, your predilections are, in general and in particular, she says : that does not sound serious, I think.

In the end I'm not in the confessional, I say to myself, driven to sexual excitement by 1 passage ("……") in Sabine Hassinger's text, the GLOSSARY at the beginning of the *POST CARD* is quite memorable, all of 1 sudden the pleasant ("flattering") feeling of being able to understand French, read it, which is at odds with reality, etc.

Your face was upside down, says EJ, I think, out of the *Egyptian Book of the Dead*, I say, I'd barely given up (the pensum of the day), once again I cursed myself back into the quaking writing vigil, into those wheezing attacks of fever, without which I am unable to write down 1 single word, 1 sm. white tablet falls to the floor, I press another tablet out of the aluminum foil, but once again it falls from my trembling hands, namely, the sm. hairiness I am forever determined for this moment, 1 empty eternity, 1 emptiness arises, which in any event is not as threatening as usual for me, etc., I am extremely open to all the fine traces in everything and everyone, all of 1 sudden this reading opens all the locks, Sándor Márai, *Diary 1985– 1989*, maybe I am looking for *someone to worship*.

I am alone, I sleep alone, read alone, go for walks alone, almost nothing outside of the daily writing still binds me to life, I say to EJ, *Unworldliness* by Peter Sloterdijk, often in the morning, after waking, 1 taste of weariness, next to the bed 1 red plastic basket of books which I have begun to read but haven't finished, why, I ask myself, maybe because over

and over something new grabs my attention, these books I've read like untouched meals, vile, I say to EJ, recently spidery handwriting in the morning, later in the day indecipherable, "how wonderful literature was, the other one, the true one, through which electricity flashed as through the stars and *through Hansel and Gretel*" (Sándor Márai), in my fingertips the tingling of the alphabet world, I dreamed 1 long poem this morning, I wasn't awake enough to write it down, now it's lost, namely, the attraction of the flattering earth ("the face is completely swollen with tears, the quick floods roll immediately off the cheeks, etc."), trembling of telling the tale : 1 fluttering at the back of the head, I say to EJ, you turn the language on its head, do you remember, I say to EJ, we were sitting in the internist's waiting room and whispering to each other so softly we could barely hear each other, my condition was bad, I say, waiting for the taxi I didn't have the strength to make it back and forth from the door, I was looking for 1 place to sit, but there wasn't even anything for me to lean on ("Crisis-daughter" / I'm losing my voice). Love-hate relationship with platitudes, one abhors them, one uses them, I need 1 absolute solitude, every discussion : 1 burden, and yet at times SALVATION, he looks like 1 Renaissance man, says EJ, after we said goodbye to C.E., long talk on the phone with Wolfgang von Schweinitz, he says : music must fly somehow, *it bleeds through*, it's received 1 different color value, etc.

I call Bodo Hell, he says : God bestow grace upon our neighbor's soul, which he calls from out of our midst. The peanut gallery was full, those are particular experiences of images. Ach, I cry, I wish I had *providential wings* so I could praise the poetic portraits of language and seek the poetic pulse of life and dreams, I am outside myself, EJ on 9 March

1998, the emptiness, he says, I'm not thinking about anything, my head is completely empty, etc. Emptiness, says Tàpies, makes you aware of 1 strange melancholy and is almost always connected to 1 feeling of separation, which lets us see face to face who we really are.

In the end he, EJ, saw 1 white dove flying around the room and drops of blood dripping from its beak, the leaves in long rows as tears / little teeth or tines on the branches, waking-dreams, flying alder trees, in my head orange-colored symbols overtaking one another, scurrying past, that is through light-green treetops glances into 1 pale-blue spring sky.

Trace of a Sofa, Tàpies, crosses, ribbons and corners, suggestions of ears, mouths, noses, phalli, "completely white and with arches"—from the window the wandering mountains, I say, and think of you, of the smallest of your moments, with you, and then this rose tortured me as 1 cobweb on my left cheek, look! he says, *if my backside is clean*, he says, I am 1 silent person, I live along the Danube now, see the water every day, it passes by like life, I dream the words 1 FATHER'S GERANIUM, 1 love like apricots (April), *oil-garden shed*. I am at times completely wild as I do not know what I should do, but sometimes I am very sure indeed what I should do, how I should decide, then 1 voice says what's appropriate, e.g., "go there, don't go there, respond, don't respond, choose that word, this word is too strong / too weak, is too insistent, misleading, etc."

I could not decipher your flowerlike handwriting, I write to Elisabeth von Samsonow, they must have been consolations, I compose your lines, check them until they are like my own. Derrida's *POST CARD* has been 1 constant companion over

the last few weeks, I write to Elisabeth von Samsonow, I lay the book down next to my pillow and read whenever sleep escapes me, etc. Everything such terse things, mouth barred as with "le lecteur" (Tàpies), *I'm going to get 1 FAX*.

I think one can no longer get free from 1 longer text, does not want to leave it, wants to keep adding *1 little bit and 1 little bit more*, the considerations, better to begin with 1 new piece, are immediately rejected, how terribly abandoned, petrified one feels when attempting to write something new.

The body's whole anatomy is appalling, says EJ, the chest filled with things that don't belong, *namely, the alcoholic population of this country with songs of différance, raging laundry, wonderful vegetation, and fever*.

I walked back and forth in my writing room, and then, in order to cast 1 last glance at my work, go back to my writing over and over, I mean, over and over I'm drawn to the fixed piece of paper, I check, or *refresh* myself, what I have written, or fantasize about how it could go on, etc., *train station, with aureole, completely ossified*, Julien Green writes, Dalí is 1 bit like 1 child who's afraid of life, Dalí says, in the darkness I would no longer feel ashamed, I could then look Gala in the eye and she would not *see me blush*, etc. as 1 schoolgirl I was EMBARRASSED because in certain situations I would BLUSH, which really bothered me, I couldn't stop it from happening, but had to hear people who were looking at me make fun of me, tease me, *1 accident of the skin, the soul*. So that males would dribble out of me, or rather, dribble into me, that is, into my head, or in other words THE LILACKING OF LANGUAGE took place within me, as this long COAT EMBARRASSMENT took place, when I was 1 child, because I always had to wear such long coats, which didn't

make me feel good, because I had to grow into them, so that flames shot from the lining of my coat, and I was ashamed because I would always blush whenever someone pointed to my long coat or laughed at me—the spoon stared at me, another one dripped blood and honey, and so I wander around in my long children's coat, everything seemingly incomprehensible and inexplicable, I had the long legs of my father my mother my ancestors my irises and *everything speeds by me in infrared, etc.*

On very late evening walks I step onto the street, little light, when darkness comes crashing, and am gripped by 1 feeling of vertigo so that passersby and buildings look like silhouettes, that's when I wish I had some sm. flares blazing out of my eyes so that my eyesight would improve. In the past I could find my way deep in darkness too, but now anxiety drives me relatively quickly back to brightly lit spaces, etc. As if eager to please, *to give us wings*, the animal grazed vehemently across the mountain pastures, do you remember, I say to EJ, it was our 1. summer together… it's 5 minutes after 10:30, EJ calls me, I slept until now, briefly woke up 1 few times and dreamed, dreamed about Chinese, you told me that you are crying so much, but you didn't come, you told me that you would come to make me breakfast, *ach, bring the laboratory on over here*, my writing's 1 form of escapism, I think, I say, sometimes the feeling now 1 very rigorous style *or voice* is breaking through me. On 24 November 1997 during the dinner we are eating in silence EJ suddenly says : "*At the threshold of death,*" in 1 strange voice, "*I want to follow the death of Christ.*" I call him, "the mornings are always so holy," yes, I said that back then, in general we say such essential things to each other on the telephone, I say into the telephone, "I'm reading 1 lot of books but in reality I'm not really reading, the

books are simply camping out around me, I could, e.g., write something about doing nothing, because I am so comfortable, so lethargic, objects that fall off the table stay on the floor because I'm too lazy to pick them up, etc., that's how far things have gone with me already, that's how advanced the deterioration is, isn't that so, strange enough, at noon I was really listless but then I heard your voice and all the blood ran to my heart and was completely awake and wandered around my room for 1 long time, it was only 1 few words, by the sound of your voice almost blinded, I don't remember now what you said.

In the feverchamber in the fracture, I arranged my medicines on 1 sm. shelf like I was putting books in 1 row, when someone's caused me 1 great amount of pain, I say to EJ, 1 kind of petrification begins to take hold of me, I begin to roam about, can no longer get my bearings, I have lost my foundations, I look in the mirror and say YOU DEAR MUSIL CHILD, etc., but don't know what it means. Fully clothed, I sit down on my bed, on the side of the bed and from somewhere feel warmth on my hands, I measure my blood pressure and realize it's too high, ach, this alphabet delirium, tucking one's hair behind the ears has become fashionable, in the past the old shopkeepers used to stick 1 ink pen behind their right ear, when Father would stand in front of the mirror I could see his profile and how he would tuck the hair at his temples behind his ears, many young women carry water bottles around, that's become fashionable too, I say, while writing down the sentence "in the simplest and basest things we recognize God's work" I remember AUDIBLE (as if my memory were being acoustically accentuated, that is, UNDERLINED), at the Literaturhaus last night how carefully I went down the stairs : high blood pressure, flickering heart, afraid of all

those there who would hug me, something I can barely take in such 1 condition.

Brown and floorcloth at the top of 1 painting by Tàpies, I feel this floorcloth, only just wrung out, almost stiff, waver at the top of the painting, I feel the need to touch it, "one day I attempted to reach silence directly," so Tàpies, namely, so Tàpies : "then the sky was rolled up like 1 scroll…" etc., laying out dominoes, over and over *scurrying* to the machine, add 1 word, 1 sentence : 1 stone to the fixed piece of paper, strange growth : overgrowth of 1 text, instead of bookmark, LITTLE PIECE OF DEERSKIN between the pages of the *POST CARD*, or 1 book I am reading, 1 torn-out calendar page as 1 bookmark, or *dog-ear* at the upper corner of the page, when I left Ulla, the 1. fireworks this year already in November, *extremely desolate*, *1 floppy dog*, swim season long over but a bathing suit's still dangling in the window.

Around 5 or 6 weeks after EJ's death 1 short earthquake shook the city, I'd already gone to bed and fallen asleep, I woke up and thought with melancholy and 1 kind of gratitude : "finally 1 sign from him," the bed reared up and I was delighted that he'd finally gotten in touch, early the next morning the announcement on the radio about the nocturnal quake, only then was I afraid.

In 1 street café : fauvist style, at 1 little round table the alder tree shack, state of enlightenment, appearance of the white light, and how the paths of poetry and madness meet, I say to EJ, misread, injure, mistype, my controlled hallucinations, poor vision : I no longer see the point of living, perhaps 1 optical illusion, this violet optical illusion, Georg Kierdorf-Traut writes, lifelong succumbing when I simply think about

the dark-violet, indeed black-violet mountain ridges when the sun goes down in Eisacktal, this color vision, in the dark still, I mean, perceiving 1 black violet, etc.

You won't even be able to operate my machines, says EJ, *once I'm bedridden, isn't that so.*

The echo of the paper in your voice, says EJ, that is, namely, all, that all amounts, namely, to 1 holy story line, like the weeping of the holy Seven Sleepers or Ignatius of Loyola, who possessed 1 extraordinary talent for weeping, as he himself reports, during prayers, which most of the time was connected to "the greatest sweetness," during Mass I wept so strongly, he reports, that the host in the altar chalice became completely soggy, etc., the suspension of the plot is necessary, says EJ, as is the poetic superimposition of divergent forms of existence. I cry when I write, I say to EJ, everything sticky with honey, even my writing paper, I say, when I saw Elisabeth von Samsonow at the Kunstakademie, I say to EJ, prior to her lecture, in the hallway, and coming toward me, that is, from close by, I immediately recognized that there had been 1 change in her appearance, she had grown even more attractive, her hair real dark, in fact she looked veiled, and I was shaken by 1 premonition, then she said : "*animals are apparatuses…*"

Nina Retti's call, she had dreamed of me, what? I ask, she says, "you handed / presented me with (indescribable) *Christianities* in 3 empty eggshells, in the middle of 1 meadow, I wanted, when the dream ended, to go back into these inner unities, I had truly fallen out of my dream, I wanted so badly for the dream to continue, but I couldn't get back, etc."

Apparently 1 little ill, I say to Alma, buried the eagle eye (dispersed) into the soft white clouds of the bed. I hadn't intended, back then, to consult 1 seer, I say, ages ago in Warsaw, she comes up to me, wants to read my hand, I think, the left, I say : "but only after the reading"—I'm nervous, I'm afraid, she looks at my hand, the inside of my hand, *and gets started right away* : I would live to be very old, would be lonely, then she pauses, I don't pursue it, *on the open letter*, while asking myself whether we could live with or without the other.

Before Easter, many years ago, I meet (perhaps) the hospital doctor R. at 1 tram stop, he asks how EJ is and how I am, ach, I say with growing tears (pausing), he turned to 1 different woman, like back then in my dream ("dispersed rigidity").

"Ink on burning paper," I say, Dalí, too : "the ecstatic melancholy of the sm. dog, senile like 1 dizzy ski-glide," collage and drawing on postcard.

The motifs are always the same, I say to EJ, on the one hand the skeined (clumsy) ceremonies when starting to write, on the other the surrender of myself : "I can't go on I can't go on…" : every morning. Mia Williams calls in the night, says only : "*ripped-out sentence*," hangs back up, *emotional canapé*, I say, glistening, some kind of writing on your cheek, I say to EJ, case study of 1 going wild or frenzy, I say, 1 obsessional looping of this compulsion to write, and soft, milky, namely, the MILKCAT really did lick up everything, etc., calendar growing thin, the year almost at 1 end. Heinz Schafroth writes me, "it was different in D. this year, EJ dead, H.C. dead, and you didn't walk past the panorama window of the hotel, alone in the twilight, the younger poets are already starting to take

1 caregiver-like tone toward me, they don't do it just yet, but already they act as if any minute now they'll have to help me across the street, and discreetly adjust their steps to adapt to the slower way of walking…" Wittels assumes that one LOVES WITHOUT CEASE, just like one continuously dreams, whereas the dream spins on through all the states of being awake, I say, as oracle, what did you mean to express with all these stains and spills, Tàpies was asked, what did you mean to achieve with this associative style of writing, I was asked in 1 interview, *how do you write 1 poem*, etc., I order Ovid, I order Swedenborg, *how does your daily routine take shape, which times of day do you prefer to write*—

I feel what the language requires over the course of the text, 1 kind of feeling of hunger for the language and how it calls the shots : now 1 little down, now 1 little up, now onward in 1 even tone, I order Sartre, I order Jean Paul, I accompany every grip, every movement with 1 verbal legend, constantly, even while asleep.

Who then acknowledges whom, Heinz Schafroth writes from Spain, when I am alone and no one can see it, I kiss your letter WITHIN, as my flag, my standard, my Vesuvius. Namely, more bereft of knowledge now than ever.

Again the fear of dying before this book…—

I make typos constantly, misread things constantly, on 1 card from Bodo Hell instead of *symbiotic* : symphonic, which appears to be harboring 1 secret, 1 nerve intoxication : and finally spring arrives, the sky ends… Alma says, she will think of 1 sentence and then find it in the paper, which recently again happened 2 X, I hear the telephone voice of 1 few

friends in my head, something crackles beneath my left clog : I've crushed 1 glass splinter, I hang my wet socks over the open door of the dryer, leave the light in the hallway on the whole night long so that I can find my way with all the getting up, I call the middle aunt to see how she is doing, the tough skin of my left heel is cracked and painful, I say in 1 dream to EJ, I am afraid I will never see you again, in the newspaper the reproduction of a painting by Arnulf Rainer, *Goya Frau*, tempera on panel, passion, woman's head over cross, half-closed eyes, passionately raised eyebrows, sm. mouth, voluptuous oval of the face, probably lying down. With every drop of ink, fur hat still on my head, I hurry to the machine, ach, these rose, travel, and writing pleasures, I shout to Alma, the whole day long, great indulgence, truly mad love, and *on horseback leaning against 1 bed*, etc.

On the 24. and 25. of October I helped organize 1 colloquium in Paris at the Opéra Bastille on Schubert and Mendelssohn, writes Erika Tunner, 1 journalist from Vienna was also there, she told me she saw you on the plane, you were on the same flight to Paris, on October 23 presumably—1 vision I convinced myself of—or in fact reality?

I slept 1 long time, probably because I had taken 1 Demetrin the night before for my high blood pressure, and the bananas turned black overnight, 1 distant sound of bells in the morning, through 1 fog, I think, I can see the bells, or is it 1 ringing in my left ear, letter in my hand, and, in order to take some time, to touch oneself with words, thus Christa Kühnhold's call telling me that she too had dreamed of me that night, over the sea 1 gray-black wall, she says, and the whole day long it did not get any lighter, you can only see 1 bit of the street, I dreamed that I invited you here, but you did not want to

come, so I tried to tempt you away from your quarters, etc., during the call I note, "she has her roots in the innermost part of her life," *I have sports-feet or the swarming down.*

Through 1 phone call it retreats : THE SPIRIT : then suddenly the spirit stops, then suddenly the spirit disconnects, through 1 telephone I say to EJ, "I caressed your voice, and still now, and you are the only one in the world…" (Derrida)— over and over the *sm. stool* (little collapsible stool with fabric so that you can sit) FOLDS UP as soon as

I lay 1 stone (from Crete, Bolero) on top of the notes lying there, to weigh down, hold fast, press down, aisles in the grass in the water : tones of blue gray and black, one immediately remembers Mother's *middle* sister, the one with the frizzy blue-black hair up into old age, in the end streaked with only 1 few white threads (*middle aunt*), and whenever I came to visit her, her 1. glance not to my face but below, to my feet, whether my shoes, I mean whether I'd cleaned my shoes on the mat in front of the door, etc., *the middle tint* (Jean Paul) : *middle aunt*, Mother's middle sister, in her large, red flower (rags)-painted dress : silk dress, out of which she fell or *sagged* down dead, I wasn't there but was often told that it had happened, so that my imagination exceeded the witnesses' memories by far, isn't that so, namely, *the sudden end smack in the middle of the cloakroom*, as Bodo Strauß writes.

I know, says EJ, that I can't take any great leaps anymore, EJ says to Edith, *but little ones, I still want to take 1 few little ones…*

Over and over the doppelgängers of particular people come up to me in the street, 2, 3 *heralds*, before the real person appears, odd ways the two of us, EJ and I, right after we'd just spoken about her we ran into GUGGI IN THE CENTER, viz., she must have seen us first, crossing Stephansplatz and looking at the window of 1 carpet store, in any event, GUGGI appeared 3 X I mean in 3 various versions, the other two rather infrequently, EJ and I, I support him, we stumble over, he hooked into me, him hooked into him, growing out of my hips, etc.

I washed him I know I washed him, he says : nevertheless and to some extent good heavens am I already clean.

You see him, EJ, on the back of the book, you see him walking off, holding the shoulder bag with 1 hand, you see how he walks off, on the back of the book, on the cover, determined, as if he knew both where he was going as well as his end.

With 1 *glimpse* in the eye with 1 *glimpse* in red the vis-à-vis woman in the window grabs the red bow in her hair (as if painted by Picasso), is the laundry outside the window already dry?—odd image, I carry it around with me for 1 long time behind my closed eyes, feel its reflection in the middle of my body, almost as if it were pain.

Slept 1 long time, 1 unfamiliar face stares back at me from the mirror, I say to Alma : when he makes his laborious way up the stairs, he only uses his forefoot, I say, he only places his forefoot on the stairs, like Mother in the last years of her life, and my brain chases after the *fly curtain*, and my heart chases after the painful memories, *and my late tears in heaps*. The voice is dispersed (kaput), is perhaps dark red in 1 corner

where unhappiness hides, Elke Erb, I've misplaced the Luther Bible, wanted to look up Job 1:21, tears running down my face, some days ago meeting Ivanceanu and son, he hugged his son and said : "This is my father!" and the son hugged his father and said : "This is my son!"

This is 1 defiant ice-cold morning, this is 1 adjustment-of-coats, according to time of the year, temperature, this permanent fervent fantasy, I say to EJ, and saw the tears on the amputated tree, glowing yellow like HOLLERPLATZ : sunflooded like Markusplatz, do you remember, the table's garden. Old blanched note : "I have shown you all how NOT to live…"—3 hours ago I could have worked, I say to EJ, in the meantime meals and doctor's visit (domino), instead of Munich I write *Mouthich*, received 2 exciting letters… *suffering from women bushes, smoldering butterflywork*, etc., it, happiness, I say to EJ, crawls up the spine, or from top to bottom, fills our body, trembles in our temples, imagines the pure MAGIC of our love-object within the excited fiery eyes, I say, now after verbal indulgence *was I something like the inner Schumann*, so much is in flux, the basket with the clothespins springs off the table in the hall, the bread crumb on the windowsill has moved 1 bit farther, human beings in the same boat as cattle, I say, in the tobacco shop where I buy stamps someone says : "The myth of the weaker sex is no longer tenable…"— pauperized I go to the ENT doctor, pauperized I go to the eye doctor, she looks into my fly curtain and says : "You have to sublimate everything, you'll be able to write for 1 while longer still, reading less so (*colorful*)." I take *huge gulps* from the coffeepot, the cup dances on the edge of the table, I stand between the two rooms, and so I heard soft piano playing, knew that neither the radio nor record player were on, was tempted to imagine Mother playing my piano, although it's

something she hardly ever did, for me it was 1 overflowing warm feeling that at the same time seemed uncanny / spectral, I listened repeatedly, stopping to type, I interrupted my work at the machine and listened, went to the open window : from the apartment downstairs I could hear 1 delicate tinkling as if from 1 child's hand, (trees wither, in nerve shadows, etc.).

The bush's spine, writes Samuel Moser, 11:29, Heinz Schafroth has to come, when you come, you made that 1 requirement, but I think he wants to come, your letter made me so happy, and so you want to "come, read, and" : that sounds somewhat Caeser-like, but it isn't, because you don't want to conquer but to steam off, perhaps with the now nonexistent paddle steamer on Lake Biel. We'll reinvent it for you.

Indeed, here we have 1 box of colored pencils : Joan Brossa.

On tiptoes the flower tribunal, I write to C.F., here too 1 kind of verbal back and forth until something finally fits, like 1 tile in 1 game of dominoes, etc.

I'm sitting with Alma in the garden of the MAK, I feel like I'm freezing in the middle of summer, the shade has overtaken me, at the same time I break out in sweat, I want to vanish immediately, to be invisible. Thunder and lightning my soul, there in the west the double rainbow, 1 X I wrote the ROSICRUCIANS, never received 1 response. The sun jubilant, as invisible, my parents are walking toward me, seem different, 4-leaf clover in the gutter, 1 PORTABLE TOILET next to the construction site, on 1 tour bus the words *Exterminating Angel*, but how, I call Wolfgang von Schweinitz, who is setting 1 text of mine to music, how, when 1 piece of music has neither beginning nor end and thus no

development can take place, the whole composition moved by 1 ghostly hand, says Wolfgang von Schweinitz, celestial and subterranean, 1 little arcadian too.

I wake up, it's 4 in the morning, my 1. thought : "*I hate flat narration,*" I'd had, so it seemed, 1 of those nightlong chaos dreams, "*I crave flat narration,*" EJ was still alive and we'd come back from our holidays the night before, during the night I hadn't produced any urine, which concerned me, we were in 1 big hurry because it was the 1. day of the new school year and I couldn't find anything, not my laundry not my clothes not my footwear, etc., and I was hungry and complained that no one was there to make us breakfast, but 1 tender atmosphere prevailed and in truth we wanted to laugh about it all, and I put on EJ's shoes because I couldn't find

my own, my pillow damp, I must have cried in my dream, I thought about Peter Waterhouse and the Lord Chandos letter, I felt confronted with reality, AND EJ WASN'T THERE. I turned on the light, swallowed my morning tablet, and tried to reconstruct the parts of my dream—I saw the *northern lights*, they cast 1 yellow reflection on this piece of paper, etc.

With the abandoned dogs, woody areas, brittle opus, I hear myself saying to myself in my dream, it is 10 to 4 in the

morning, I am wide awake and alone, taste the primeval forest of the perceptions (of my dream), all the way up top, on 1 branchy tree lining the avenue, my trunk, after 1 trip, branchy paths, street woods, I cannot get my trunk down without help, my parents absent themselves, I try with 1 ladder—they want to go to meet some friend or other, I want to go with them and at the same time first go back home, with my trunk, it is nighttime or early morning, they are both very agile, adventurous, I am wide awake, read the *POST CARD*, my heart beating hard, my heart : 1 heavy clump in the body, *over the course and tracks of time*, etc., nothing but nightmares, EJ says, you've gotten over your mother's death, you'll make it through my death as well, *face of flame*.

(And zebra, animal of the hereafter, symbol of unexpected FLITS, in thoughts…)

With the abandoned dogs, in permanence, then you look at me from the shopwindow, I say to EJ, that was 5 years ago, I say : on the same day, the day of my death, I will call you, I say to him, just like I called you from all the places in the world I traveled, I got in touch wherever I was, etc., and you waited for my call… the bandaged kitchen knife next to the bowl, I say, rather partial, the halting way of the crows in the inner courtyard, the swallow, the eagle, the bird's wing on the underside of the sm. basin, that was the double wing of Frida Kahlo's eyebrows in the self-portrait with small monkey, the dove's wing graced my head, suddenly all the birds flew in my direction.

See, hear the little one panting up the stairs, think : 1 ENRAPTURED CHILD, POOR ENRAPTURED CHILD—nothing but sm. little shorts, white boxers in your bleeding Spain-paintings, I say to Maria Gruber, nothing but

marathon lines, I had the shock of cold, and I say to Maria Gruber, yes, back then the flame was still in me, and at 1 time this flame was in Mother too, I took this fire from her, the best thing she could have given me, by that point she only continued to sit in her CANADIAN, which let itself be put in various positions, which she did not however want. In the end she just stayed in her nightgown, did not want to wash herself anymore, did not want to be washed, she just sat there and waited for you to bring her something to eat and to drink, and sometimes her eyes closed (movement of the soul).

Snowchest—I let my body whine and ripple, he, Bodo Hell, had become 1 shepherd and had stuck the male lamb into his rucksack and that was how, namely, by rain and by snow, he strode into the valley, *the lamb's head, enraptured, outside.*

(woods nothing but nature)

I shut the bedroom door with my left shoulder, C.F. asks me whether I've already bought the *little fir tree branch hand*, I wave to the tailor on my street, who sits in his window and sews, 1 big red pair of cardboard scissors hanging on the door, I recite the alphabet to myself in my head in order to find the keyword in the *GROSZE BROCKHAUS* encyclopedia, in the café 1 strand of hair on the person sitting in front of me falls across their nose and mouth, I make typos constantly, sit in my bathrobe on the side of the bed, listen (hum along) to Buxtehude's "Song of Solomon," I'd like to live 1 little while longer in between 1 tear and 1 smile.

In 1 dream I remember another dream ("bluish, Berlin") : grove or trip Berlin ("washing blue"), maybe I should make 1 workbook, I say to EJ, no, not 1 diary, 1 workbook, in order to retrace the individual steps and storms and how the work developed, etc., I stand at the window, look into the terrace garden and suddenly I know : it is 1 *Dufy painting*, outside in the garden, up on the terrace *1 Dufy painting*, I am moved, dazed, *inspired*, I mean, the soul bewitched, *1 sparrow as small as 1 child*, yes, *1 sparrow as small as 1 child, and roaring.* JUST NO IDYLL, EJ on 16 August 1988, "phase of depression defined as : very strong longing for something, you don't know what..." I walk back and forth, up and down, in my narrow quarters to entice the thought masses, leave the light on in every room.

Through the crack between the window and curtain the morning stars, heart ruffled like the mallows, pinkish flowers, in the front yard, from D., back then, monstrance and tear, *no verb at hand.*

"And writing you scorns the laws of physics," Mikael Vogel writes me, "to write you, of all people, how could that how did that come about, from what kind of amphibian state, how different than in the best of cases now, with the one next to me slowly dissolving in constantly refilling, warm, hot-warm water because collected, dammed up, deposited 1 long time over so many years, my fountain pen carbon, my black ink carbon, carbon, for they continue to dye black ink with carbon, nothing else, with grime (and steam locomotives), etc."

My ink darling, I say to Daniel, who we eliminated 1 long time ago, he allows his fantasies to gallop, he tries to simulate 1 delirium, Tàpies paints 1 painting with the title *Without Thinking*, 1 painting with the title *Project for Cloud and*

Chair, I start off the day with Maria Callas and in that I try to verbalize every tiny chore, every grip, with the desire for constant inspection, from the window the wandering mountains, this Tipp-Ex fluid is going to my head, that 1. step out into the garden (which I don't have), just over the threshold, so green the steps in front of the house, Hercules harps, horns and tongues, red over red, 1 entire sm. levitation on the street, *I am outside myself* : EJ on 9 March 1998, and lives in thoughts.

Hardly has the frenzy begun when my blood pressure comes undone, how can I save myself. Ulla Didrichsen says : "your apartment is 1 three-dimensional collage, on tiptoes the flower-tribunal..." she says, here too 1 verbal back and forth until something fits like 1 tile in 1 game of dominoes, etc. or halfway to classical, I say, is the hereafter 1 drugstore, is the hereafter 1 mountain of diamonds, says Ulla Didrichsen, 1 verbal invasion, 1 bewitching. 1 certain BROODING plays 1 part, I say, all of 1 sudden something comes together that you weren't aware of before at all, existential bewilderment, HOW, FIERY SECOND.

The vis-à-vis woman has put her bedding to sun in the window, I say to EJ, I have given up hoping for 1 hereafter. I say to Father, when I came I saw you lying upside down on your bed, I say, they'd cut 1 boil off your back, you could only sleep on your stomach, I was shocked : *he seemed defeated*, stretched out facedown, I asked him whether he was in pain, then forgot it again : HOW WE DEAL WITH OUR NEIGHBORS, I say, patriarch.

At the 1 window it's raining, the east window, at the other the sun is shining, the west window, whirling laundry on

the terrace, 1 rubber tree, everything mirrored in the open window, up the stairs, down the stairs, that's how the mealtimes (dishes) go. And like 1 fur-bearing animal the mangy (bristly) fur hat peeping out from under the old newspapers, I say, while I finish off Laura's LASAGNA, the door in the apartment next door creaks, I have put on 1 white plastic bag instead of 1 napkin, I say, looks like 1 bib, sesame seeds scattered across the tablecloth and my skirt while I finish off Laura's LASAGNA, the telephone rings 3 X, he, EJ, in the last weeks of his life would use paper napkins as tissues, I say to Alma, which reminds me of Reinhard Priessnitz, who did so too, at the pubs he'd blow his nose into the checked tablecloths when no one was looking and say : "I'm not going to make it to be old…" which turned out to be true, in the last months of his life EJ would say, I'M NOT GOING TO LIVE MUCH LONGER NOW, MY MOTHER TOLD ME I WOULD DIE SOON—

The doctor asks : "how is your mother?" though he knows she's dead, "I haven't heard from your mother in 1 long time." I say, she's in heaven in my books, she says : "when you come in the morning I am already sad because I have to think about how you will leave again in the evening, but when you leave in the evening, I'm already happy thinking about the next time you'll come, etc., instead of being sad, which would be understandable…" 1 swallow's wing is hanging off the telegraph wire and 1 white-crowned peacock's picking through the fuzzy flowering tree, and before the tumbling row of houses the bellied fields. BECKMANN writes, this morning I captured 1 beautiful landscape, 1 road after the thunderstorm with 1 white blooming acacia tree and laburnum, otherwise 1 number of poplars and many bushes, *all in the heavy breaths* (of the warm and damp spring), the

headless silver fish in 1 cart, pulled by 2 black horses, and then the driver with his whip, the little dog with pointed ears at the window. Namely, the HANDTHOUGHTS, says Mother, that is indeed the art of living, says Mother, for me it is as if 1 lit. cord from your heart to mine, and I am held tight and can feel just how you are, and cannot stop, she says, *it is mainly in the chest*, my love for you, some kind of 1 soul moon, or in the garden, not thinking of anything, walking…

Passages of departure, and what counts is what we do while speaking, writes Derrida, what we do, how we again touch each other by mixing our voices.

Field bindweed with white bust, I say to EJ, you're caked by the whole environment, ach, 1 grief, the one under the breastbone dances 1 little, etc., the day's pathetic zigzagging melody.

And in order to continue writing, I say to EJ, I mean, to go 1 certain distance, and to what's been written : it's 1 submersion : face and body, and foot and hand, and emerging then, fresh and clean, *but nervous*, back to the little table again, Maria Callas again, anxiety about the end of writing again, this writing, anxiety about what kind of end, how will I find the end, I mean, 1 tearful one, etc.

I postpone the end, as always, still smuggle 1 few more materials in : *desert-son scrap of paper*, in order to prolong it, long, long, and endless, without end, namely, unending.

(Suddenly, in the middle of winter, on the tongue the taste of saltwater and coast—my wavelike sleep.)

12/13/01—12/05/02

And I Shook
Myself a Beloved

all that is said is constantly taken back so you constantly doubt what was actually said, all that is said exists only in the realm of the possible, but it could easily be different, somehow it has to do with a person, but it crumbles apart, dissolves over and over then takes on a new meaning, it could easily continue, and by no means is it excluded that, well, that's not the way it was exactly but I have no idea how it could have been any different, etc.

—Peter Weiss

my nerves were all aflutter and Gertrude Stein says that it always showed in his face when he observed a square of grass and it had been just a square of grass but when he met the one he loved and looked out on any square of grass that square of grass was filled with birds and butterflies there where there had been nothing at all, that, you see, is love.

And the way they drag nature into the hall, I say, and was always afraid that if the summer wind grew strong it would blow away all the scraps of paper with my most important notes and that I would never find them again in my apartment, and so I weighed them down with the huge stones EDITH had brought me from Crete, somewhere I would always have liked to go but never managed as I never got round to leaving my home for that long a trip, and so the whole of language floating, as if with arms outstretched.

And then Lili was there and she had an amazing ear, if not much of an eye, but she could immediately weave whatever she saw into some kind of life story, that is, she could see something take place on the street and simultaneously understand everything that had led up to it, the background, and regardless of whether people or animals appeared to her on the street, straightaway she could see their whole lives and fates, that is, was fed with the small and smallest characteristics and events of their daily lives. *And then it floraed all around me and I shook myself a beloved.*

Whenever I would say to EJ, we should take care of that tomorrow, he would say, but only *during the day*, in the evening I'm too tired, I can't take care of anything when I'm tired, I just want to sit quietly, drink a glass of wine and rest awhile. Now, I say to EJ, I've reached that point too, I try to take care of my things during the day and in the evening I sit there reading under the lamp or writing letters or listening

to a piece of music, isn't that so, and I put off going to bed from hour to hour as I don't want the day to end, for morning will follow and those morning hours take up all my energy because I have to force myself to do things, get up wash get dressed. Then one day followed another without life's basic questions having been solved.

I let myself be carried by my language as if endowed with wings that could carry me into the air, but I don't see it and it's got to come on its own.

About half a year before his death we were walking down the Hauptstrasze, past a florist's shop where I always order bouquets and wreaths for dead friends, when all of a sudden from out of a terrifying silence he asked, *so where exactly do you order your wreaths?*

The sky was blue that summer, day after day, and when I looked out the window I could imagine it was the blue of the sea, and though it was only a substitute for the sight of silky flat glimmering seawater, it made me happy. Throughout the war we constantly had gas masks in our hands and practiced using them, particularly on quick walks and runs, which was quite difficult, and now and then I could barely get enough air, and when our apartment was destroyed by bombs we moved into the apartment of a friend of my father's and I immediately began to look through his library and most often pulled out the illustrated editions and catalogs of modern painting and *zeppelin alarms* day and night.

And I balanced myself above the abyss with outstretched arms, and that's how I dealt with the clean copy, and when I was in Mondsee and wanted to call my mother from a phone booth *the midday bells came in between* and I couldn't hear a thing she was trying to say and she couldn't understand me either but I spoke so loudly that I could continue, through it all the bells' heavy sound, and looking at the blue of the sky

I felt vexed, a secret blessing, isn't that so.

The poet, he did not work, did not need to decide what he saw every moment, no, poetry for him was something to be made during rather bitter meditations, so Gertrude Stein, but agreeably enough, in a café. This art does not depict reality, but the perception of reality.

And I always told Mother to stop putting on her slip while standing, that is, *climbing into* her slip, because there was always such a great danger of her falling, and Christa Kühnhold told me on the phone that, from time to time, the woman with MS she was taking care of no longer had any idea what she should wear on hot summer days : every day she put on the same pair of jeans and woolen sweater, jeans that were so dirty she could have stuck them in a corner where they would have stayed standing up, staring, etc.

The Picassos were in Spain and Fernande wrote long letters to Gertrude Stein describing Spain and the Spaniards and earthquakes ("I'm in a garage," my old doctor used to say to me while interrupting my reports on the mobile), and they were dining-room relationships, *and she's supposed to say hello to me unconsciously, that's according to Lenchen*. I remember just after the war I was in a garage having my car fixed, so Gertrude Stein, I like garages, I mean, I like a great many things but I almost like garages best.

It was in the postwar years and Mother would always wait outside the restaurant where Father was eating and he'd leave her to wait a long time even though she was hungry but during their vacations, which they most often spent in Gösing or Mariazell, there just wasn't enough money for both of them and so she'd sometimes buy herself a piece of sausage and get it down with a dry roll, which was really painful for me to hear, *inflamed Spanish beggar* in my lap the scraps of paper warbled as I write, as I move and cried—who called or

was it that told me about Pleyel, and to whom did I respond, yes, Chopin did in fact play a Pleyel, etc. Back at that point in the '70s I was an ardent Beatles fan and an ardent fan of Satie and I would always say that the whole of classical music was inside it and the whole of Romanticism balled up just the same, and throughout the many years of writing I was very ambitious I was excessively ambitious and EJ always said, you are terribly ambitious I can't stand it, and on the many car trips we took together EDITH always asked, has Heinz Schafroth turned up, has Marcel Beyer written, has Helga Glantschnig called, and she was happy when I could say, yes, she or he called wrote faxed (*properly*).

We were in that village world and I dreamed "Ovidian cadences" and Gertrude Stein says that if you are way ahead with your head you naturally are old fashioned and regular in your daily life, and when the doorbell rang, my heart beating faster, I always thought it would be you at the door or at the sound of the phone always hoped I would immediately hear your voice, I say to EJ, you know how you feel, Gertrude Stein said to me and looked at me in her graceful way, she possessed so much grace and rigor and she always made me feel like she knew everything, when I asked her once about something I did not dare ask anyone else and, for a change, she did not know the answer, in an almost dismissive tone she said, I do not know, and that's how you were turned away and for a long time didn't dare ask anything else.

After three weeks in the country I come back home but do not recognize it any longer, or is it I can no longer imagine it, and that was *a flurry of thought*, and I literally had to go from one room to the other to repossess it all. Jargon or conversation remains and Heinz Schafroth wrote a postcard from Greece upon which : when I looked into the eyes of the Lion of Kea I felt a little ashamed of my mortality, he

for his part has been looking onto the world's comings and goings for more than 2,500 years and it doesn't seem that he intends to cease anytime soon, *and how all of these things are necessarily true.*

At the moment, writes Leon N., we don't have any flowers in the apartment at all—with the exception of a white rose : an artificial flower. Ach, I must spread my wings, I say to EJ, to be able to get farther with the copy, or : as if I were endowed with wings (and tears), and as if they could carry me into the air but I don't see it and it's got to come on its own. And once again I hear the midday bells from Mondsee where I am standing in the phone booth talking with Mother but the echo of the bells drowns out our voices, etc., I think I've forgotten how to swim, I say to EJ, that is, how you swim and thus keep yourself above water, I was always a good swimmer, but now, when I would like to recapture my youth, I can no longer hop into a pool and swim, I've simply forgotten how to swim, I say, I ask my old doctor, who by now has an answer for almost everything, if you can forget how to swim when you get old, yes, she says, it's possible. And my old doctor often says that's just part of it all, when you've known someone long enough, you have to accompany them on their final path, isn't that so, and when one of my patients has an exhibition or receives a prize it's just part, you go and are present and wish them well, *and she said hello to me unconsciously, that's according to Lenchen.* I mean, with such a snout *my snout* I already know what's wrong, and where it's leading me, I mean, in terms of writing, in what kind of new direction it's leading me, *and I am now writing figuratively.*

In the end people are unconscious / so : when they are alone they want to be with others, and when they are with others they want to be alone, so Gertrude Stein, and my maternal

grandmother had the habit of not being able to spend a lot of time in one place : at a tavern with her family she wanted to be at home, at home she complained about having to be at home and that no one came to visit, when someone came to visit she yearned to retire to her room or take a walk, I have inherited this unquiet body of hers this character, standing too, leaning against a window or door, standing balancing a bowl from which I'd eaten and drunk while standing, and I can't spend a lot of time in one place, and whenever I visit someone, walking in, I say I can't stay long.

I never knew what to say, I was unable to start a discussion or join a discussion because I am unused to being with others, isn't that so, preferring to talk to myself or reading a book, which, outside of writing and walking, is my favorite activity, etc.

Because my throat, I mean, my throat is tied and making me cry, which is always a sign of having a lot of work to do, isn't that so, here in these legendary surroundings I am familiar with the sky and whether it has something to say or reveal about the weather to come, which means I am so familiar *with the little sheep* when they come, and the vapor trails disappearing beneath them, and I have learned that a whirling evening wind means rain the following day and, likewise, when I am in unfamiliar surroundings and unfamiliar with the sky's signs I just have to let myself be surprised by the weather the following morning, isn't that so.

But my eyes were more important than my ears, so Gertrude Stein, and it was always polite to be there, at every reading, and walking into the room Ulla said, WE ARE ALWAYS AT WAR and I was surprised, and it was a flurry of thought, and in my lap the scraps of paper warbled, as I write, as I move, and it floraed all around me and I shook myself a beloved, well, now I have a lit. dog, and in the

mornings and afternoons I'd go to Drasche Park, and I enjoyed it though my lit. dog did not pay the slightest attention to me as we walked, astonishing, and so up one street with my lit. dog then down another, and that made me happy, and then another lit. dog walked up : namely, EJ called me from Berlin and said, I've found a large flat in a beautiful villa, and there's a neat lit. dog, too, and you'll like everything, and so we moved to Berlin for a year and met a lot of people and had a lovely time.

I sleep most of the day because of all the medicine, at night I wait for EJ to speak to me in my dreams, I often dream of him, he acts the way he did when he was alive, I have no fixed ideas about the beyond, sometimes I am afraid to imagine it, sometimes I play with the thought of how it might be, sometimes the feeling that there is no beyond, I read a lot, writing's only possible *when I have these wings*, that's my secret, how much longer do I have to live. My wrinkled forehead, until now no serious illnesses found, which means I could be happy, at times I even am. I don't know if I believe in God, I pray to him, I guess I believe in him, I cross myself before every church but do not go to Sunday Mass, why not, I beg for his blessing, I ask his blessing for writing, for my health, for the well-being of my dead parents, for EJ's well-being, I've made a note: *The Gout Register*, no idea. I hope I have a lot longer to live, there are so many things I still want to do, the sm. Ischl in the Kaiserlichen Park of Bad Ischl, I feel the summer wind on my arms and legs, cheeks and forehead, but from time to time it's cool, rainy, past the same shopwindows a hundred times, and it all repeats, year after year, but how long will everything keep allowing itself to multiply, I believe very strongly in the Holy Ghost, the wings too, but that's my secret, etc. I'm listening to the end of Arthur Honegger's *Le roi David* oratorio, a powerful composition,

I'm in the spheres, no flurry of thought but a vision of light while listening, ravishing music, etc.

I could hardly write a thing in Berlin because I'd go on walks with the lit. dog, whose name was Fifi, for hours every day, we lived in the area of Krumme Lanke with its lake and delightful landscape and I would go walking with Fifi, and I see myself, I still see myself the way I do everything and I see myself in moments from long ago, that is, as if I had continuously taken snapshots of myself, I see myself, e.g., at night, after visiting Barbara Frischmuth, stepping out of her house and thinking, I'd be afraid to live in a house all by myself, and as if she'd read my thoughts from my forehead she said, I'm not afraid of living here alone.

On the front side of the shortened tram in huge letters I dream: MISSING CAT, we went into the *garage* to get the car and once again she said she wasn't afraid even though her closest neighbor was rather far away, we were in that village world and I dreamed "Ovidian cadences" and whenever we, EJ and I, talked about our trip to America we always had to think of the East Coast first and Washington and as to Washington nothing but our trip to a Laundromat where we were helped by an old white-haired African American, he had large yellowish eyes, and we talked about New York, we talked about how we stayed at the Algonquin and at breakfast ran into Siegfried Lenz, who was waiting for his translator, but he was so lost he barely saw us, and how at first we stayed in a dirty hotel that we left again immediately and how we went walking down Broadway and someone told us always keep a few coins in your pocket, etc., they'd come in handy if we got robbed, but we never got robbed and the coins jingled in our coat pockets on our way back home, and how Boston was the only city in America that seemed completely European, and how our trip out West took us only as far as

Bloomington, where EJ had an acquaintance, and south to Miami, which impressed me, what with the Atlantic sloshing up against the hotel window or me at least imagining it did, and the vegetation seemed paradisiacal, the only thing we didn't like, I said, were the air conditioners as soon as you stepped into a building or a cinema so that, instead of taking off whatever we were wearing on top, as usual, we had to put on everything we had, I froze in all the buildings, and I asked myself why it was so excessive, was it simply fashion or a habit, and the second thing we didn't like was that, in some hotels, we didn't receive any breakfast, which meant that first thing in the morning we had to wander the long streets to find a place with coffee and muffins and sit on a barstool, swinging back and forth, what an uncomfortable way to breakfast, the Algonquin was the only exception : there we received breakfast, *and then I paused, I traced.*

And then we began to call each other using only our first names, my editor and I, on the phone, and when we talked about friends in common we only talked about José and Sara and Ulla and Jacqueline and Lutz and Katja and Wolfgang and EDITH, strangely enough, one talks to oneself about chestnuts and walnuts and hazelnuts and beechnuts, one talks to oneself about how many one finds and whether they've got worms, one talks to oneself about apples and pears and grapes and the kinds one likes the most, *in times of war*, one talks to oneself about caterpillars but never about spiders or lizards, one talks to oneself about dogs and cats and rabbits but not about bats or mice or moths, so Gertrude Stein, yes, but I am subjected to a step back, a regression, a *mountain station*, just like how lit. old ladies begin to get cheeks again, like lit. children, babies at the breast, isn't that so, and so that late summer afternoon I walked up the Waldstrasze, which isn't too steep and covered in asphalt, and saw ants in droves at

my feet, walking over one another, and all the trees seemed bent some of them stretching their main branches in the same direction, in other words, toward the slope of the meadow, it was the end of August and the trees had already begun to lose their leaves, the evening wind blew from the NW and cooled our cheeks, *cozy tears*, and *there was that bag with the swans*.

And the huge stones with hieroglyphs and hearts from the coast of Crete that EDITH had brought me lay at my feet in my writing room, and my feet were naked and I thought about the sea and waves and going under and swimming backstroke, which I wasn't that good at, and all the while I howled and howled, mornings and evenings I couldn't stop scribbling and howling, in other words, a regression, a regression into puberty, EJ constantly looking into Lili's eyes at the pub, yes, literally going under in Lili's eyes, first her left and then her right, and as if wanting to excuse him she said, it's because I have a rather peculiar iris, and he could not get enough of her, then suddenly he had to tear himself away from her iris, and she knew how often a clock would strike.

And I said to EJ, I can learn a lot from my old doctor, I could learn a lot about life, I say, especially as far as discretion's concerned, she is the most discreet person and was unable to stand one of her chauffeurs because, as she said, he had no discretion, she always said, he is not discreet, everything he should keep to himself just comes right on out, etc., my old doctor especially reminds me of the figure of Gertrude Stein and I admire her immensely, she is very cultured, she likes to laugh, but she can also take command or be jealous, *this arm of blooms*.

And over and over we told each other how much we had liked Boston, yes, that it was basically our favorite because it seemed so European, and whenever EJ and I talked about our trip to America we affirmed to each other how much

we had liked Boston, indeed, it was our favorite and we
repeated ourselves constantly until all we could do was laugh
whenever one of us began to speak about Boston, and because
everywhere and, most of all to my friends, I said, ach, I'd like
to write ONE more big book before I have to go, now I'm
afraid, I mean, even more afraid that everything could turn
out to be true, I mean, now I'm more afraid of dying than
ever before, while my old doctor, to whom I also said, I want
to write ONE more book before I die, just smiled and said,
I am not afraid of dying whatsoever, I am ready to die at any
moment, namely, prepared.

And Elisabeth von Samsonow wrote me a guardian angel
for the throat and a dress into which the soul too can climb,
and that certain South American doctors can lure the soul
back to its ancestral home *by waving clothes* at that very place
where a patient is scared… you're no doubt out and about a
lot and incubating a new book, a bit like Paracelsus writes :
"the generation of things with sensation in the soul," it was
gorgeous and the whole day glowed with the beautiful feeling
of friendship, etc., then stay healthy while you work, my old
doctor said to me on the phone and I write everything down
on back of all the fax paper I've received from Mario, and my
blood pressure was up because, in my head, I was writing and
writing constantly while Elisabeth von Samsonow had written
me a double-sided letter I really loved and kept with me at all
times, I ate a fig and said to EJ, I have to buy Bach's complete
works, I need the complete works because on the radio only
the tiniest of tastes, etc., only ever Mozart… ("*go for a walk
down the beach today like Ely…*"). Back then, I say to EJ, back
when the RADIOPLAYDAYS were beginning, I didn't
trust myself to ask Paul to house Ely and me together in the
same youth hostel so I could be near him day and night and
so instead I struggled but did not waste a single opportunity

to escape to meet him, to talk with him, to seek contact, and so, being with Ely the whole time, that was the story with Ely but it's been over a long time now, I say to EJ, *and it floraed all around me and I shook myself a beloved—*

I am ablaze, I say to EDITH, but I am not allowed to talk about it at all, I am not allowed to accept it at all or it won't continue, I say to EDITH, I didn't hear a thing, EDITH says, just reswallow the fire like the fire-eater does, EDITH says, the light was flickering in the other room and it's like a bat twitching over our heads as evening breaks it's like lightning, and I am in another world, I say to EDITH, and I don't understand that it won't always be this way, and in the morning I ran into a man with a white turban who looked at me, I was in another world, namely, on one day I am different than the day before, thus when on Tuesday I can write on Wednesday I can't and have no idea how I could do so the day before, etc., on Wednesday, e.g., I was so far gone I felt like I had never written a thing, isn't that so, and I was amazed that I'd been able to write anything at all because on Wednesday the thought of ever having written had completely vanished, was utterly *unimaginable*, as when someone who had never written hears something about being able to write—it was completely UNREAL / UNEARTHLY.

And whenever the fax bell rings I think and hope it's you, I say to EJ, and that you'll tell me about your world, how exciting it would be to hear your voice telling me how you are, what you're up to, whether you listen to music or the nature of the fires you've been making your way through, in other words, from one fire to the next, and do you still think about me?

The thicket of wings rigid frame of wings, and he embraces me and says, my God, you can feel all the bones this frame of bones how thin you've grown, and it was a flurry of thought,

ach, I always followed him, I say to EDITH, and then there was a clatter (patter) of someone or other's feet, I mean, I don't know, in my lap the scraps of paper warbling as I write, as I move back and forth in my seat, and my nerves were all aflutter, and then one day followed another without life's basic questions having been solved, and everything that was but is no longer there comes closer, who called or was it that told me about Pleyel, and to whom did I respond, yes, Chopin played a Pleyel piano.

So, I was in another world, I say to EDITH, whenever I could write, and though I longed for it all the time, I knew I would not always be allowed in, so on one day a kind of enchantment, on another a disenchantment, namely, a state of disenchantment, isn't that so. And she just radiates so much dignity, my old doctor radiates as much dignity as she does spontaneity, according to her mood, and she said to me, you look pale, that's because you're anemic, you're anemic, she said, and we've got to do something about that.

And I liked having this curtain in front of my face : my hair and the calmative (Demetrin, 50 capsules) pulls me down from my sky, namely, *an altered state*, I would like to be in this altered state all the time, both outside the world and in, rather intense, but then the calmative pulls me back down so I am once again utterly in the regular world where there is no writing no soaring just emotionless recitatives, and we were in that village world and I dreamed "Ovidian cadences" and I say to EJ, now I don't have anyone, and EJ says, I'm speaking from the water, and nothing and everything happened, so Gertrude Stein. And during my frenzy I am *exultantly ablaze*, but otherwise and indeed I constantly deny myself, that's what it is, and say : what I'm doing is bad, and as I am always looking for someone else to be guilty, in truth, I am the guilty one even though innocent, I accept guilt without complaint,

but at times so weak, I say to EJ, no one is allowed to ask me to do anything, isn't that so.

Eating is intimacy.

And over and over this geriatric view of things, I say.

Up there it's storming and down here the cars are roaring past, so I guess sitting in a plane is just as dangerous as crossing the street, I say to EJ, and sometimes, I say to EJ, I feel like you're protecting me, or when, e.g., I feel a live wasp between my lips and spit it out before it flies down my throat and kills me, maybe, I think, it was you who helped me, *devouring your tender heart like the glory of flowers*, and once, on my way to the rehearsals of a piece of mine, it was pouring but I didn't have an umbrella and Maria jumped from a doorway and laughed and held her huge green umbrella over me, everything so engraved though so many years have passed, everything so present, and I can see the whole scene so clearly, and I put a Gerhard Richter catalog next to my bed to read later on.

Oh, she said, with such long wings I can only walk by myself, she said, and I said, but I've completely adjusted my gait to yours, yes, she said, but sometimes I'm slow and sometimes I'm quick, she said, and next to you, with you, it's impossible to take a walk : my breath is the strangest, one day I'll sleep for four hours and the next day for ten, and you just can't take a reading or make it a rule with me, she said, and I'm able to wear my clothes without wearing them out for years for decades, my shoes too, she said, but with you it's different, so quickly or vehemently or RAGGED, as you say, but as far as walking is concerned I prefer to go alone, that is, on my own : I can stop and take a break whenever I want, take a breath and close my eyes then open them back up, whatever my body wants to do and I don't need to pay attention, that is, show consideration for the person next to me, etc., that's how we'd walk up the Fahrstrasze, Mother and I, stopping

over and over again, remembering the plum trees that once lined the street, and we would walk along the maturing wheat fields, long and abandoned, the open inner courtyards of the farmhouses *along Dithyramb Way*, and later, once she was bedridden and I had to spend more time with her than before, sometimes I really just had something against her while in a soft voice she said, be patient, please, be patient, but I was far away in my thoughts and I cried over my bitterness and that I had so little sympathy though I loved her so much, but my thoughts just kept returning to my latest book and the whole time I would write down words, entire sentences that came to mind while preparing lit. meals for her. And there was the snowlamp and I began to curse, softly to myself, so she wouldn't hear, but her ears were good all the way up to the end, and she said, everything changes and it is odd how everything changes, isn't that so, and then Mother sprinkled salt on my head to ward off the evil eye, *the lamb's atelier*, and I sink down and my throat is tied, and I wiped the blood out of my hair, and while looking for something in the drawer, for silverware, room for silverware I didn't find, I began to curse softly, for myself alone so she wouldn't hear but she heard it anyway, she probably heard it, and the boy yelling across the street, *pourquoi, pourquoi*, the dirty pants, flagging a taxi, carefully sitting down so as not to leave any spots on the upholstery, at home then with the scissors large scissors large scissors cut the pants while sitting on the toilet dirty pants and trembling EJ trembling and yelling : scissors quick the large scissors and in I came, running, scissors in hand, and it was a flurry of thought and my nerves were strained and everything that was but is no longer there comes closer, etc.

A jump of the nerves, I say to EDITH, I'm distracted when I read, even when I read intensely I keep on losing my place,

that's why I think images and ideas and fantasies keep sliding in between so that I have to reread the line I just read, memories, friends' words, point-by-point subterranean intimations, and so reading the footnotes to Jacques Derrida's / Geoffrey Bennington's *Jacques Derrida* I constantly slip off onto some side path, the wrong path, a stumbling path, so that I have to reprimand myself, return to the reading thread : taking myself by the hand and returning, a kind of pleasing veneration and attention, isn't that so.

But it's all turning into a fetish, I say, standing and reading two pages of Novalis, using a little sack of elderberry as a bookmark where I stopped, with the wolfsbane plant through Dresden, on a stamp DOG WITH CROPPED EARS ON THE MOON, *glowhound* a little bashful because of the thick outfit, isn't that so, *glowhound* endless and in private, and it was that soft September weather, and the sun shone blissfully, and I leaned against the window and felt the pinch of sun on my cheek and the breeze from the southeast and while my hair was blowing with the wind I laid my forehead onto my hand that was resting on the railing, the hasty questions, but the midday bells as well, *namely, the cloths that encircle the angels.*

Our many friends they all pray for us, writes Leo N., *and I took a higher dose.*

So quick this dream tourism interbrunette and waking up so many images in my head and a dry mouth and a memory of my 50 year-old black *swimsuit with the lit. red kayak swimme*r on the bottom-left corner and diving into the water like a dolphin, and it floraed all around me and I shook myself a beloved, *and then it flashed like in "Hansel and Gretel," and you have to be able to wait for that moment, everything else is craft.* Or when I, rarely, go to the theater, when buying my ticket I ask how long the performance is as I prefer short pieces

though every day I am almost sorry I only get to the theater so rarely. Earlier, EJ would get the theater tickets because it was annoying to me, etc., every year in fall when the new season begins I decide to go to the theater at least once a month, in the end I am happy to have gone to the theater once in fall and once in winter even though I find it really exciting to spend an evening at the theater, writing down a turn of phrase whenever it really strikes me.

And the sun shone blissfully, and when we silently looked at our meal, at each other, at Ubls Bar and out in their garden the wild roses the swollen bloodred roses at one with the softly smelling evening, ach, at Ubls Bar, I haven't been back since, I say to EJ, it wrung my heart.

Sleepwalking perhaps and boundlessly moody, moonstruck as a child, EJ in a little white shirt wandering beneath a full moon, later, nerves aflutter at the machine the whole night long and then there was a clatter of someone or other's feet but I didn't know and everything that was but is no longer there comes closer.

Nor do I know why this bath towel with the borders has been hanging next to the tub for more than three years without being used, without ever being used, the last time maybe, I think, the last time it was was by EJ, I touch it over and over, let it slide through my fingers and, fondling it, for a while simply carry it around before hanging it back in its place and how frantically I move away, helplessly haunted.

Back when he broke his big toe they didn't want to operate, the doctors said that if they had to remove the toe he would no longer be able to walk, in the past I was a WOLF now I no longer have anyone I can trust, I act something out for the world, I have grown alienated from the world, I manage best on my own, the veins of my right hand and underarm are swollen, why? the upper arm is baggy and loose, everything

at heart a puzzle. Lili calls every three, four days, asks about my health as if I were already dying.

That's a side altar, I say to EJ, what I heard said, and the easel takes off and God's eye reproduced, and you've got to keep moving and I look through the *Grosze Brockhaus* for the word *ether* and find fresh air, cloudless consecration, the not-any-further defined or identifiable medium in which electrical waves spread out through space, world soul, astral body.

Connected to you as if by waves of ether, I say to EJ.

What's going to happen now and how do I get an emotional response, I say to EJ, for without an emotional response I can't continue my clean copy, it was a secret blessing but I don't see it and it's got to come on its own, and then I go back to Südbahnhof, *and the gleam of his eyes*, and I say to him, ugliest station in the city, and I went up to the mezzanine and sat down at Café Rosenkavalier at the very table where we, EJ and I, always sat, back then, most often Sunday afternoons, to eat, and we always felt like we had just come back from a trip and all the more because I always had my lit. black backpack, and I was even served by the waiter who used to serve EJ and me, and I looked at the empty chair in front of me and my throat was tied and I see him in the empty chair in front of me just like before, and then we take the escalator down into the station hall and EJ buys his favorite cigarillos and a chocolate crème for me, and then we would get onto the tram and go back home, and on weekends now I wander through my city together with the feeling that time is passing ever so slowly, in point of fact has stopped, but that was all so long ago, and *I suck the poets' ether*, namely, in gripping stories, isn't that so.

The young women carrying rubber bottles around with them, my blood rushes down to my feet, Ulla-Mae *cites Gypsy belonging*, I dreamed of Ely and how intimate we were back

then, I met him in a clearing, a meadow, and he had a shadow in his eyes, I said, you've got a shadow in your eyes but he only said "coronary arteries," he had something to sew, something had torn on his suspenders, I wanted to sew it and looked for the needle and we talked about a heart-disease specialist and I rolled over a damp meadow and there were big fat black clods of earth, and beneath one of those big fat black clods of earth, like molehills, old dirty clothes, what a struggle not to roll into them, a meadow of wildflowers, wild bats, then Ely disappeared, but I wanted to mend his clothes and looked for him everywhere, I looked at my right arm and saw that the skin was loose was wrinkled and then it finally rained.

Sitting on a worn bench in a sm. garden I thought of you, Georg Kierdorf-Traut writes, I almost drowned in the blooming rhododendron bushes, our many friends they all pray for us, as Leo N. said to me on the phone, and before we, EJ and I, traveled to New York everyone said that in New York all four seasons take place in a single day and it was on Broadway and we were holding hands and all the sidewalks were large slabs and the whole time afraid, waiting to be robbed but not so much that we didn't enjoy being together in New York and at night on TV a program about heart disease and the doctor on the screen said, it's like a giant animal sitting on your chest, an elephant, that's a sign you're sick, and at breakfast we saw Siegfried Lenz, absent, bent over his books, and we learned that he was waiting for his translator, and he looked exactly like he did in the photos of him we were familiar with, and many years later an American woman looked me up in Vienna and said that she had translated one of my books and she was an excellent translator but she had fallen in love with me and I broke off contact.

And now it's heading for me or what does the old Barbara branch in the window mean, in the art deco vase between the

panes, and I'd like to spend the whole day in the country, walking around, looking, being silent, or on a bench or in a tree, branches, *ach, EJ says, we aren't socially integrated*, it's always been that way, I say, that's how I escaped my own blossoming, isn't that so.

Nothing and everything happened, in the middle of the endless, I say, the structure of everyday life rattles me, and so I sat on the train and the landscape hurtled past the window.

Connected to you as if by waves of ether, I say to EJ, and with the years his hearing gradually grew worse, which also had to do with how he liked to listen to loud music but then he would say, when I listen to loud music I don't hear the booming and buzzing in my head, namely, the booming and buzzing drowns out the spoken words, etc.

I always followed him and he always led the way, and sitting on the edge of the bed and scribbling on my notepad for a rather long time I felt dejected and asked myself if I would ever see something through to the end, and then we were crossing Stephansplatz again and everything was covered in blood but we did not know what it meant, and EJ bought me a pair of foldable glasses so I could decorate my eyes, *and she said hello to me unconsciously, that's according to Lenchen*, sometimes we would start to argue, *ach, what a sassy basin, how we dealt with each other from time to time* and I would immediately start to cry because I can't handle being in conflict with someone I love, and he was always the first to say, enough, while I constantly worked myself up even more, and it would last a day or two at most until everything was okay again and we would treat each other with particular care and consider every word before saying it, when a bird or birds fly into a room is that good luck or bad luck, let's say good luck, so Gertrude Stein, and everything at heart a puzzle. Again

the long red billowing curtain like a flag a tongue out of the open courtyard window across the way, and Jacques Derrida writes, that's what they cannot handle, that I don't say a thing, that I never say a thing of consequence or validity, nothing true and nothing false, and I myself have never been able to contradict myself, that is, speak, that's why I write, that is the word, as if made to be forgotten, you can always come and go and softly step away, I am still so young, I say only the maternal, the kindergarten... and as I don't say a thing, I write in order to alienate, surprise, confuse, drive to madness all of those who I turned against me by not saying a thing, etc.

And this sequence with the bells in Mondsee keeps showing up and shivers down my spine and most of the time everything uneasy, and he says, you've shrunk, and we're sitting in the Colorful Cow and he's drinking a glass of dark beer, and my reading of Gertrude Stein had opened up all the floodgates and I was really happy because my writing was spouting, almost without any resistance, and from my memory previously unknown images appeared, and they begot others, and all in all my view is freer, yes, freer, and it had already settled down within me, the writing had settled down within me although I had only written a little of what I had in mind (*at the end of the pulse and parks, etc.*), ach, words in their speed, I mean, I had an idea of the whole without knowing where it would lead, in other words I did not know what exactly I wanted to write, BUT JUST TO WRITE!, isn't that so, that was the main thing.

And so I had been sitting at the machine since dawn while writing handwritten notes in between and here and there I looked at the clock and was amazed at how quickly time was passing, and at the back of my head a steep hike in the mountains with EDITH, and how the bushes and young trees bend *in the valley*, and the sun shone blissfully, that is,

primulas punches phantoms, namely, the sun while at work and how it haunted my mind, namely, blinded, ach, the world too naked, much too naked, at eleven I walked to the window to crack it but then closed it again and I took a higher dose, and now I've got to get my wash ritual over and done with immediately, the blanched weeds in the eaves across the way shaken by wind, a single swaying poppy too, and the flies had created a buzzing a real buzzing in the room, houseflies probably, but it was just the beginning of September, isn't that so, in my lap the scraps of paper warbled as I write as I move as I sit, a flurry of thought, *ach*, *roaring life*, and my nerves were all aflutter, and my fingers got lost between the keys and I was helpless (possessed) and everything at heart a puzzle.

And it was the cloudless consecration of the sky and everyone was asking me for addresses, and K. called and asked for Josef Hiršal's address but he passed away yesterday, I said, namely, the body in an orchard, concave in the morning, the dreambirths, the overgrown third toe of the left foot and I armored myself off, I didn't want to receive any more calls, and when I got back from my trip I was so tired I had to think about which country which city I had been in.

The trembling hands : the missing keys, I am trembling my hands are trembling I keep hitting the wrong keys, I mistype, in other words everything missing, marred, poisoned, out of tune. Everything can also be completely different, I say to EJ, and I remember saying to a friend, X. is like HARE. *Young Hare* (Dürer), and he accompanied those hand movements of his which were necessary for treatment with exact descriptions of what he was doing : he was now doing this and that and then there was this too, and that, and then the treatment session like he hoped was over without having been too painful, and EDITH is so communicative, and she can talk with anyone, that is come into conversation

with anyone and at the same time amuse herself as well as the other person, and when taking me home after the trip to the theater H.H. said *this is the only thing I'm good at*, and I had to disagree, which he appreciated and he smiled without saying a word, and then it will be today and we are bound to this earth but in the end that's not so bad, so Gertrude Stein, and Mother always said, *I'll remember that*, and when I would say, go on and write it down, or a bit more gently, maybe it would be better if you wrote it down, she would repeat, I'll remember that, but then when it came to her having to remember she had not, she had forgotten because she had not written it down, and I think that I react in the exact same way, but I put things I don't want to forget in specific parts *of my mind or cabinet*, etc.

Without debt without phoenix, so Jacques Derrida.

I walked into the paper store but upon seeing the owner's utterly bare head I cringed, I was thoroughly ashamed, for at that moment I could identify with him completely and he looked rather disfigured, and his head had taken on a conical shape, and asking for my 20 folders I avoided looking at him, for I would have gone into him, namely, transformed into him.

Sometimes I simply write the words or I write them in shorthand on a piece of notepaper, the words the sentences everything I don't want to forget, nevertheless over and over I forget it all, misplace them in my head, and then they appear somewhere I never expected to find them again, in the middle of a phone call, say, or at the edge of sleep, and you have to get back into *the swing* of things, EDITH says, once we'd come back from Camaiore, really get back into the swing, EDITH says, work reading studying, oh and I am ablaze, I say to EDITH, I collapse and over and over adjust my course while writing by rereading everything I've written so far, namely, to obtain a clear direction and wonder, will I get

this together, will I pull this off, but anyway I like what I have and now it is today, so Gertrude Stein, but anyway I like what I have what I have written up till now, *rose of the flesh*. And it floraed all around me and I shook myself a beloved, but I don't see it and it's got to come on its own, but I actually wanted to make a collection of those words and put them down in a particular place on my overcrowded desk, that is, a list of those words that keep slipping away from me but years ago I already tried something similar, namely, just that kind of collection but forgot where I had put it, so : exotic perverse nostalgia esotericism infusion adrenaline piety, etc.

"Oh Wild Bats," I really want to have that wonderful poem by Thomas Kling sent to you right away, Georg Kierdorf-Traut writes, growing older is causing me great problems, Georg Kierdorf-Traut writes, uneasiness, anxiety, panic : drawing to a close... whether beetle whether hill whether consecration of the sky, what keeps me awake : all blows away, amid clouds of angels, James Joyce.

Namely, wrote what's between my shoulder blades, but the tap was dripping and when I left the hospital, out in front of the hospital I felt the soft grass beneath my feet, and a few flower beds, and that was comforting and I stayed there a while, strolling through the grass and looking into the sky, and I went to visit Mother every day and once she was doing better we could go to the lounge, where we were alone, leaning against the window and talking about how everything would be when she was released, and she was always patient and quiet but sometimes she couldn't answer the doctors' questions so I did it for her instead, *and a few letters from the way*, etc., and my GP wrote me, it's a good thing when we don't have to see each other, and that was a mysterious line and I thought about it but could not find any answer and so I pasted his little note to my desk, and over and over this, my geriatric view of

things, and so I cried out of the hotel window, what I saw, what I saw from the hotel window : WAS IT A DUFY?—what I saw was a Dufy, the sea's blue consecration in Camaiore, the little flags and masts the boats and buoys the beach, and my hands on my eyes defined the image sideways to make it be Dufy, and I did not want to see anything else but this view from the hotel window, my hands on my eyes to define it sideways, I imitated Dufy, I'd invented Dufy, I had seen Dufy again, I mean, in reality, and so my very own Dufy, but down on the beach, everything disenchanted, beach life gone due to the time of year, the beginning of September already and the promenade stretching for kilometers with its markets and stands and changing faces, and I touched oleander and pine trunks and avoided looking into the setting of the bloodred sun. And then there was a clatter of someone or other's feet but I didn't know, and then one day followed another without life's basic questions having been solved.

At the end of the pulse and parks, and it was a coming and going, and while walking through Hartmann Park I once again ran into that woman who lives in a building at the end of Hartmann Park who always speaks to me when we run into each other, she is a friendly woman and once she said to me, WE'RE JEWISH and she said she had read some of my poems and wanted to get all of my books, and in the eaves a slender poppy flower was blooming, a little bent but aglow, *between violet and lilac* I dreamed of a horse pulling a wagon, and it pushed or carefully *moved* a few larger objects from the middle of the street to the side, and I dreamed that Luc Bondy said to me, I am a suitcase-person, I travel all the time, and I answered, me too and I don't want to travel anymore, and then I dreamed that, holding up a bleeding finger, Marcel Beyer said to me, I cut myself on my writing

paper every day, I mean, it's so sharp, and the eye of the hurricane over the East Coast of the USA was on the front page of the paper and we hooked into each other, Mother and I, but the path down the slope was not without its hurdles and most of the time we stumbled but I don't remember what kind of hurdles they were, so we were careful and EDITH said, *Salute*! and raised her glass of red wine to me, like primulas phantoms, *and nothing and everything happened*, and thanks to a simple walk in the beautiful summer the seeds for wonderful work in winter are sown, so Elisabeth von Samsonow, horses flying through the ether and the forest must steam, I say to Gertrude Stein, but she is off in her thoughts and her naked back shone, and she said, ideas are not important, but light and loveliness are. And stepping onto the street it smells of sacrament, and there was a great twinkling in his, Picasso's, eyes, and sometimes the wind blows a leaf off my table and I had fallen in love with the lit. dog Gina and had completely crawled into its soul and looked through its eyes.

The anthill in my hand (Buñuel) and enraptured (ecstatic) I look into the tiny living room carnations, and murmuring : murmuring his name on the phone when I called, which just about intoxicated me, I say, *and there, the little barefooted soul, how it shuffles*…

and then Nina Retti calls and says, Pierre Michon is writing about the holiness of writing, and that really wakes me up and then my ego starts to ogle from out of the ether and those are the most beautiful fragmentations and blisses of the heart, isn't that so. Everything changes and it is odd how everything changes, and Gertrude Stein also had a lit. dog but it was not called FLOCKI or Gina but Basket, *ach, hanging lines, I say to Gertrude Stein, I had an epiphany*. And when at one point the elevator broke I called the mechanics and complained that I had to walk up five flights to get

to my apartment, but the man was very friendly *and as a storyteller* and he said, I am very sorry and if I could I would do everything possible to help you but as far as carrying you up, I mean, there is simply no way, *soft or floating bushes*, and so everything is a reason for unreality or inhospitality, etc., namely, the car slipped or soughed like a waterfall.

And eating is intimacy, and EJ said to a friend, she (me) is incredibly lazy and if she starts one thing she keeps going until she starts somewhere else and when it, writing, doesn't work on one day the following day it doesn't work at all and on the day it doesn't work at all she does not understand how she was ever able to write a thing, it would be another world, completely normal world a completely disenchanted world and that makes her (me) sad, etc., and on those kinds of normal days there was no form of insistence or vigor, that's how it was, he said. Back then in Berlin we would go shopping and order things we simply did not need and on the way home EJ would be plagued by doubts and EJ said, we really didn't need to order another CD player, but I would reassure him and say, that is the best CD player we could get, and there was a zeppelin alarm and he was a skeptic through and through.

("dear Göre…") last night illumination and the poem is a single lit. wild dove but it always cost half a life, I say to EJ, to see it that way. *A forestroar without debt without phoenix*, and I read a few pages of T. S. Eliot and quote : "April is the cruellest month, breeding / Lilacs out of the dead land, mixing / Memory and desire, stirring…"

and once EJ said, you're not a good woman no really you're not a good woman, you're extremely ambitious and concentrate only on your work and one day when I need your help you won't know what to do, isn't that so, and I cried for a long time and accused myself and cursed writing as a whole, and I thought that I had always done everything wrong, and

when Father died it was curious and horrific at the same time, Mother said to me, do you know what he would have liked the most? To make me go with him, I don't think he could understand that I wasn't coming with him, that is, that I was not letting myself be buried with him, namely, that I wanted to go on living without him, that is, the idea of having to go over without me was the most terrifying of all, and there's a kind of panic inside me, *and to live with the law of reality*, and I took a higher dose, and everything at heart a puzzle.

Then my blood rushes down to my feet, and over and over my geriatric view of things, *and old age and pain and sleeping*, so Gertrude Stein, and I observed my own sins in comparison with those of my parents and I saw that those of my parents were greater, and I can hardly remember the lit. relationships I grew up within, that is, into which I was born, and I could hardly imagine how we all managed to make it in the cramped apartment and that I did not have a room for myself and how much pain and hardship my mother must have had to bear throughout all the years decades, ach, maybe I was like my maternal grandmother, I took a lot from her, I mean, I did a lot of things just like she would, I would lean against the window, balancing a bowl and looking into the distance or into the sky and I always refused to believe what had really happened.

And Mother always wanted me to speak with her but I was taciturn and would hold her hand but that alone could not make her happy, I needed to speak with her and whenever I came back from a trip she would ask me to tell her about it, and she would say, when you don't speak with me I forget the entire language, but she didn't want people she did not know to come and speak with her, she wanted me to speak with her but it was difficult for me, and Father, who had always spoken with her a lot, was no longer there, and she

said, speak to me and tell me what you do all day long, etc., and what you are writing, and she said, speak to me, and that way I can start to understand what is happening in the world again, isn't that so.

Most of the time everything is uncomfortable, and they would wear long gray raincoats, *rubber coats* in fact, even when the weather was nice, and whenever a hearse would pass by under the window they would not eat for the rest of the day, fearing contamination, namely, bacilli, and they would only eat with their left hands if they had shaken a lot of hands earlier, though returning home the first thing they would do was go to the bathroom to wash their hands : my great-aunts, my two great-aunts : Milli and Mizzi, that is, to constantly make a new start for oneself.

And that evening they were happy, so Gertrude Stein, so happy that we had to send out twice for more bread, when you know France you know that that means they were happy, and after all it is the adventure that counts, etc., Matisse had just finished his *Bonheur de vivre*, his first big composition, which gave him the name of fauve or a zoo, and I like a view but I like to sit with my back turned to it, so Alice B. Toklas.

And over and over we, EJ and I, would say, *after all tomorrow is another day*, we would say that to each other, when something turned out to be difficult, indeed, insoluble, or when we did not know how to approach a problem, after all tomorrow is another day, we would take turns saying that to each other and most of the time EJ would begin or we would say it at the same time, and we both would feel relieved and the matter was adjourned, *while the script of a body, or the cut the seam—*

and we were surrounded by immense red flower sleeves, plateaus, and a horizon of pines in the cut of the window

and I thought about all the hikes up the Cobenzl I had taken with EDITH while the seasons fuchsia red, *or a wish to the branches*.

And I put on Keith Jarrett, and just because I read a line from Montaigne somewhere ("I now deny myself"), I bought myself the collected works of Montaigne and went on the search for the line but couldn't find it, and I closed the book and was disappointed and pushed it aside, and EDITH had the wonderful ability to elicit the innermost private details from people, acquaintances friends relatives or complete strangers, in the shortest amount of time, details that other people would not have managed in years or decades, and once she asked someone, how old is your lit. dog and how big is he, and could you take him on a plane, and she answered, eleven and drew his silhouette in the air, and then she said, he's probably too big to take on the plane… A fox pelt tree marten lynx, and so hang the clothes to dry facing west, psychospiritual intercourse as the anthill in my hand (Buñuel) and enraptured (ecstatic) I look into the tiny living room carnations, and when Ely and I left the Prater where we had spent the whole day, and wandered along the Danube Canal, Ely said, now we should take the ferry to the other shore, but I was afraid AND THERE WAS SO MUCH STRAW for some reason there was a great amount of straw I think on the ferry or across the water or in the sky, I remember precisely that it was a bundle of straw and that the entire evening we spent hand in hand walking slowly had to do with the straw, why that was I don't remember now, but it smelled of straw and soon the fantasy was over, namely, the grass bed and with our eyes we accompanied the freight the ferry of people to the other shore, and the illusion had faded, and this word, illusion, was the last thing I was aware of before falling asleep, and it really was a gliding down, a gliding over, how

one sinks into sleep, that is, how the deep sinking, the senses' deep disappearance—namely, point to something : show, and to fill one's hat with fruit and to sit on the dry ploughed ground and dream, and never hear them when they would all be calling simply not pay attention simply pretend one's deaf (dead), and the wind would be so strong it would blow the leaves and the branches of the trees down around them, so Gertrude Stein.

And when Mother would call everyone to dinner everyone would come to the table hungry but me, I would not come because I was not hungry, I was never hungry when I had spent the whole morning writing, and Mother would explain to the others, confused by my not coming to eat, Mother would say, she *can't* eat when the whole morning, etc., she was always on my side, isn't that so. And when she received the results, which was always the case, for she suffered from a stomach ulcer, and she was always afraid it could be cancer, she was so afraid of opening the envelope, namely, the examination results, that Father had to open it for her, which he also did.

We, EJ and I, would take the road that wound upward to a grove of slender lit. trees and I would be excerpting from the *Autobiography of Alice B. Toklas* and my leg muscles no longer worked, and so I had to pull myself up onto my armchair, my leg muscles had simply grown weak like back when Mother could no longer get out of the tub, isn't that so, namely, the books images pages and manuscripts jettisoned in my head, "sweet mouth," he said to me, back then, when we visited him in Austin in the '70s Christopher Middleton said "sweet mouth" to me, they were my rights as a woman with one hundred heads, Max Ernst, *this mind popularity* from Pierre Michon who once wrote, "in summer the afternoon is fixed in the gold eye of the hen," ach, the trees along the avenues, the cherries to hang behind your ears, and a letter

from Elisabeth von Samsonow, and then everyone clapped and my eyes would no longer cooperate because a being is constantly glowing, the left eye's weaker than the right, I say to EJ, I'm a dreamer (disaster), *will the hairdresser still come*, the ashtray filled with water inside it a half-dead moth, cobra and tiger, I write that down right before falling asleep, the purple foxglove on the terrace, and then the lit. headrest or HEADPELT sprinkled red because I'd hurt my head, whether in dream or reality I cannot say at the moment, in the morning, in any event, the headrest was sprinkled red, which frightened me, because most of the time it's got black stripes thanks to my hair, and I wiped the blood out of my hair and my throat was tied, for I did not know what had happened to me and I took a lit. hole in the wall for moth larvae, and I could hardly read the daily paper anymore, and I sucked in my cheeks so that my face looked *sunken*, and whenever I saw old couples in the pubs and stores I felt utterly abandoned, everything has changed everything has stayed the same, I say to EJ, every organ must be in the right place, that is, it has to *parry* and, oh dear, if it doesn't parry there are difficulties with our inner balance (aura, circuitry), I am careful that everything conducts itself in the same way, etc., my life is not made of gold, EJ says, but it's got its worth, at the end the eye takes leave of the ear, the nose the mouth, the hand the arms and then the whole construct breaks down, so EJ, amid clouds of angels, James Joyce, and so I am unholy…of a sleeping heart, and the hand towels like a board, I am like plywood, a thing for daily use, a simple humble thing whose every use, without asking me, just like that, makes a simple humble thing a miserable object that lets you do anything you want with it, ach, my soul so wrung out (like a floorcloth / wild dove)—in the heart of nothingness.

And so where was I early this morning, did I just get back

from a trip, I wonder and look at myself and see a schoolgirl and see Susi Thorsch with a wreath of violets in her blond hair, gentle quiet well-behaved child, and she was able to escape to America in time, back then we were going to elementary school, English girls, and I would wear a beige-colored trench coat that was too long and too wide, calculated for me to grow into, and I was ashamed and trembled, and in the school's garden a lit. pond with water lilies, and that's where I threw up on the gray dress that Mother had sewn for me, also too long and too wide, and I was supposed to play Cinderella at a school function but I could not remember my two lines and I had an upset stomach and I looked at myself and saw my reflection in the lit. pond and during the performance the two lines didn't come and I was afraid and began to cry and I just had no idea about anything anymore and was as yet unfamiliar with *the howl of the soul... ach, roaring life.*

In certain sudden sensations and thoughts *in wood and mountainflowers* I caught sight of the many crosses like Tàpies, namely, it was the middle of February and making my way back home through the twilight I heard a blackbird's delicate song, and I remembered having heard a blackbird singing at the end of January once, in another year *what a promise, etc., the lamb's atelier*, that is, the confluence of the blood.

And all my tears of love, and this morning I say to myself in the mirror, who are you talking to, I missed you, you missed me, there will be a few more days years here before the transition from life to death, so Jacques Derrida, and he said *the woven shoes* EJ said *the woven shoes* and we were both infatuated with the words WOVENSHOES, and he had often bought himself woven shoes but in reality it did not have to do with buying or wearing such shoes but solely the words WOVENSHOES and for us they possessed an extreme

power of attraction, and we liked using the words and in the morning I would ask him, are you going to put on your woven shoes again and sometimes he would say, I don't think they fit anymore, my feet have changed, *the swelling of the wings*, today his woven shoes still on one of his shelves for shoes…

I've ordered Gironcoli's sketchbooks, they will teach me something I desperately long for in my current state, half-asleep I forget to urinate, *onto a bloody branch*, etc.

The eye hurled raw into the dark corner to find furniture books and blind garments : spiritual exercises of the mad.

A little beyond my hotel window the apple tree is blooming, I say to EJ while I was away and wrote in my notebook : "*borrowed ink from EJ.*" And my eyes have grown worse, I write to Heinz Schafroth, because I also always in artificial light, and otherwise everything on shaky feet, I mean, just one object from my room crazed and everything falls apart, a unique chaos, and no normalization in sight, I write to Heinz Schafroth, you write, has it been that way for a long time or just recently?—that was exactly the feeling I had, namely, the one of just consumed experience, I can remember that clearly, on my way to the next post office, close to the hospital where EJ was, in order to cancel our trip WE CANNOT COME WITH YOU TO SIFNOS…

as far as what I am reading is concerned, since you've asked, I am reading Gertrude Stein almost exclusively, just like a few months ago I exclusively read (and excerpted) Jacques Derrida, it's slowly rolling on, I write to Heinz Schafroth, this long reading of Gertrude Stein, and sometimes reading is like a big heavy stone on my chest, and I can't breathe, all the same I continue : reading so attractive, sometimes it's like I know it all already so I don't have to continue, but then I keep on reading anyway, without being completely satisfied. This morning awake at four, I change my nightgown because

it's damp with sweat, my neuralgia, right side of my head,
pulls at my wet hair, the quilt reversed, the damp end by my
feet, agitated dreams I can't remember, I dream rather wildly,
congruently : likeness : my old doctor and Gertrude Stein, I
saw her yesterday, she was smiling-like-a-mother concerned,
which moved me, hits one of my weak points : fluctuating
blood pressure, etc.

Sleep almost the whole day long because all the medicine
I have to take makes me tired, at night I wait for EJ to speak
to me in my dreams, I say to EDITH, I often dream of
him, he acts the way he did when he was alive, I read a lot,
writing's only possible when I spread these wings, that's my
secret, my wrinkled forehead, today I made a note: *The Gout
Register*, no idea, the sm. Ischl in the Kaiserlichen Park of
Bad Ischl, I feel the summer wind on my arms and legs,
cheeks and forehead but from time to time it's cool, rainy,
past the same shopwindows a hundred times, and it all repeats
year after year, I mean how long will everything allow itself
to multiply, I'm listening to the end of Arthur Honegger's
Le roi David oratorio, a powerful composition, I'm in the
spheres, it's a flurry of thought in fact a vision of light while
listening, ravishing music, etc. I miss you, I say to EJ, I'm
sitting up in my bed and writing across the paper lengthwise
with weak light, I need room, I always need more room.
EDITH says, hardly have you stepped into a room and
it's chock full of all your things, dark things, unappetizing
things, I don't understand it, she immediately notices my
exhaustion, I'm immediately wrenched, the contact : wires
cables to the most various people, some days easygoing, others
full of anxiety insecurity horrible presentiments, and senility
is of course not *civilized*, so Gertrude Stein, my old doctor
and Gertrude Stein interchangeable, Jacques Derrida was
also called Jackie, yesterday a long talk on the phone with

Elisabeth von Samsonow and Jacques Derrida, whenever Giuseppe Zigaina calls, *in order to replace the lilies of the valley as decoration*, neither of us knows which language to use—

It's five in the morning, I am wide awake and almost happy, my old doctor as well as Gertrude Stein have something against intimacy, maybe they are both immortal, my old doctor is domineering, whenever she's in a room she fills it completely, it's astonishing, and when I'm with her I feel meek, insufficient, comfort to me is both an intolerable as well as a familiar thing, to practice both humility and exuberance, I once said to EDITH, it was around half a year after EJ had died, I will never be able to be happy again, it produces logic, Gertrude Stein says, perfect! My old doctor says, perfect! when she likes something, and when writing to repeatedly put the small against the large, I say to her, I leave my bed and hurry over to the machine, while my heart ran riot, etc. And I like to read inwardly not outwardly, Gertrude Stein says, and then he kissed me on the cheek and there were strawberries on the outside of the coffee cup and behind the rolling blinds a glowing ball lost in the all, and I had an inwardly glowing being, figurative art, and had to swallow five *globuli* every morning but the world was still tender and I experienced the disintegration of my nerves.

I was both island and country and the housings surrounded, and like swallows noctule bats can apparently drink while in flight, namely, variety of violets, *this silent embroidery*, almost hours at the window and looking up and down into the sky, and color and bitterness, did one really write those letters did I really write those letters, *or had one only remained in memory*, and I say to someone, I'm happy you're coming, but it's not true, in truth I am afraid of you wanting to come, probably to disturb destroy my plans my thoughtplans,

isn't that so, *my Napoleon hat, Holbein hood*, namely, he, EJ,
really had lost a Napoleon hat, left it somewhere, in other
words simply forgot his Napoleon hat just like my old doctor
simply left her fur hat somewhere, forgot or lost, in the taxi,
she says, on that taxi ride, it was too hot in the taxi, I put the
hat next to me on the seat, etc., and then I forgot to take it
with me, *and so love too in and out and unprecedented.*

Elisabeth von Samsonow calls and wishes me
WRITING-ATTACKS, and Christel Fallenstein tells me
on the phone that she heard that Elisabeth von Samsonow's
lapdog (laptop Heinzi) died, all of a sudden he just fell over
just imagine : this lit. deerhound sport dog that used to stand
on such soft feet simply fell over, namely, from one moment
to the next fell down dead, namely, when he saw a huge dog
that had begun running toward him : killed by fear, and he
was eleven and a very smart and attractive lit. deerhound, and
he had, one could say, been raised well, he was a well-raised
child and, when she gave her lectures, he would lie on her
knees, and I had always liked to speak to him while he would
look at me with his big dark eyes, maybe he understood.
And walking into my doctor's surgery he kissed me and said,
you look good, a feature's immortality, lit. white immortal
room, I say, wooden slats boards and stones, I say, it was a
moldy, imprecise image : winter image presumably in which
one could no longer differentiate a thing because everything
seemed leveled out by the white, isn't that so, and I could
feel my heart beating when I received a letter from Leo N.,
and sat down with the letter in my hand and read the few
lines and read them over and over and multiple times, and I
could see everything right before my eyes just as he described
it, and I could remember the apartment, EJ and I had been
there often, and Erna had always cooked, she had insisted
on cooking for us, I was always so touched by her cleverness

her knowledge her hospitality and once upon a time we were out in the garden and Leo N. was taking photos and when we dug them up a number of years later we called out, how beautiful it was back then, how young we all still were, and now he wrote, Leo N. wrote me, Erna was doing rather well and sometimes he remembers how they were together before Erna became ill, he loved her then very much but now even more, her body her sm. hands and feet her soul so different from his own, and without her he will only be half a person, and I read and read and could not stop reading these few lines and I was there in Leo N.'s and Erna's apartment and everything was right before my eyes and it was a winter image and I began to cry and thought it was *an excess of memory*, and I thought it was beautiful, one could INFLATE everything inflate the whole text or even reduce, DEHYRDRATE, the whole text, isn't that so, you are indeed inside it and can move around, and love it, and have a sack race there, and basically do anything within it and with it, you can celebrate in there and cry in there and it was the most beautiful thing in the world to be at one with it.

And now we're standing, and I noticed that even with great attention and inasmuch as I had turned to my reading with great attention, that is, took up every word, every phrase, with the greatest devotion, I could not stop unexpected images from arising in my head and changing into other new images, that is, the images came and went and overshadowed the text so that the most diverse apparitions came in and out, appeared disappeared in my head so that I had to wait, pause until the images disappeared, and wiped away I could continue reading—but after a little while everything repeated and I could barely read a text to the end without interruption.

Lit. greyhound and -hint, and *is this ever a sassy basin*, and I think, I say to EJ, one cannot be realistic and crazy enough

when writing and one cannot be infatuated enough with this and that and with this and that person, and all my tears of love, a lot of scribbling in my head and I am now writing figuratively, I say to EJ, and I am too old to let someone tell me what to do, nevertheless sometimes I long to be in a state where I can listen to someone, to my old doctor's recommendations, e.g., but a couple of days ago a bee stung me on my right index finger, it was a burning kind of pain and I winced, and I walked to the pharmacy and said IT HAD TO HAVE BEEN A BEE but the pharmacist said, if it flew away it was a wasp, a bee that stings you loses its stinger and dies, and everything at heart a puzzle, and over and over this, my geriatric view of things, isn't that so, and then my blood rushes down to my feet and my nerves were all aflutter. In my lap the scraps of paper warbling as I write, as I move, as I sit, and my doctor says, when your head's so full then maybe the body grows heavier and loses its sense of balance until, again, something begins to float in your head, etc., a forestroar, *without debt without phoenix*, so Jacques Derrida. I let myself be carried by my language as if endowed with wings but I don't see it and it's got to come on its own.

And I am getting closer to the center of writing and it's a wonderful cloudy morning and I swallowed a hunk of white bread and had a stomachache because I swallowed the white bread without chewing, it slid down my throat, *smooth and like a lit. snake*, and here and there the atelier would be opened up so you could see what all was being made, and I took a higher dose, and my suitcase was lying on the sofa half-packed and I knew I would have to finish packing it that day to be able to begin my trip the following one, and I liked the soft continual drops against the windowpanes and I sit down at the machine and write a clean copy, then a blue vein appeared in my right arm, actually a number of blue veins, variety of

violets, and it's a confluence of blue, isn't that so, and outside in the hall EJ's moth-eaten suits, windbreakers, and I walk in and out and past his old clothes, and I am gullible and a skeptic, and I walked up the forest path and there was a lot of shade *forestshade* and then I sat down on my full rectum and had a bowel hysteria, and I was close to the center of writing and silence, and love came in and out and unparalleled and the chestnut trees along the rich avenue stretched their branches and boughs down over the slope of the meadow and they were stooped, namely, hunched over and I wanted to keep on going in order to reach the outlook at the end of the woods with its unimpeded view, etc., *and forkbreakfast.*

Through the closed window a passerby's little cough, my old doctor says, I'd like to have a discreet birthday, but back to the forestshade walk, so I continued slowly on and when I was tired I sat down on a wooden bench to rest and thought about summer's end, when the rains would come and the fog would come and I would be able to write again, namely, the brainrush in the morning, it dreamed me, then smashing the pale moth against EJ's clothes with my naked hand, isn't that so, and something sticking to the wall hanging's fringe like lifeblood, etc.

This, my poetic process, namely, poetic palpitations while the cuckoo clock allows the wooden bird to hop out, which repels me, namely, to work oneself into the materiality of language that produces electrification. This morning after waking up the second time I think about Getrude Stein's sentence : "I am I because my little dog knows me," and when EJ died I lost the greater part of my identity, had my friends turned away from me I would have lost another part and I would have spun back off into the by-and-large-unconscious state of my early childhood and wouldn't have known a thing about the world and wouldn't have known a thing about what

was happening or seen any point to life.

And in the morning it's almost impossible for me to get up and in the evening I need to stretch the day out until midnight because suddenly there are so many things that I want to do, namely, I don't want to end the day too soon, in other words I can't get enough of the day that's drawing to a close, which, in any event, makes the following day's start all the more difficult.

And I am getting closer to the center of writing and screaming and it is an incredible cloudy day and then it begins to rain and I look out into the rain, and everything that was but is no longer there comes closer, and being alone is a curious thing, isn't that so, a mixture of anxiety and pride, and then one day followed another without life's basic questions having been solved, and in the welcoming moon in the welcoming garden "Geibel Service" and at the height of Mother's head a palm branch.

And I said to my old doctor, that is what makes you so dignified, your discretion, you made me healthy, I say to my old doctor, the logs wood kindling detailed work, I mean, tiniest work of my brain is thanks to you, ach, the gallbladder thyroid stomach. You must know that I'm not a hypochondriac but like every crazy person a solipsist, an egotist, I only go to the doctor, repeatedly, once again, to attempt to halfway cobble together my torn body so that I can carry on with my writing, that's the whole secret, isn't that so, breakdown of the glance.

Ach, *the secrecy of language* behind hedges I'm mad about walking I hear the yapping or signal mechanism in the dahlia cove, etc., I remember a tree on a hill in Rohrmoos a number of years ago, I've sealed everything deep inside but can reproduce the image in front of my eyes whenever I want, *blue be it this blue heaven*, so Hopkins.

When the large red-lobed flowers on the tablecloth : appear in a poem of mine my balance will have been restored, namely, this collection pansy family in its speed with its reverent faces *and the glimmer of her eyes* it's a thought flurry a forestroar and in my lap the scraps of paper warbling as I write, as I move, as I sit, and it floraed all around me and I shook myself a beloved, and EJ says, *there is nothing outside the text*, and the right arm is longer than the left, two black eyebrows on the sidewalk, I say, a few plants shot up on my roof garden probably sunflowers, ach, the menu chair's wobbling the menu chair creaks and Motherwell says, for years afterward spattered blood appeared in my pictures, while the large-lobed red flowers on my table floraed like the moon beyond the window, and I took a higher dose.

You smell so good like woods and lit. woodland animals, I say to EDITH, *boyish jersey* and a great need to write though my blood pressure was high, I want to wait until mold begins to appear on the packaged pieces of bread : that's how long I want to leave them in the bread drawer : DESTROY, naturally I could throw them out right away but I just can't manage, I can't throw bread away, wasted bread, etc., and so I leave the bread alone until it has begun to destroy itself, namely, until it has grown moldy, then light-heartedly into the trash, isn't that so.

It was a burden to me, I have always felt burdened, I say to EJ, whenever I was supposed to visit someone or someone came to visit me, that is, when I was expecting someone, and what made it worse was expecting a number of people, the Apennines in my notebook, the Apennines the agave in my notebook, at the moment I am leading a nonexistence because I cannot put up with anyone, a lapsus, a dressing gown but the arms always turned to the inside, by a single eye movement,

I say to EJ, I immediately know what you are thinking, your face : an open book, and I looked out the coffeehouse window and saw a storm and heavy rain and passersby with their open umbrellas almost being blown away, umbrellas snapping inside out, and the changing leaves were flying and the birds were swaying in flight, namely, *birdmatters torn to shreds*, etc.

Tall lilac and Gütersloh, bought Bruno Gironcoli's sketchbook, and he said to me, do come visit us sometime, he said that, I promised I would, and today I received a letter from Georg Kierdorf-Traut and he writes, my escapes to the solitude of Fonteklaus at ever-shorter intervals, isolated and cut off, nightly talks with the graves in the mountain cemetery, have found incisors, bone fragments, etc., under a violet night sky, stormsky : an endless horizon line I see the whole scene before me as if captured on paper. And it was summer but had now turned to winter and I did not understand how and the seasons changed so rapidly and almost overnight, and just this week I had been wearing a light jacket, now I had to pull out my wool coat and I wore it on my trip and once it was neither too heavy nor too warm. Everything changes and it is odd how everything changes. And I am afraid that time too could end before its time, and the tip of my bathrobe's belt was wet and Keith Jarrett in the background, *or the cuckoo in a brightly colored suit*, in a brightly colored suit, namely, Father in my dream I want to kiss him but he turns away and emits a cry, we drive to Mother in the hospital, we see her just for a moment DYING, underneath in old frilly script The End the closing frame of an old, overly faded film. I review my seemingly hopeless situation, reach the conclusion, as so often in the past, that everything must continue on just as before, hopeless, immutable, balancing weights above the abyss, a crash can happen at any point, I say, no one is capable of helping me, here everything encrusted covered in dust the books the

tables the spoons the flowerpot, nothing to be done I circle above this pitiful situation, nothing can be changed, nothing can be shaken loose, I say, Keith Jarrett in the background, I was vexed and how all of these things are necessarily true, isn't that so, *and there were zeppelin alarms* and it was as if I were numb and the intention to write COLLAPSED *at the end of the pulse and parks*, and he called out "*rouge rouge*" and I was really frightened he called out really loud "rouge rouge," out in the hallway in front of my door and he was in front of my door wide eyed and I began to cry I was so upset and again he called out "rouge rouge" and I asked him to come inside and I got two lit. bottles of red wine from the kitchen and he grabbed them without a word, namely, a loop on the neck an eagle a swollen vein and he could not breathe and I let out a howl *absolutely only on the neck on the eagle* and my blood rushed down to my feet and I had that feeling of unconsciousness unhappiness and it was a long dark walk and he raced along the pavement with a cane and a rage snowblossom shower blossom desire, a sudden blinding of the winter sun, then overcome by *a kind of stutter* whenever I was supposed to report something, that is, my language retreated here and there while I swallowed words and sentences whole and sometimes I would choose inappropriate words, namely, whatever came to mind, that is, without determination or order, and radical wonder about my new impediment—a lot of people made fun of the random way I spoke or my addiction to repeating words and sentences with no apparent reason, or to employing incorrect terms, and I was embarrassed and decided not to say anything else and to limit my interactions with people and I saw how being so tired and sleepy in the morning I would shuffle down the hall, *and she's supposed to say hello to me unconsciously, that's according to Lenchen / glowing soul*.

I was bleeding, the dusty flowerpot, the snow-covered

fanny, the driving snow in my heart—landslumber little-grinding-hands and legs, shuffling through the stone-tiled hall in the early morning, a polished lamb in the window, and the structure of everyday life rattles me and I am getting closer to the center of writing and screaming and EJ calls out, I am connected to you by waves of ether—

and the two of us with Angelika K. in the beer garden of the Schweizerhaus in the Prater following Harry's death and I feel, see the three of us in the beer garden of the Schweizerhaus and how the leaves whispered and rustled above our heads the warm wind and how Angelika K. tried to take part in the conversation, that is, with choking voice and how she held back the tears, namely, following Harry's death, etc., and we sat and EJ asked about her work, and how we tried to comfort her, and my throat was tied, or as Leo N. wrote when Erna was deathly ill, "our many friends they all pray for us" *and some lines are missing, wandering below the dream below death—having come from (heaven)*, so Sappho, and series of thoughts pass by my inner eye so quickly I am unable to hold on to them, a landscape in a fast-moving train, when will I sit down for my last flight, I wonder, and it was as if I were numb, and nothing and everything happened, and I remember a tree on a hill in Rohrmoos, and I'd engraved it in my mind, and it was many years ago but I see everything just like it was, and it stood alone on the hill and I looked at it for a long time and thought I would never forget.

And I think I am always in love and my throat is tied, and I love only my tears, I love and speak only through them, so Jacques Derrida, actually I imagine I write like Francis Bacon painted—colossal painter free of all taboos, and I found an old note and I read my old note and I found a pen-and-chalk sketch by Mimmo Paladino entitled *Gymnopédie* and I found my note with it and I read my note and it said, huge tails from

his eyes the one from the corner of his right eye sideways to the back, from the corner of his left eye upward wafting down, antagonistically thick eyebrows, arms and hands fumbling forward, pushing an eye-trolley, or as if he were surrounded by deep darkness. The eye-loops and -manes stretch on the one hand halfway down the chest, on the other to the top of the back, a significantly frightened female with two made-up children sitting at the edge of the table, that's why she left, she was so cold. Always the heavenly maenads, she cried, *the damp meal at her back*, namely, gradually the pale iris blossoms sinking into waxen dead yellow, etc.

And Gertrude Stein writes food is damp in America but not damp in France, and the little basket in front of the window, and I thought with satisfaction *that one had already mustered the strength had mustered the great strength* to meet her, namely, Gertrude Stein and to meet my old doctor and my Swedish translator and that it was a great mental effort but also a pleasing effort and that I could *look at* these encounters, these efforts with satisfaction, could pursue them with my glances, my memories, and I was thankful that back then I had mustered the strength I probably would not be able to muster today because the necessary power to jump, the necessary elasticity and emotion are missing, and I thought about everything I had managed and was happy that I had managed because today and in the future I will not be able to achieve : muster the necessary power of wings for I lack the power of wings because I am constantly growing slighter and smaller and losing strength and in the hour to come, day to come, will lack any dignity freedom or madness, etc., and just next month next year over the next few years, and in the shade of the woods as I walked in Bad Ischl in the shade of the woods I saw *a rich avenue* of chestnut trees that had withered before their time, namely, whose leaves had turned,

namely, brown, they had lost their former green, isn't that so, and I slowly climbed the Waldstrasze feeling a lit. bit anxious, as if someone were following me to do something bad, following me because I was alone, and my throat was tied and I turned around and went back to my quarters and found a single piece of paper with a few unrelated sentences but it seemed inexhaustible and I imagined shaking it, all the while ever more words and sentences spilling out, tumbling, falling to the floor, and I couldn't stop shaking as ever more words and sentences came to light, and it was so noisy in the café where I was sitting with Bodo Hell that I could barely understand what he was saying, and I thought the speed at which he thought and spoke had grown even greater while my own had declined, and would keep on declining, so that I would fall completely behind and no longer be able to catch up, and he would wave back to me from a great height and call down to me to follow him, which I wouldn't be able to do because my strength would have disappeared, and so there I'd remain standing on a small speck of grass watching the whole world spin and swirl around me and growing very dizzy and folding up and saying to myself, now it's over but in the end I managed to achieve everything put everything down for everyone to see but really who in the end would bother.

Whereas in the past we had been connected by a very similar speed of thinking and speaking, isn't that so, I say, and I promised to attend his next reading though I knew I would not be able to keep my promise because I only reluctantly leave my quarters. And it drove me to the machine and I rolled out of bed and hurried over to the machine because I thought I knew I had left a bunch of densely written pages on my desk, which was very convenient, and that I, or so I believed, only needed to make a clean copy, but I did not find any notes, which confused me even more because I thought

and that frightened me, and I opened a book I had written years ago without having given myself a direction and I was astonished and something in me moved and I was TORN, something in me was completely torn, and *unraveled*, and I retrospectively felt how it had torn me up when I wrote it, how I was completely torn up, my heart and body and head and I shut the book and thought, I've got to be able to do this all once more, one more time, and *blood on the dining-room floor* and not a single piece of paper stirred and I heard myself say to Ely as if from afar, when will I see you again?

I say to Ely, I enjoy listening whenever someone has smart things to say, I like to listen, that is, I prefer listening to speaking but most people want to hear our opinions about this and that, and most of the time I did not have my own opinion or I could not formulate it, or as EJ always said, "I don't have a worldview," he'd say that whenever someone asked him his worldview, and he would get angry and yell WHAT A WORD! and everything continued and everything went so far that I avoided going to theater premieres although I really enjoyed the experience but I avoided going because I was afraid that at the end journalists would come up and ask me my opinion of the piece and I would not have an answer ready because at the beginning of the evening I had already decided not to have any opinion I just wanted to take the piece into myself, namely, the language, that's how it was, namely, the stage's bushes, and then, asked my opinion, I did not know what I was supposed to say so I would ask EJ what to say, WHAT SHOULD I SAY, I asked him, and he always had an answer ready and he said, tell them this and that, but the answer he had suggested was not made for me, that is, it was not my opinion, and I had to think a long time, think whether something occurred to me, but everyone will know that, isn't that so, and Basket in the middle of all of us

and the child was wearing black stockings and a white shirt and had corkscrew curls about both ears and she looked like Shirley Temple in her first films and the shirt she was wearing had puffy sleeves and the goat was curious, namely, she had a curious look on her face and the sun shone blissfully and the gleam of her eyes the slanted eyes of the goat, and it was like a sacrament and Laura Ouveden writes a postcard from England and the text goes, last weekend I saw this gloomy looking angel at the Saatchi Gallery in London, he's even got hairy legs and is sitting on a barstool, and he's resting his head on his fists, the artist's named Ron Mueck, etc., and changing course over and over when reading through my most recent excerpts ("sought-after nature and the little Jesus…"), and I can have a fondness for everything, I say to EJ, here in this landscape where everything you can think of grows, and where we could have all anybody could want of joyous sweating, of rain and wind, of hunting, of cows and dogs and horses, of chopping wood, of making hay, of dreaming, of lying in a hollow all warm with the sun shining while the wind was howling, etc., so Gertrude Stein in her book *The Making of the Americans*, but one does not know where Gertrude Stein begins and my own text ends, or the other way around, and the swallows in the country back then in Deinzendorf, how they shot over the paths, almost touching the ground, back then, how often I have called it back to mind myself, but everything engraved into my soul in large letters, isn't that so, so that I never forget, so that I could never forget how it was everything that happened everything that happened with me, *it was all a sacrament*. And the sun shone blissfully and I said to Elisabeth von Samsonow, ach, sweet panic studying your writing how I know you are warm and nestled, isn't that so.

And I began to grasp that my original copy was starting to move away from the clean copy ever more clearly or the

original copy always branched off, and Mother said, you can set the clock by you, and you've got to look at the calendar, Mother says, and it is heartbreaking to see how people wither *literally wither*, it ties your throat, isn't that so, and it is a woe and it is a wretchedness, and I see the hotel in Meran again, right on the river and how we, EJ and I, on those spring days hiked up the hill and hairpin bend to hairpin bend made our way higher and we, down below us, we saw the other hikers coming slowly upward and there were other flecks of clothes, red and blue, a pattern and I could not get enough of watching the people's various clothes as they wandered among us and I wondered how the waterfall to my right crashed down violent crashed down tearing the boughs and branches of the bushes at the edge down with it, and we always hiked up the hill and twisted upward as if we were being swirled and twirled ever upward by a huge carousel.

And she had a *prewar haircut*, Susanne Becker had a prewar haircut : a puff around her head held with clips and lit. combs and she laughed and said, I don't know *how to do hair* anymore—she said that, because I've got so many gray hairs and I found the fact that she had grown children, as she said, incredible, yes, that's what she said and : whither with the gray hair and then Katja came, a burning torch with her beautiful red hair and fiery eyes, namely, the gleam of her eyes, and she hugged me and I was touched by her affection and her sweetness and it was enough to make you cry, so much warmth at once, etc., and then off down the cold stairwell without a coat to unlock the door for Thorsten Ahrend and Thorsten Ahrend brought all the cold inside *and with the bundle on his arm, etc.*

And Mother had *stored* it it was Father's latest storage place, I dreamed that, and it was somehow *gussetheaded* but I

don't know what that means, and she had slipped his clothes over him and he was sitting in our midst although he was cold and his skin was very white, actually, ashen and we all cried, Mother sobbing heavily, and I had to think of his naked body beneath his clothes, and he was acting as if he were still alive but without speaking, and I saw his black pen on the floor in a lit. puddle because I had knocked over the full water bottle when getting up and my hand still hurt from long typing and his black pen was lying in the lit. puddle on the floor and next to it there was a wet paper tissue I had tried to use to clean everything up but it was a swan sequence and I was senile, and like in a film I saw, during my dream, this black pen in the lit. puddle and it was a film by Buñuel, and I felt my heart constrict in pain and at the same time I felt hungry but breakfast wasn't ready it was only five in the morning and I imagined Klaus Reichert's ANTLIKEWRITING and his pale eyes I really loved and I didn't know whether it was still a dream or reality already, and the sharp notebook pages cut the fingers of my left hand and the blood dripped onto the dining room floor and Marcel Beyer lifted his bloody hand and called out, I constantly cut myself on my writing paper. And whenever something was difficult for me or even seemed impossible, I felt the thorn he had driven into me, and at first it was simply painful but then began to spur me on, and I thought that, if he entrusted this role to me, it was something I was supposed to do right, and I said to myself, *I'm doing it for his sake*, and I felt a great push from him and he had incorporated the great push into me and it was an anchor he had dropped in my heart and I was already floundering a bit but trying to do my best and I said to EJ, *I'm doing it for your sake*, I said that.

And sofa and books and in summer lying under the trees in the garden, I say and I heard myself say to EJ, caught by

the beauty of Bad Ischl, I've moved there with my books and with you, dream or reality, so that whenever I think of that time I always have to sigh passionately, etc.

I saw this gloomy looking angel, Laura Ouveden writes, and even hairy legs and he's resting his head on his fists and he was sitting on a barstool, and in the background the music of Bach, and I was met, I mean, Gertrude Stein's style met me, and I was listening to Mozart's *Adagio for Glass Harmonica* and it excited me and I wanted to buy the record, and then Susanne Becker appeared and she was dressed for a party and she had a lot of clips and combs in her hands and she talked about how she did not know how to hide her graying hair, and later she was just a figure on a steady baseplate that slowly began to turn like some advertising columns on the city's main roads, and then there was a clatter of feet but I didn't know, *and sun shone blissfully and the gleam of her eyes.*

That is how we kept on going and when I am working on a long text I don't show anyone what I have written, doing so might keep me from continuing to write. *It was like being in a village-world and* Ely always waved back when we said goodbye to each other, but that day, when we said goodbye and I turned around to wave back, he did not and I was surprised, and suddenly, sunk into my reading and the sun reflecting on the windowpanes of the building across the way and in the lit. puddles on the street, I saw the pages of my book turn pink and bright red and the dining room floor was swimming in blood. How could I say something when at the moment there was nothing to say, when there was nothing to say at the moment, and how could there be something to say, in doing what I had been doing, so Gertrude Stein, and that was from *The Making of Americans*, now, in any event, neither beginning nor end, *and she's supposed to say hello to me unconsciously, that's according to Lenchen.* And then I called

Wolfgang von Schweinitz and said I would like to write the libretto for one of his operas, did he like the idea, and he said, a chamber opera, how nice, and Ksenija Lukic could sing the main role and I said, but I could only get started next summer, and in the background I head Mozart's *Adagio for Glass Harmonica*, and again I saw *the caretaker's white lashes*, and I cried when this photo of EJ showed up and we were talking about happiness and had no idea about happiness, daily happiness, happiness many times a day an hour or fragments of happiness, as Siegfried Höllrigl wrote, *I am so unbelievable*. Ach, this photo of EJ, and how he reached for his wallet as it was late at night in the Café Hawelka and in the photo we looked tired, we looked exhausted, and I was sitting there with my eyes lowered my hair messy and he had pulled out his wallet to pay and earlier we had met a colleague who took photos of us, and years later he sent me the photo, and my throat was tied I could read everything from the photo, his thoughts and his fears and his silence, and we took a taxi home and on the weekend I saw this gloomy looking angel in a gallery in London, he's even got hairy legs and he's bent over on a barstool resting his head on his fists, etc.

And I took the path down to the grove and I called his name but he did not come back, I never saw him again, never again, and so here I conflate the name of God with the origin of tears, as Jacques Derrida writes, I remained quiet and held back my tears when they addressed me when everyone addressed me they always wanted to pull everything I wanted to keep for myself out of me, the whole time, and they drove into me that I was supposed to have time for them but I had no time because time was for my writing, and my throat is tied when I look at the photo and I wiped the blood out of my hair and I sink down and constantly mistype just like I constantly promise things because my thoughts, I mean, my

Wendelin Schmidt-Dengler used every free moment to study his Russian and learn Russian words by heart, and how the white night of Saint Petersburg enveloped us on the banks of the Neva and I was battling the flu, which was preying upon me with sweats and shivers, and how he wrote many postcards and deciphered the street signs for us and the steam from the open-air pool rose above the many swimmers, and in the middle of the city, and in the middle of the night, etc.

What should happen now and how do I get an emotional response, I ask myself after turning off the Bach record, and everything that was but is no longer there was coming closer and I took a higher dose, and I was afraid of the lit. walk to the car because I felt really dizzy and though he, EJ, was walking next to me I was afraid of simply falling over and at the end of the pulse and parks and my nerves were all aflutter and I had left a lit. red tomato on the windowsill for weeks without it having changed and he was the God of Excess, Ely was the god of excess and transgression, and once he told me he had an 87-year-old girlfriend and their lovemaking was exciting and that he often went to see her, but I didn't want to believe it—he was a very attractive young man with blue eyes and blond hair and he was gentle, *and there was blood on the dining-room floor and suddenly it was a dolphin language, and I sink down and wiped the blood out of my hair*, and Father mumbled that the years in between played no role, and I like to read internally not externally, so Gertrude Stein, and while reading about the life of Petrarch I thought about Sabine H.'s small-lipped mouth, and the image imposed itself and drove off everything I read, and continuing to read was an effort but then it just wasn't possible, and it seems to me that I am only interested in my own identification, I say to EJ, and Mother always had an aversion to card games, she refused to learn any kind of card game and said *it was a waste of time*.

He, EJ, carried a sm. ashtray around with him in the form of a powder compact so he could smoke everywhere and get rid of the ashes—it was a sm. box with a built-in mirror.

I went to the cemetery and brought him five yellow roses and I thought he would speak to me, but he didn't, and I touched his gravestone and lit a candle and closed the lantern and left the cemetery, saying to myself, everywhere different everywhere otherwise I'm close to him, or at least to his grave, etc., what are you thinking what were you thinking about, over and over the question between us, and EJ said, I'm not thinking about anything, I wasn't thinking about anything, not thinking about anything just existing the empty minutes hours and half days, with every step the hope to reach one's own quarters without falling, isn't that so, and one, two years before his death EJ turning to friends, when I was away, and saying, you've got to stand by her then, when it's time, because he did not dare speak about it with me, and as soon as I heard the discussion I began to cry because I didn't want him to die, same thing with Mother whenever she tried to talk about her death with me I always began to cry immediately. There was a zeppelin alarm and it was as if I were numb, and I thought about him for a long time and that I did everything wrong, my whole life I always did everything wrong, especially my behavior with EJ but I also treated my mother poorly, now I would know what she needed a lot better and how I could help her but it was too late, and I drove home and for years, decades, I had done everything wrong, pushed everything away from me and left it to others, years, decades, my responsibilities my custody even my love, as I tended to call my sentimental feeling… and at the height of *Mother's head* a palm branch, and the structure of everyday life rattles me and I am wearing clouds of dust on my hands and feet but everything's pounding so vehemently.

And for some time now in the afternoons I have been going to a particular coffeehouse in the center city and bringing my reading materials with me and my medicines and my blood-pressure machine and my strong glasses, which have been made for reading small print and which I now have to use for any print at all, that's how bad my eyes have become, isn't that so, and I have been going there above all because there's a large table where I can spread out all my things unlike at home, namely, at home there is not a free table anywhere for me to write and open my books but sometimes, *mad for walking*, I'd be counting my steps to the café that's how tired I'd become and then I would sit down at my marble table and have my notebook in hand and a pen and my books and next to me a Japanese couple chirping and that was pleasant because I don't understand any Japanese and it sounded like birdsong, had I understood the language their discussion would have bothered me, namely, distracted me, and in truth I write almost uninterruptedly, I say to EDITH, namely, in my head, *and EJ with his cap of light came toward me*—and then I met Linda Christanell and we were standing out in front of the coffeehouse and she told me how she had made a short experimental film and that it was being screened and I promised to come see it but my primary mistake is not looking things in the eye because I start to tremble, VARIETY OF VIOLETS, without knowing if it's been two years or one year or longer, which could also be the case, and I say, I am an only child but I would have liked to have a brother, an older brother who would have taken care of me, isn't that so, I would have felt comfortable and not so abandoned like I do now and in truth my whole life long, and so we strolled and Gertrude Stein said, *I think I write so clearly that I worry about it.*

Namely, variety of violets, I said to EJ, and I was aflutter

and I watched someone on the tram taking a bite of an apple, and I let myself be carried by my language, namely, the great wings, which is my secret as if endowed with swings to carry me into the air, but I don't see it and it's got to come on its own, and my blood pressure was up and I am aflame, and I dreamed "Ovidian cadences," etc., and sometimes it was hard for me to think on my own but when writing it was not hard for me to think on my own, I say, and that makes religion, wandering, and architecture, Gertrude Stein said, but this is all incomprehensible and unfathomable to me, *and that's where the fire of my blood.*

And then a letter from Siegfried Höllrigl reached me and he wrote, how beautiful the valley is when not depressed, how beautiful the valley, how enchanting, how wide, how friendly, *on the descent things happen ceaselessly, isn't that so,* argument slip-and-fall-to-death, we talk about happiness and have no idea about the happiness we had, daily happiness, happiness many times a day, every hour every minute or fragments of happiness, I am so unbelievable, namely, such an unbelievable happiness that driven by the unbelievable we had to immediately look out as far as we could see, into the open air into the sacrament.

Does it have to do with nostalgia or what, I say to EJ, Fatima is ensouled by prayers, and was I stimulating to the mind, and the appearance of small branches, it's nine in the morning and I'm sitting in my work turban with my shattered eyes and in my lap the scraps of paper warbling as I write as I move as I sit, and it floraed all around me and I shook myself a beloved : and I hear Maria Callas speaking and sobbing, and I'm getting closer to the center of writing and screaming, and a forestroar without debt without phoenix, everything at heart a puzzle and Father murmured, *the wandering starlight.*

"Such was my heart, O God, such was my heart—which thou didst pity even in that bottomless pit …" (Augustine).

Then the point will come on its own when you sit long enough and write and brood and dream, daydream, and then everything comes on its own, works without my help, and creates reserves, and then I read I read I read all the pages I have written, no, not me someone else wrote (thought) all these pages, etc., and now I am in another lane, I say to Franz Kraberger when he calls, I say, perhaps a figurative lane, but when I want to have an exterior effect, when my point shoots upward when I lose myself the magical particles swirl become mixed up it's like *tailoring fashion*, I say, always the same and still so completely different, isn't that so, and the way I sleep is also the way I write, that is, in fits and starts and *heart-hermetic*, and then my attempt to unite the pieces, and now I am making figurative art, I say to my Polish translator when he wants to know how I am, and it's the HALF-MOURNING, isn't that so, and I write I produce, the restless impatience, narcissistic introspection, and the caretaker's snow-white eyelashes, I say, that I come to a halt in the middle of a sentence, etc., and I ask Erika Tunner on the phone, when will you write "for yourself" again after this long pause of producing because you were so busy at school, and *the red thread* : EJ : nowhere home (utopia) while, as in Utamaro, I am carrying the giant child (rose child) on my back and combing my hair.

A laugh in my feet, a tear in my eyes, I dream, around my neck a tire, winter necklace massive winter clothes, in the morning reread the repulsive pages of the lecture, now acceptable, "pishing," my old doctor says and looks at me with surprised wide-open questioning eyes as if she had just discovered the indecent word, Russia Moscow Saint Petersburg : the

phantoms of localities, she often says "that is psychosomatic" when I complain about some pain or other, "is this something *spiritual*," I ask on the occasion of my birthday visit, "when sometimes I feel a pain in my spine and sometimes I don't, otherwise I would have to feel it all the time or never, no?" She laughs. It is five in the morning I roll out of bed and walk to the machine, two hours later the rush is gone—

("rather Aids than lose you"), so Jacques Derrida, the scene will not leave me for the rest of my life a few minutes before the paramedics picked him up, on that 9 June the late afternoon of which he died, he hardly had the strength to stand to urinate, *hanging* off the neck of the in-home nurse just before his total collapse while I stood next to him, appalled, incapable of doing a thing, of holding his hand, of saying a comforting word, disintegrated into tears, that is, having broken into tears, without embracing him one final time because I didn't know.

And the appearance of tiny branches, isn't that so, and at the height of Mother's head a palm branch, and I think I know, Elisabeth von Samsonow says, why your favorite thing to do at night is to read your favorite books, because you feel how rapidly time and thus your attempt to hold it back to not let it go because you still have so much to do, isn't that so, restless impatience, and before going on a trip Mother always made the sign of the cross over me so that I would be blessed and all well being come to be, and someone said, when Father died, good that your father died before your mother, he would not have been able to take care of himself, never, but she could, it's just that she was no longer capable of really going about alone, that is she never, e.g., went to town on her own, sometimes however she said she wanted to take a walk, and Augustine says, piety is wisdom, *but I came two hours too late to close her eyes*.

She often asked me to come visit her and speak with her, but I did not fulfill this wish often enough because I was always working on some new book or other and so would ask friends and relatives to visit her, which she did not want, and sometimes in tears she asked me to cancel a visit : ach, she would rather be alone than to have to speak with someone, in truth she only wanted to speak with me *and I break out in tears when I think about it, isn't that so*. Today I understand everything better and would, with greater devotion, *back then as if shrugging her shoulders within the bitter LEOTARD*, *her tiresome taxing soul*.

A dog with its hair brushed away from its forehead at the supermarket entrance, the head of a dog quite clear in the trash the white pointed ears, I think, a German shepherd. It is I come from Wales an apple strudel shop such a kind of standstill of the material, and I don't know why Leo N.'s response delights and enchants me so, it's just a few lines but they are full of mystery and gentle eroticism, he writes, Erna is once again at home, and between 3 and 7 o'clock in the evening they are alone, but as a rule a nurse is there 24 hours a day, but they had just had a little argument because Erna wanted to get up after her afternoon nap and wanted him to dress her before he was dressed himself, now and then he remembered being together with her in the time before Erna became ill and he loved her now more than before, namely, her body her lit. hands and feet her soul that is so different from his own, and without her he will only be half a person, and his throat becomes tied when he thinks about it.

Today electric hair and I can hear it crackling and EJ mumbles he'll do it later, namely, organize all the pills in his pillbox *while they are dragging nature into the hall...*

Confusing déjà vu, I am wearing my fur coat, everything covered in snow that 1 November when EJ and I go to visit

his parents' grave at Hernals Cemetery, I am wearing my fur coat and in the meantime it's been a number of years, I say, but it was very cold and I wrapped myself up in my fur coat and now, at this moment, I can create the way my body felt back then, and we go up to his parents' grave and it's all the way at the top of a lit. hill and next to it is Konrad Bayer's grave, I say, and then back down and the November mist and our voices in the November mist and I say to EJ, I've got to take care of my voice, I can't speak too much, so my heart, etc., once again completely in sync so I am waiting for your voice in between all the lines, I say to EJ, and I just heard a voice within the room's silence, and after visiting the cemetery we go to a pub in order to warm up and in the window there a Van Gogh, and I say to EJ, once Monday's over the whole week is over, isn't that so, and EJ nods and we look at each other for a long time, and I say to him, maybe I should start with the *late* Mozart, to get to know him better, and Ingeborg Nemetz called me "Lynx" whenever she wrote, maybe thanks to my mop of hair and my eyes, that is, the double view, *and EJ with his cap of light came toward me.*

And I was infatuated and I sink down and my throat is tied and Ely pushed me up against the empty classroom wall and kissed me and I began to tremble, and does it have to do with nostalgia or what, I say, and a former student from back then says to me, we all felt it, something erotic was in the air, but we didn't know, namely, the examination of conscience, and my mind storm-shaken water, we exchanged a few letters and that was a long time ago.

And once Peter Handke had overcome his experimental phase and his book *A Sorrow Beyond Dreams* had appeared, Fredy K. said to us, but this book has been written in a very simple language, he said that, and we were surprised. And on

the street a black-clothed man who was biting into an apple and looking at me at the same time, and I say to EDITH, October's going and November will go and, although I had intended to go to the theater at least once a month, I will once again not go to the theater because it's hard for me to go out in the evening, and there was an old woman in workers' clothes and a colorful apron and she was getting onto a tram on a Sunday afternoon with a large straw broom, and that did not happen onstage but in reality and it was unusual and everyone looked at her in surprise and I gave her a sympathetic glance, and EDITH calls and says, where are you hiding? and I say, I've spent entire days at my dentist's, and the furrier says, the animals you eat can also be made into furs, and I had never known that and she showed me a coat made of rabbit fur and I held back my tears, and I felt the need to write *candlestraight sentences*, but now and again there'd have to be an exciting unexpected sentence, a sentence, namely, shot through with electricity and my soul was aflutter and I heard Maria Callas sobbing *and I broke into tears* as the winter sun's slanted painful arrow against my eyes forced me to close them, and I was ablaze and my blood pressure was up and I dreamed "Ovidian cadences" and I was vexed I was numb and then the blood rushes down to my feet. And Oskar Pastior writes, come to my memory even when you're gone, go through my mind through all my senses, through my sense of time—separation flowing.

And I ask Gertrude Stein, when is the best time of year for your work, I asked her that and she said she did not know but now she would like to ask me when I write best and I say, October November December January and I thought of the caretaker's snow-white lashes, but why, I say, and Mia Williams writes me, *my aunts sway toward lovers and morphine, at night they walk the rooms with brooms in their hands, at the*

moment because someone is laughing at them from the window, etc.

And it was behind the Chinese dogs and the first time we slept with each other, Ely and I, I looked at his head and thought, *a stranger's head next to mine on the pillow*, but nothing happened, and he said, leave the light on so I can see your eyes, and we called it our white night and everything outside was also white, and then he said, let's go to sleep. And how can someone change anyone else one has to be as one is, so Gertrude Stein and she lived for a while in Vienna, and Christel Fallenstein writes, you've often changed and you had to cover a long way in your life, not only did the way you look change but your handwriting too, but above all your voice, your voice has changed, I barely recognized your voice in a documentary from the '60s, that is a certain DECOMPOSITION, isn't that so, says Christel Fallenstein, a disassembly and reassembly, that could be it, I write back, everything's been vulgarized, everything ties my throat, and I sink down. I constantly mistype that's because my hands are trembling so much, *and I've got the thoughtfever*, and when the first snow came and the tilt-and-turn windows were thick with snow so that hardly any light could come in, namely, the snow gradually *slid* toward the bottom and no light at all came in any longer, I called the installer's wife and said, I'm freezing here in my flat, oh, she said, that's impossible, oh, it must be so warm in your apartment indeed hot enough for you to go naked, which excited my imagination, I've tied a turban around my body, namely, the two tips of my pajama bottoms, which had grown too wide, and I'm forever waiting for *some kind of magical particles*, and in the morning I already know if they will come that day or not, and I am now writing figuratively, stimulating to the mind, one is blissful one day after dying, these are all reasons for irreality, namely, that is the origin of tears, so Jacques Derrida, and we always had two

train from Moscow and we were amazed by the midnight sun and went over the Neva, and Wendelin Schmidt-Dengler was learning Russian words by heart and enjoyed translating all of the street signs, and Mia Williams writes me on a postcard with wolves, some Russians jump into lakes with the help of a rope hanging from a tree, and I wrote her back, I dreamed of the Bocca della Verità and that I put my hand in its mouth and it bit me because I had told a lie but sometimes I needed to invent a lie even though I was afraid, but, well, it happened over and over and I was surprised by how easily the lie crossed my lips, as if I were telling the truth, most of the time however it happened because I was afraid of telling the truth, it seemed terribly shameful to me and I just could not admit the truth, and Father murmured, *as (if) psychospiritual intercourse in the hand, and : how tiresome pulling up socks and stockings, instep too high, etc.*

Skilled afternoons and great need of the body, it's nine in the morning and I'm sitting in my work turban and behind the rolling blinds a glowing ball lost in the all, and EJ with his cap of light came toward me, and I put the Maria Callas record on, a sweet panic, a sacrament, young women carrying rubber bottles, eating is intimacy, and then there was a clatter of someone or other's feet but I didn't know, and into winter then back out of winter again and into summer then back out of summer again, into the lambs then back out of winter clothes again and into the lighter coats *the transitionalcoats* and out of the lighter coats again and into the vibrating colors of the spectrum on the wall above the lamp and from the right-hand side when, during the afternoon SIESTA at the camp, the winter sun's burning, eye-burning rays, and though I was never really a coffeehouse goer I catch myself going ever more often going quite happily to a particular one, I graze I graze my appointment calendar and look for a free afternoon to

be able to go back, and the change of seasons also has to do with my preference for a particular one, and clothes change so quickly you never arrive anymore. *Namely, fevered out my face of armor, three lit. yawning jackets in the atelier*, and the promise shall come, says Ely, and the coniferous forest on the tabletop and wonderful weather crystal weather, *ach, the fallow soul brushes me on to fantastic books, isn't that so*, my fingers get stuck between the keys. Ach, perhaps I should start with the later (late) Mozart in order to incorporate him better, my weak ear my ear spells out or counts what you say, I say to Ely, the vase is on the table, the breakdown of the glance, mad for walking, there at the height of Mother's head the land of holy cypresses, lit. nodding dog.

And I broke out in tears because I do everything for his sake, for Ely's sake, for EJ's sake, I can no longer get my bearings in the world, and everything is a burden, and I have always felt burdened by the responsibilities, ideas, fears, self-accusations and feel stalked by crass snapshots and was *torn apart by bird objects* and sink down and wiped the blood out of my hair, oh it's awful, I barely dare to step onto the street : *an illness of the soul*, I wonder, do I have an illness of the soul?

Repulsive foreign infantile, everything I've written up until now, I say to EJ, at the supermarket two Japanese in front of me in the line I say to myself, *I'd also like to be Japanese*, a glass of beer's been knocked over, the remote control underwater, the next day EDITH with a new piece, when I look below the camping table I see *Gertie's First Goat, Four Years Old, Gertie with Her First Goat in the Garden, Four Years Old*, I'm supposed to write a laudation for Kehlmann, my blood pressure goes up with the fear that I won't be able to write, *Thorsten says, pull out the tip (completely foreign) pull it out and make it your own!*, because I have placed the numerous Is in brackets, Christel Fallenstein says, monk-like, mysterious,

full of hidden panic, back then Sabine H.'s stay in Spain :
Valencia Granada, and I asked if she already knew Spanish,
yes, she said, a bit, I am so infatuated with this country, she
said that, in the background the Maria Callas record, then
out into the winter afternoon, like new life : new fantasies,
the lit. traces of bird feet in the snow, re-excitement, packing
Lebkuchen for so many trips, from trip to trip, but never eaten,
then at long last consumed, etc., I mean *the Godmeal*, the sky
looks imploring and I have a CATARACT in both eyes, I say
to EJ, Mother always said she would rather die than have eye
surgery, *Bashō hangs in the air*, ach, EJ says, we aren't socially
integrated, and in an interview Franzobel talks about his fear
of death and he says, I'm going to finish this text but then
I'm going to die, that was fascinatingly close to my soul, isn't
that so, and once again it had become morning and I had my
morning spices I mean I was sitting in front of the machine in
my house clothes again and could feel my heart trembling
because I could sit at the machine, and in my mind I saw the
wild violet in the windows vis-à-vis and the gleam of her
eyes, namely, collection : violet family with their pious faces
and in their speed, and a bud burst in my breast even though
it wasn't the right season and I heard Keith Jarrett in the
background and it was a wonderfully cloudy morning and in
my lap the scraps of paper warbled as I write as I move as I
sit, and it floraed all around me and I shook myself a beloved,
and Gertrude Stein says, when I am remembering this thing
I remember why am I remembering it, and I had just written
a page about the reopened Café Museum where EJ and I had
so often and so gladly gone, and then I was half-asleep and
half-asleep I observed how my right hand and in particular
two fingers of my right hand neared my mouth, and it was
my hand's movement that I brought to my mouth, namely, it
was this movement of the hand which wanted to bring a glass

Elisabeth von Samsonow writes me, cloudy with great wind, with ghosting gliding clouds I see you floating over the city in your attic of the world, at most, missiles and birds crossing the cut of window, I was so happy to hear from you, Elisabeth von Samsonow writes, your ether voice on the phone, Elisabeth von Samsonow writes, with an electrifying undertone as you were in your writing rage, etc., whereas with me the ink's still stuck in the canal, I am thinking of you, *how you're in awe*, I've planted honeysuckle and lilies of the valley, I've picked violets for you (= against coughing!) and for me Biedermeier eroticism, *Daffinger*, found a snake's head on the stairs to the garden, while I was sweeping the stairs a large black bird hammered into a window, I saw it three times up there on the last floor, and pulling out a tip, completely foreign, pulling it out and making it my own.

And then all the lights went out, and I could feel a standstill, that's when not a single word's available, although Keith Jarrett in the background, and I remained standing in the bluish palm room and last year's dried-out and dusty catkins against the wall, crooked and old and malapropped, and sometimes, earlier, in the early years, he wanted to provoke, EJ wanted to provoke, and EDITH came toward me with a word, that is she helped me with a word, she whispered the word I couldn't find to me, which really touched me, *and the appearance of tiny branches*, I say, namely, the violet's variety spectacle, and it has to do with nostalgia, I say to EJ, and I was all aflutter and on the tram I saw someone taking a bite of a large apple.

And I was sitting in the kitchen and felt her presence, I mean, I could feel that Mother was close, and my GP, though he knew she had been dead for nine years, asked me, how is your mother, which frightened me greatly, and because my hands

were trembling I no longer write letters by hand, I say to EJ, my handwriting atremble like spiderwebs, and I turned up the lights everywhere so that I would feel inspired, not only in my study but in all the other rooms too, everything needed to be bright, and my head was in flames, and my nerves were all aflutter, and in the background Maria Callas, and the place had boxwood hedges and the moss hung down from the tree trunks, and I will always be afraid, Gertrude Stein says, but in the end it depends on not refusing to be dead, although everyone refuses to be dead, and I say to her, I am now writing figuratively, and no sense of time disturbs me, and she looked at me quizzically, and I say to my old doctor, this medicine is inhibiting my writing, I mean, it inhibits my writing hysteria, that is, would it be okay not to take it anymore? and everything makes me uneasy, and Gertrude Stein says, I get worried lest I have succeeded and it is too commonplace and too simple so much so that it is nothing, isn't that so, anybody says it is not so, it is not too commonplace and not too simple, but do they know, I have always all the time thought it was so and hoped it was so and then worried lest it was so, etc.

This past summer I was in Bad Ischl as well and every afternoon I went to Café Zauner on Esplanade where you can sit outside and always chose a table close to the river so that I could hear it rushing while I read, that is, I always sought out a removed spot so as not to have my reading disturbed by conversations nearby, for I am easily distracted, I say to EJ, if someone next to me is speaking I am already distracted, I say, running into conscientious visitors is rare, which always annoys me greatly, *and that was the bloodiest, isn't that so*, and it was the writing, you can also call it *the godmeal* because you feel overpowered by a strange force, and you step into a strange word but one *full of halos*, and that doesn't happen whenever you'd like but depends on special conditions, and on

top of that you need an internally glowing being, that's how it is, a strange event blows open the everyday breast, and it is a copulation with the spirit, and it is an excess and a secret and then you've succumbed to writing and become addicted to writing, whereas in everyday life, I mean, in everyday life you don't have a lot to say, in fact, nothing at all, *and I am ablaze*, but then I am always enchanted and, sweet panic, in fact curious and MURMURING that is I am in a blissful MURMURING when it is Sunday evening, completely bewitched because of a very particular anticipation of the gravitation toward a new week, a bewitching week and all it will bring me, but once Monday's over, I say to EJ, the whole week is almost over and Tuesday evening already I begin to feel uneasy, namely, a rapid jog through the week toward its end, which is always the most deplorable thing because all the shops are closed and there's no mail and the pubs are unavailable, etc., it's pounding so vehemently, I've got waterfalls in both eyes, and the sky looks imploring, and the only one that's available is my café, my favorite café, I love it and it's noisy but because of all the great buzzing of voices most of the time you can't hear individual voices and thus I can dedicate myself to my reading undisturbed, but maybe I've already become a bit hard of hearing *and EJ with his cap of light came toward me—*

flapping about in front of my parents, just hanging on to my sleeves, I say to them, I'm hanging on to my sleeves like strings, yes, I say, pockets empty, and many bouquets, I say, behind the pub, Father says, and a snapshot as customary back then, I am wearing a green cap and green rubber boots, *the sofa carried off actually alone.*

EJ says, let me go on my own I want to go to the movies alone, let me go on my own through the nighttime streets, observe the unfamiliar faces, visit the movie theaters, the

bars, yes, I say, and drape my green arms around his throat, yes but. I plunge into his pair of eyes, scratch him raw with my glassy eyes and glassy arms with my glassy chest, this is the origin of tears.

And someone mumbles, I believe EDITH, and she mumbles, after we, EJ and I, had spent a whole day with her and she drove us back home in the evening, that was fascinatingly close to our souls, but perhaps I had behaved that way on purpose in order to provoke her remark, her observation, then my bloods rushes down to my feet, and nothing and everything happened.

A recurring dream : joint walk, and EJ suddenly disappears, looking for him, I wander through the streets crying, I cannot find him, and the memory of our summer trips to Altaussee and how EJ would spend the evenings in front of the TV while I would go to bed early but bothered by the voices from the television, would walk over to him and would he please turn down the volume, it happens multiple times throughout the night, mad for walking, seated woman with hood, namely, Matisse had just finished his *Bonheur de vivre*, his first big composition which gave him the name of fauve or a zoo, and the painter Rousseau was so timid he did not even have courage enough to knock at the door, so Gertrude Stein, *when Ely was feeling pensive he sat with his legs crossed*, funny that I am always so on time, yes, I come too early rather than too late.

Once, many years ago, EJ made a drawing of me, for in fact he had always enjoyed drawing immensely, we were on the train to Puchberg and it was summer and we were sitting across from each other and I had my reading glasses on and was devoting myself to my reading and EJ drew my portrait, and once he was finished he showed me the picture and I said, that's a nice picture but you made me older than I actually

and it was getting dark already, and I kissed his cheek and stretched and pushed myself up against him and lay my cheek against his own and he reached for my breast and *tremblingly caressed* and the tall bushes in the lit. side street enveloped us.

And on the stone from Crete stood *tout* and I broke into tears and softly said *tout* and I took the beautifully white and dark-gray veined stone into my hand and pressed it to my cheeks and it felt cool and smooth and I took a higher dose, and once I brought flowers, once I brought Gudny a bouquet of flowers, but in reality I always brought flowers whenever I came to treatment, I always brought Gudny flowers although the flowers : thanks were due the dentist but I brought them to Gudny, which always made her happy, and when I brought the flowers this time I had forgotten to take them out of the paper before handing them to her, and when the treatment was over, I said to her, I forgot to bring the flowers, today I truly forgot to bring the flowers, but she said, you did bring me flowers, I am quite sure you brought me flowers, she said, and I said, I am quite sure that today I forgot to bring the flowers, indeed it was unclear what had happened, but in my head the moment I had handed the flowers to Gudny was completely erased, and the water when it flushed spluttered KAYAK, the flushing water spluttered KAYAK and it was an eager rushing and I disappeared in the bathroom and I saw the two-year-old animal welfare calendar open to April and a rabbit standing on its hind legs in color in a meadow of flowers and I sat down on the toilet seat and wrote everything down, and pulling out a completely foreign tip, pulling it out and making it my own, and then it was a phantom and below the folding table was the photo *Gertie with Her First Goat in the Garden, Four Years Old*, and then I walked off leaving the light in my writing room on, then I had an eye meeting and the Apennines the agaves were lying in my notebook, and I

voice, to call him in order to hear his voice will no longer be able to be pushed back, and I sat crying in front of my machine without writing and looked in smaller and larger intervals at the clock while I deliberated on whether it was the appropriate time to call him, and then I catch myself writing on a piece of paper I WILL NOT CALL, but it does not help I call him anyway and I feel how his voice melts on my tongue *and that was the host* and I say to myself, what on earth could I give as a reason for having to call, were there any things that were important enough that I had to share them with him, and everything was incessant and dissonant, and then I remembered that we, EJ and I, were sitting together with Gisela Lindemann and her husband and she said to us in that she sighed, *what should I do with this pubescent son* Friedrich's got to take care of that, and Friedrich Lindemann showed that he agreed and smiled, he was a pastor, and back then I took a lot of notes but I never throw away anything I've written on, isn't that so, *lit. clover lit. honeyness*, and everything was rather captivating and once Klaus Wagenbach wrote to EJ, *now that the first tenuous success is looming*, and we were both impressed with the expression and I say to EJ, I have already read Gertrude Stein's *Autobiography of Alice B. Toklas* multiple times, but the last time I was disappointed because Gertrude Stein attempts to adapt her style to the figure of Alice B. Toklas, that is, it wasn't that breathless ceaseless hectic style I loved so much in Gertrude Stein's other books so that I began to wonder if I shouldn't give up reading the book, in the background studying your writing I know that you are warm and nestled, I say to EJ, namely, the seat of the bicycle that was leaning against the wall of the building protected from the rain with a lit. plastic tarp in reality SACKCLOTH, which surprised me, I had often seen it leaning against the door already, my reflection in the elevator going down, the

fur collar flipped around so that it was against the throat like
a raised collar and in a flash the photograph of a great-grand-
aunt comes to mind who also wore that kind of upended
collar on her fur coat when she was photographed and then
this photograph was treasured through all the decades until
it finally came to me, ach, sweet panic, a child does not forget
but other things happen, so Gertrude Stein, *and those were
the most incandescent things* that happened to me, and I say
to Bodo Hell, this is now my favorite thing to read, I said
that, but naturally I don't read the original but the German
translation as I excerpt ceaselessly, isn't that so, and Bodo Hell
said, I understand that well!, and then the call was over, and
I grew dizzy or suffered a fainting fit on the street and my
neurologist said, close your eyes and take a few steps toward
me, which I did but I was very unsure and he caught me,
and I said, since his death I don't have anyone else and I am
completely alone, and EJ said, the music of the 20th and 21st
centuries is jazz, he said that, *merciless*, I say to EDITH, I
am making a confession in my new book, and as we turned
into the Karlsgasse, Liesl Ujvary said, I don't have to stay
here, I can go to another country at anytime and live there,
and she began to cry while we stood in the shade of Boxwood
Street, etc.

Pantalones slung over the shoulder, enraptured I look
into the tiny living room carnations and someone mumbled,
these vulgarities—

from you I accept everything, I say to EJ, I am in
mourning, in this acacia world or maple, once again struck
with falling sickness, I say to EJ, unflashed world, namely,
the attacks of vertigo when I'm out, which really impedes my
movement because I like walking so much, perhaps it was an
illness of the soul, and I did not dare turn my head to the
side to see whether cars were coming because I immediately

became dizzy, and it was *an eyefrenzy*, isn't that so, and I was extremely frightened and trembling, nostalgia or what, and breakdown of the glance, I say, ach, all the coats on top of one another, the many tears across our cheeks, the many letters, and my feet want to leave the room on their own, *I have now philosophized my tapestries with your texts*, Linde Waber writes, and every syllable an oracle, Linde Waber writes, and then I took, while I was lying on my bed, I perceived the smell of an apple, on a plate in the middle of the table and someone in my dream said : blockbuster, but I did not know what it meant, and on 13 December 1989 EJ said, *fornication in the brain*, and *spirit as a function of matter*, he said that, and I said to EJ, *my idea was to write about nothing and everything*, and I say to him, animating passing water through the rushing of water splutter of the waterlines, burned lit. lip burned, I say, Gisela von Wysocki says, during your reading the image that you are an Indian and from then on she only wanted to address me as such, AND IT WAS THE HAIR—

miracle bird, was for the first time at the funeral of someone I hadn't known, EDITH says, driving me to Hubert Aratym's funeral in Lower Austria, and Christel Fallenstein mumbled, miracle bird miracle bird, there are agreements there where air butts up against nonair, mumbling in the tongue-woods, at the new moon felt unexpected power, in the middle of the endless, and one always asks for pardon when one writes, says Jacques Derrida, I've contracted an illness of the soul, I say to EJ, I mean contracted an illness through provoking emotions, and whenever I am excited my voice changes, and I always want to cause time to slow down but it gallops it rushes it emerges, and when I'm afraid my eyes get stuck, but I am too old and I am almost happy with everything, my quills have grown dull, I say to EJ, and Elias Canetti writes, life's greatest stress is not resigning oneself

to death, and in truth I feel completely lost around people, I say to EJ, and had dream and reality really merged into each other, namely, had dream obliterated reality so that I could no longer distinguish, no longer differentiate between the two : there was a text I had written for a reading and when I woke up I looked for it but only gradually realized I'd only dreamed it, and Bodo Hell and Reinhold Posch and I were sitting in an old pub on Lerchenfelderstrasze and the two were speaking wildly about *Kantians* and how the wildflowers in the glass on the pub table were the first heralds of spring and called them by their Latin names, and in a vague way I felt excluded although both of them are some of my best friends, isn't that so, namely, I couldn't follow, *and my blood pressure had gotten lost*. And then it was a phantom and Mary with the string of pearls and Mary with the vetch flower, and on an envelope *pourquoi* and my cheeks were too big and my arms were enough like slowly advancing shafts of sunlight into the left corner of the window, ach, I say, sweet panic, so white, I say to EJ, so warm and nestled studying your writing, and when I looked at the lit. red basket my eyes blinked green onto the writing paper, and standing up it suddenly occurs to me what lies behind 70, 75 years : Mother's reproachful glance when Father nearly smashed two of my fingers in closing the car door, and I had been careless and had stuck my hand in between, brutal, EDITH said, brutal, and maybe it was a favorite word one of the favorite words that EDITH had been using recently, and when I awoke from my last morning dream "*decimated pussies*" were wandering through the middle of my mouth, and I'd forgotten something in my cheek, and everything that was but is no longer there comes closer, and the young women carry hot-water bottles made of rubber around with them and taking a few sips on the tram, on the street, and the structure of everyday life rattles me and I take

and I had an EMOTION and emesis as I'd gotten angry discussing the everyday, that is, bristled against it, my whole body, my insides in conflict with what was happening, namely, it was a misery and my heart hurt and I was close to bursting into tears and shouts, that is, I had contracted a bodily illness from an emotion and began to grow hoarse and could no longer utter a word and felt horrible and my nerves were all aflutter, and then there was a clatter of someone or other's feet but I didn't know, and sometimes I also suffered memory loss, but on other days they would come, my memories, in great number and force and I could not resist them and I sat down at the machine and wrote down whatever was said, someone told me the words, someone dictated them to me, and I had to write them down, *Bashō hangs in the air*.

And it had to do with the angels' memoirs, and I dab against the sun rings, and my book has many witnesses, I say to EJ, begun with prayers and tears, and now I'm confessing it to you, I say to EJ, in this book I'm playing all that I've got left, down to the very last, isn't that so, maybe my feelings are split, as Jamila writes, as to whether these lines are of eternity or a moment, etc., oh and I sink down and my heart is tied and I wiped the blood out of my hair.

I am a divided subject, Bruno Gironcoli says, abnormally edged and coruscated, I am a helpless gesture, that is, indeed something like an autodidact, Bruno Gironcoli says, and called his drawings "relatively desolate drawings," folded into themselves and intractably smitten, he also loved situating his figures so that you can see the soles of his crouching figures' feet, some of the figures have put roller skates on, and on one of the pictures he calls *Design for Modifying Column with Skull* (mixed media on paper, 62 x 89 cm) you see a shimmering white bent lit. dog that's right about to do its business, namely, you can see the animal defecating *in that it*

is bent and mumbling, in the rose copse, that is, the face of a waterfall and in the growing light of the waterfall's repeating falls : dust or haze : that which falls a second time, and then the itching was over too and I emptied my coat pockets and there were old pieces of chocolate and transportation tickets and a lit. chestnut and it floraed all around me and I wandered in my thoughts to this or that friend and I chased after the respective birthday parties and leafed through books I had recently been given and, standing in the kitchen, took notes, after I had lost the courage of being able to continue this manuscript for many hours a day, and I had sat down on a kitchen stool and ruffled my hair, and then I wanted someone to drive me on and I said to myself, I need *a charge*, and decided to go back to my favorite café in the afternoon though I would just as much have liked to go to the Francis Bacon exhibition but I thought, I shall escape to Café Tirolerhof to dedicate myself to my reading, which I really hoped would inspire me, and I took out a few old notes and examined them to see if they'd be of use to my current work and I thought about EJ and Ely and that they were silent and that basically I had no one left who was close to me.

Everything affects everything, so Gertrude Stein, and writing's included and it's tough for everyone to go forward with any activity because everyone is disturbed by everything, isn't that so, and I see the horizon line when I look out the window the horizon line of the dark clouds and it is a clenched sky and my anxiety has increased so that when I decide to go to an event in the evening I prefer to take a taxi because it gives me a feeling of security, especially when I have to go to my own readings, and then a bit more of the path through the sun and my shadow runs ahead of me, and when Ely left, I caught myself asking him one question after the other, while immediately knowing his answers as well,

and I think to myself, maybe we'll see each other again at
some point, and my memory of him so vivid that the tears.
And my face in the mirror ERASED, completely erased,
then I went to my physiotherapist and she spread my hair
across the headrest and began to massage me, and while she
massaged me new thoughts kept coming and coming, and
I thought that my writing is a soliloquy, and that I keep on
pulling out new tips, completely foreign, pulling them out
and making of them my own, and the white horse had fallen
down on the street, in my dream the white horse fell, but
everything is connected to everything else, I say, everything
affects everything, says Gertrude Stein, and writing belongs
to that, and my shadow runs ahead of me, yes, my shadow is
larger than I am and seems threatening, that is, my shadow is
a threat, a guardian angel for the throat and a dress into which
the soul too can climb and that one can see how certain South
American doctors want to lure the soul back to its ancestral
home by waving clothes at that very place where a patient
is scared, we were together in a deep green mountain lake,
Elisabeth von Samsonow writes, and jumped, not that you
didn't have to encourage me a bit, into the same and we swam
like spaceships briefly and quickly like a flash of spirit through
the pneuma and everything was greenish bluish cool and fresh,
and you were wearing your characteristic black cap (instead
of the bathing cap) on your head, and it was beautiful and
the whole day glowed with the beautiful feeling of friendship,
so Elisabeth von Samsonow, and someone MUMBLED
something I think EJ, and then the itching was over and I
wore clouds of dust on my hands and feet and enraptured I
look into the tiny living room carnations, and Ely took my
face and held it to the light and checked if a scar remained
after the operation, and then he said, everything's all right
again, he said that and then he kissed me on the cheek, and

books loose garments jumpsuit *pantalones*, slung over the shoulder, and back then, in the early evening, after a lit. walk along the street, when he, EJ, no longer had the strength to make the few steps to the building and so stepped into a corner bar to sit, rest, a *Turkish place*, and ordered coffee, our eyes sinking into each other's, bag with swans. The orchard's body, we hurried after its scent, actually my doctors supported me during my madness, I say to EJ, so saturated with Dufy that afterward I long to paint like Dufy, write like Derrida, like a hall of mirrors, ach, how his white breath how I could feel his white breath walking through the streets of my city the one I love the one in which I love, I was pleasureless, I had no pleasures outside of walking reading and writing, and Reinhold Posch gave me a branch of ivy he had picked, with black berries, and there is something galloping within me and I can no longer come to a halt, wonder you all dance upon celestial origins, so Derrida, but the great connections the great meanings escape me and I sink down and my throat is tied and I wiped the blood out of my hair, and over and over again this, my geriatric view of things, *folds in the glass*, and EJ says, Raymond Chandler is my favorite writer, and I'm going to read a chapter from one of his most interesting books to you, it's really exciting, and he is one of the most important writers of our time, and I declared my doubts. And as we walked down the stairs Thorsten Ahrend said, Daniel Kehlmann's books are all reflections, and then a crow scooped past the window. We are sitting in the restaurant waiting on the young poets when Thorsten Ahrend says, he jumped through the window and I said hello to him with the words, I've read two of your books, one *The Farthest Place* sent my blood pressure surging, and my nerves were all aflutter, *and somatically what a year of soul*. I remember, he, EJ, always said, show show yourself show you want to show yourself you

IV, Chapter 5, Verse 10, and I escape and feel ready to take each and everyone's guilt onto myself as I no longer desire to differentiate between guilt and nonguilt, and now I am playing my last card, namely, the very last, I say to EJ, and then the itching was over too and I emptied my coat pockets and carried the moth-eaten suits, his, EJ's moth-eaten suits to the old-clothes collection box and it tied my throat, and whenever I'm excited my voice changes, and wool is woolen and silk is silken, so Gertrude Stein, and over the last few weeks EDITH has really accelerated, I say to EJ, and her life's taken on a rapid speed, and when she spoke I could no longer follow and understood only a few words, I was no longer capable of grasping everything that's how quickly she was speaking now, and an existential acceleration stepped in and I was really concerned, I caught myself thinking day and night, that is, in my dreams as well, about my book to be, *I was intimately linked to him*, and in all activities, and while I was walking, yes, even when speaking with someone, in the background a thought about my manuscript was always there, what was I supposed to do, over and over I ran to my desk and wrote a few lines, walked away again and went off to start the activities I had interrupted again, in my head a wavecrest constantly up and down and I could not come to rest, in reality all my daily actions handled as if of secondary importance, that is, there was only one important thing and that was my manuscript, only when reading was I a bit alert and concentrated almost solely on reading, but here too, in the meantime, I deviated and wondered whether I could use this or that word, this or that sequence maybe for my book to be, and I excerpted ceaselessly, at times too while reading gathered up by recollections and I had to think of dead friends and family members, which is to say they shuffled about my mental picture, between my reading and me, and I saw, e.g.,

a dead aunt in a silk dress sitting on the sofa, arms and hands in a strange crossed position, drawn to the left so that her left hand came to rest on her left hip like a belt buckle, isn't that so, but it was an old photograph, in general I was really *haunted* by old photographs, in fact, vexed, and as far as some of my recollections were concerned I no longer knew if they could be traced back to old photos or if they were original memories, a lot of yellowed photographs in cartons, caskets, and I would have loved to have the early photographs of my grandmother, who was a very attractive woman, in fact *fairylike* and with a magnificent head of hair—this have to do with nostalgia or what, I said to EJ, and the sky looked imploring, and it had to do with the angels' memoirs, I said, that is, I am of a Passion age, I say, and everything that was but is no longer there comes closer, and she had forgotten SOMETHING in the cheek, and I took a higher dose. And someone said to me *Schiller, Friedrich Schiller*, read Friedrich Schiller, then you can accept the job to write about BEAUTY, but everything at heart a puzzle, and Mia Williams writes, I'm walking past my Chinese fans and driving to Dortmund, *tempestuous ships on the Danube Canal.*

And my imagination *ravenous* and it is nine o'clock and I'm sitting in my work-turban and EJ with his cap of light comes toward me, and as the dove couple scurried about our feet and looked and looked at us with curious eyes and EJ began to speak to them spoke *at the moment, that is, momentarily* to them as if they were intelligent creatures while they scurried back and forth before our feet *at the end of the pulse and parks, etc.*, this pansy I think helplessly possessed with her devout faces in speed, the gleam of her eyes, namely, as we were sitting in front of the Künstlerhaus on a wooden bench and the thought popped into my head that I was supposed to call Mother, that I had promised Mother I'd call, over there, above

the street, the phone booth and now he was alone on the bench and how he continued to have contact with the dove couple, and when I came back we suddenly had enough of talking with the pair of doves and walked off and he hung on to me and stepped along and into the next bar, but that day the meeting with this dove couple had taken up something like an essential part of our awareness before developing into something like a fixed idea and I said to EJ, I've been thinking about that dove couple nonstop, and EJ said it was the same for him, and I curled up on my bed and lay down on my right side : sleeping side, namely, *if I were Mozart afterward able to write down everything perfectly, and it was a self-passion and* opening a friend's letter a strong smell of tobacco, a stream, and somewhere in my house I'd lost my right slipper, it had slipped off my foot and I could not find it again, and I had sat down on a stool, in fact, hunkered down, and I felt the desire not to leave my apartment that day EVEN THOUGH AND BEWILDERED possibly the whole day long in order to dedicate myself to writing, but I did not dare schedule myself in order not to question my ability to work, isn't that so, that is, *bewildered*, which had to do with a text by Gerhard Rühm that constituted the cohesion of the lit. piece of art, and I was in the asylum in grandeur that is the outermost version and I am ablaze and my blood pressure was up and I was vexed and then the blood rushes down to my feet and how all of these things are necessarily true.

Everything disheveled morning hours, I say to EJ, but the softest moments out the window into the open air in the early morning and how it chases one out staggers and shoos, and now we are standing there and you continue to speak to yourself, and everywhere my fingers covered in cuts from the metal foil around all the medicine I constantly have

five *globuli* every morning but the wound was still sensitive, I am suffering nerve disintegration, affliction, and behind the rolling blinds a glowing ball lost in the all, mountains of notes, wavelike hills of paper on my desk, link fusion of madness and self-exposure never before wrought so shamelessly, oh and I sink down and my throat is tied and I wiped the blood out of my hair, and the stones EDITH brought me from Crete this year are now on the floor so ordered that they remind me of the stepping stones over the lit. stream, summers in Deinzendorf, the narrow piece of parquet that's free corresponding to the narrow streambed, and so I tried, more than 70 years later, to balance myself from one stone to another, which was not without its tumbles, I flipped open my calendar and established that in the afternoon I was to meet Elfriede Irrall and Olaf Scheuring, which gave me a comfortable feeling, namely, a kind of curious anticipation, and in the late evening quite clear before me, a sequence of thoughts, but I did not write anything down because I was too tired, and by the next morning it had disappeared, and in the late evening I say to myself, oh, what a pity the day is already over again, and I write to Klaus Schöning, I would like to make something for you to realize in acoustical form, but I am very INSIDE my new prose so I am taking advantage of every minute of inspiration, while Maria Callas in the next room, *ach, the whirling dwellings*, I say to EJ, like swallows noctule bats can drink out of ponds and rivers while in flight, *while water surfaces without qualities lie around* (Oskar Pastior), while essentially the source arises, in reality Donaueschingen, while we were looking at the Donau (Danube), how and where it arises, while we touched the origin of the Danube with our hands while the blue bluish evening light enveloped us, geyser and hyacinth, while the oak leaves in a vortex floated down onto our lit. group, swished down, and Klaus Schöning

recited a Rilke poem, the litany as it were, etc., if only I had an endless piece of paper so that I would not always have to put a new one into the machine and lay the other one down, namely, *the outermost version*, isn't that so, namely, meditative immersion that frees from the rushing of time, and night's refreshment, and the rustling notes lay in my lap because no space on the folding table or else immediately buried beneath other pages—no navigation system, I say to EJ, I've discovered WOLS : WOLS : untitled and branch and flesh and the invention of night, NICKS ON THE JOHN, everywhere death work everywhere death area everywhere death sash, ach the death sash will strangle me, and in the blinds' dimness in the shadows : pecking hen or rolled-up rose petal, and in the morning EJ asks, what all did you confide in me last night, the litany as it were, I fell asleep in your arms completely exhausted I heard you say something but it's like it was blown away, I felt like they were important messages, the glacier shoes or Velcro strip, that is, he preferred to wear shoes with Velcro straps, his hearing had suffered, for the bracken, maybe cacti, in the hall window across the way, namely, the eternal flower bouquet so that I have to assume they are silk flowers, and on a tabletop, one floor down, well visible from my window a number of short sharply tipped colored pencils in all the colors that is as an offer of an unavailable dish, and something fluttered over the heads somehow, bird of death. Mother did not react to my questions anymore, her hearing had grown worse too, mostly with closed eyes and a half-open mouth, she no longer wears her dentures, today I forgot to put on the Keith Jarrett record—

and I write to Katharina Noever, all day long I staggered about as if absent, I did everything I have to do but absent, in fact, as if numb, and in the evening the poem was ready and I hope you like it, and I am ablaze and my blood pressure

was up, and everything changes and it is odd how everything changes, and it was Sunday evening and suddenly my notes became foreign to me, and I slunk around my writing cabinet as if I were on the search for something or someone, and I cast derisive glances at the piece of paper in the machine : HALFWAY BLANK!, and on the street I had another series of dizzy spells and I was afraid of simply falling over and no longer getting back up, but in the end I got home just fine and I was sucked to the machine before anything else and I began to make a clean copy of the notes I had written down at my favorite café, and I think one day I hung a large cage with a lot of canaries in the window but I didn't know where the cage had come from, that is, I don't have anything left over for any canaries, etc.

In the past I liked to hand out money even though I didn't have any, just to hand it out, and now I content myself with looking at the alluring things in the windows without any desire to buy, and I went through the Waldmüllerpark and there too I noticed a bicycle to whose saddle *a tiny tarp* had been affixed, like a rubber coat (half concert), I think, and Gertrude Stein writes, his (a young painter's) feet were very French or at least his shoes, I liked that and wrote it down, but it was in some way true that Picasso had an aura, in the café I saw a young woman with a strand of hair across her face, and she kept tossing her head to the side to whip it away, and went on trying, her left eye partially covered, to shake off the strand hanging across her face *and that was coquetry*, and we traveled to Rhode Island, to Rosmarie Waldrop, and we brought heavy bags because we, EJ and I, were completing a reading tour through America and we were exhausted and there was only one bed and we sank onto it and fell asleep immediately and that reminds me of another overnight stay, namely, at Fini's and that time too there was only one bed and

we were really tired and she had put a baby-doll nightgown for me on the bed and we fell asleep immediately and everything was extremely uncomplicated and enjoyable but the great connections the great meanings escape me and I sink down and my throat is tied and I wiped the blood out of my hair *and the room-grove reared*, and then I cried because all of EJ's friends and acquaintances included me in their admiration and affection for EJ and we were very happy and I had left home alone and returned alone once more, but I trembled as I wrote all of this down in my favorite café, whose variety of voices I really liked, and it reminded me of the voices of instruments before a concert begins and I read and read and many hours in my favorite café and it was well heated and full of bright light just right for reading and I excerpted almost ceaselessly, and the dog, the passerby, was white, WHAT IS ALL OVER, that is, I can only think visually, well, as you separate water air earth and fire, that is, obscene thoughts the ones that suddenly beset me and Robert Schumann put lit. crosses in his diary every time he had sex and I'd grown dizzy out on the street and was steadying myself against a tree and I looked like a moth creeping out of my black cardigan, namely, creeping over the tailor's countertop, which made me feel really ashamed, he was supposed to mend my cardigan as it had been devoured by moths and we got into a conversation, as we do whenever I go to find him, and it's always quite pleasant and friendly and our talk revolved around Berlin, which he had visited, and how it had blossomed over the last number of years, and a lot went through my sense and senses, so Oskar Pastior.

And I trusted myself now to openly display my aversion to certain people, which in the past I would not have been able to do, I mean, I wanted to be friendly to everyone, even the people I found unpleasant, because I always wanted to avoid

coming into conflict with someone or something, and that was nothing but self-protection, isn't that so, for a conflict would have hurt me too much and in some way distracted me from my work LIKE ROARING FROM WISHING— and I flared up and mumbled and showed my displeasure at having to continue to deal with unpleasant people, and I could barely write anything with my hand any longer because I was trembling, which I had not noticed just half a year ago, and now I could also explain why I just about constantly mistype on my machine and as if my fingers had eyes, anted up : they recognized the coins in my coat pocket, but then peculiarly alone too, *and how the painter El Greco elongated everything*, and Lili flared up then flared off again and is flirting about.

"I want to inhale your sun," so Brecht, buy myself a pair of shoes, you're like a shell, EDITH writes, I hear the rushing of the sea inside it, you're flighty, EJ says, and as far as Berlin is concerned (Tränenpalast), where we lingered, do you remember Kiepert bookstore, and *water myrtle*, and then it smells like Bad Ischl, I say to EJ, whenever I use this soap, the wind hurtling through me, blowing exposing the arms the sleeves the site, and I see olive trees, I see myself cutting through the olive grove, *I see the lit. condition*, Bashō hangs in the air. I was aghast I was excited reading a sentence in which Juan Gris appeared, it excited me immensely to read that name and I looked through the *Grosze Brockhaus* but there was only a lit. bit about his work "*painted still-lifes / this lit. corner of botany*," and I was excited, but it was pounding so vehemently, and Gertrude Stein writes, Juan Gris was a tormented and not particularly sympathetic character, he was melancholic and effusive but always clear-sighted and intellectual and he was often bitter and at that time he painted almost entirely in black and white and his pictures were somber and he created cubism—

the Cloud of Unknowing : in my dreams I was lying on a damp forest floor and someone spoke to me, I don't remember who or what it was, but there was a luxuriantly blooming forest around me, something like lilac clouds and dahlias and lupines and wisteria bushes and tall trees full of robinia blossoms waving, and I saw EJ ahead of me walking with rapid steps and though I called out his name he did not turn, he was hurrying to catch up with Wendelin Schmidt-Dengler, I called him I called after him and I cried but he didn't hear me, namely, what's written between my shoulder blades, and it smells of sacrament, etc. Psychospiritual intercourse, as the anthill in my hand (Buñuel) and enraptured I look into the tiny living room carnations.

I wrote to a certain Katja Riessner on 10/11/98 but I don't remember who that is, and I wrote, your card *The Monk by the Sea* : I saw the painting many years ago in Berlin, IN A SURGE, it played a role in the creation of my book *brütt*, I find it odd that you chose this picture, once I lived in Berlin for an entire year, something, maybe an insect, while I type slowly walking past the closed window, I could hardly decipher your handwriting, at the moment a needle lit. monkey and geranium weather, and it was a strange winter and nothing and everything happened, so Gertrude Stein. And sometimes these friendly exotic voices on the telephone, in the plaintive tone of a Slavic language, never remembered the name because I never really understood it, and the man keeps on calling, and using particular words, saying my books provide him with stimulation, and although it's always the same I listen patiently because of his voice, soft and shy, and in between the words he always coughs a bit, which I like, and I thought they were important messages, namely, the laceration of the sky, I have become alien to myself, and it was as if I were numb and I thought about him for a long time,

and I had cataracts in both eyes and the sky looks imploring, and I am ablaze, and I will be sad to pick up the last things that stayed behind in the hospital after he died, to hold them in my hands, and when we would go to the movies and the film was exciting EJ would take my hand and say, DON'T LOOK and once it was over, NOW YOU CAN OPEN YOUR EYES AGAIN, and once, at the zoo in Berlin, we saw a hare dragging a foot behind itself, he said to me, with a look, let him be, for I had begun to cry, and during dinner we played Johann Sebastian Bach's tangent piano and I was in another world, but I thought I would never be able to write again, a pointer and tears and my pen smells of Zechyr (Othmar) *braid of leaves*.

Today a single word typed into the machine : *santé*, but I will never know myself, recognize the unknown form of my self, and it is indeed that way, I hardly have a language with others anymore, just this interior writing language, it is already extremely difficult to talk with others, *to speak out loud*, isn't that so, when talking with others *always just a tip of truth the usual untruth*. And to pull out a tip, completely foreign, to pull it out and make of it my own, *and my nerves were all aflutter and I took a higher dose*.

Quickly before the sun shines onto the desk again, I should like everyone on the stage to be in yellow, so Oscar Wilde, this shepherd's speech, I say to EJ, I call Fredy K., tell him what I dreamed last night, the physiotherapist spreads my hair after I lie down on her treatment table and begins to massage me, we were at Reinhold Posch's and I bought three books, well, I mean, we bought a copy of the journal *Akzente*, Olga Neuwirth's *Ein venizianisches Arbeitsjournal* (Recordings from Venice) and Péter Nádas's *Own Death*, and I felt the need to begin reading immediately, so we went into a café and I started to read, and Reinhold Posch had given me a lit. branch

from the *rubber bottle*, lit. plastic bottle with Coca-Cola, and over and over hurried prayers on the street : I have to make it home my strength must last until I'm home, and on the street I hear someone say I NEED YOUNG FLESH, and I've made a strange observation, I say to EJ, namely, the appearance and subsequent disappearance of our poets, it's as if they were all holding themselves underwater and here and there one you know appears with a publication and then for a long time again nothing, namely, they disappear again, and in the meanwhile another poet appears with a new publication and all the world congratulates them and then they disappear again, namely, submerge, isn't that so, you no doubt also observed it, and when it was really cold and EJ and I would go for a walk how I always tripped on ahead, hobbled ahead because I froze so badly walking so slow, that is, I would walk on ahead and then turn back but he would be angry about it, or try to quicken his steps, and writing belonged to me, says Gertrude Stein, I know writing belongs to me, says Gertrude Stein, I know writing belongs to me. And in the next room Maria Callas, sobbing, and the room-grove reared, sometimes I said something sometimes I told a story or had the impression he, EJ, wasn't listening, or more frequently, he interrupted me, and when he spoke or began to tell a story everything he said was exciting and everyone would listen to him, and I was excited for I liked to listen to what he had to say, and everything made sense, but sometimes I wasn't paying attention completely, namely, those moments I wanted to write down something that he had said something I wanted to pay attention to or even use but without writing it down I would not have been able to notice, that's a sad reality, I can barely notice anything any longer, especially number combinations, and he was wonderfully inspired, and Masson's mysterious line had stopped wandering and immediately thereafter he

was lost, writes Gertrude Stein, and in cooing he took care of the walnut trees, and Ely said, hello, where do you think I'm calling you from? And in an exaggerated tone of voice I said, from really far away, wrong, said Ely, I'm in the bar on the corner, I'd like to see you—

and Angelika Kaufmann says, I've got to iron out my most recent pages iron out these wrinkled pages of mine perhaps they can be saved, ach, EJ said, we aren't socially integrated.

And when Linda Christanell came to where we'd agreed to meet she was pale and nervous and she called to me with a halting voice, *I got an electric shock*, and whenever Mother would go on a walk with her younger sister Helli, Helli would admonish her not to strike the sidewalk at every step with her cane, and Mother was stunned because she had not heard the cane striking the ground at all, she was so used to it, and around two years later Helli *fell out* of her blue silk dress and hit the ground dead.

You know that, *my cuckoos*, and in the meanwhile the room-grove reared, and I say to EJ, in the chaos of my room where every object goes under or is swallowed up, as if they were wearing camouflage, I try to accentuate certain particularly important objects, namely, position them so that it is easier for me to find them again, I even nail objects that will allow themselves to be *nailed* to the walls or keep them in *prominent* places, I've also attempted to point out those very things by means of signs and fingers so as to find them as quickly as possible, ever since using strong glasses my passion for reading half the day long has reerupted, and it is wonderful to sit in my favorite café and read in my favorite book or on my bed, half-siting half-lying, dedicating myself to my reading, I'm in another world.

As far as the reader is concerned you can't reasonably expect them to WORK ALONG WITH YOU as they

read, isn't that so, nonsense, I say to EJ, the only thing they need to do is find a comfortable place to read and then dedicate themselves to reading, that is, allow their reading to wash over them, to let themselves be inundated by the charms enchantments and allure : they don't need to make an effort— that's a misconception, isn't that so.

You know that, my cuckoos, around nine o'clock I fell asleep, Mother and her sister said they could not wake me up despite shaking so they were worried, my Lord, wasteland around me, nailed to the wooden wall of the rose cottage I felt like an empty piece of paper, ach, my Lord, I already renounce every similarity with myself, I prefer to crouch by the lit. *relaxed* lake, its name escapes me, *scartraces in the sky*— and stepping onto the street it smells of sacrament, ach, the oval writing of prose I falter in writing it down, isn't that so, kelp on the tongue, and whenever we spent the summer in the country we'd always say to each other, when we're back home in the fall let's reassess the FINAL THINGS, and we promised each other but never got around to it, hence my feeling now that we neglected the most important things the daily writing and execution of everyday things but every evening a lot of discussions, and jazz. My hands trembled and I had grown reclusive and I was swallowed up by myself and I could not open up to anyone, and my nerves were all aflutter, and Beatrice von Matt came up to me and said hello and I decided to go up to her at the end of the event to talk, and I was really attached to her, but after the event I escaped instead for suddenly I felt terribly afraid, and I regretted it, namely, I was both distressed and embarrassed : I really would have liked to speak with her and that's got to be said, that is, an internal reality alone was all I had left, external reality had been lost and I was upset, and the first winter flies accompany me when I go from one room to the

other, *and the Cloud of Unknowing trembled above me.*

A vagrant an advocate five parcels on the bed, and reading through the manuscript I notice what needs to be improved, then that begins to grate somehow, resists, and I feel there's another mistake, or some days not excited at all but flat and uninterested in seeing something experiencing something and then I know it's one of those days and I won't be able to write any farther, and the most wide-ranging feelings fits of rage too besiege me and I have to wait for a future day for the work to continue, and all the while the room-grove reared, and the sky looks imploring, and I don't have an inclination toward the esoteric, and Basho hangs in the air, and I am now writing figuratively, and Bodo Hell calls, I just thought about Basho, and everything that was but is no longer there comes closer, and everything at heart a puzzle, the lamb's atelier, I say to EJ, and I love to say "thank you" multiple times for all the blessings, it's so gracious, such a gracious magnet and it fills the empty room, isn't that so, and my whole life long I have had a stranger's gaze and it will continue to accompany me, so Péter Nádas, today it was raining and I saw the bicycle with the tiny tarp on its saddle again, up against the building, and it was a kind of reassurance, and Mathias Rüegg said, ten, when I asked him how old his daughter was, and I rushed home and EJ's glove was lying on the floor but I did not pick it up, for it comforted me to think of it there at my feet and I could see it any time lying there on the floorboards and I could think of him anytime I saw that single glove, and I said to him, I look for certain words in the *Grosze Brockhaus*, namely, I open it up over and over because over and over I forget the word's meaning, and once I've looked it up I write the word down and intend to put it in a *prominent place* in my household, but then I forget and when at some point the word again appears once again I have to open the *Grosze Brockhaus* and I get

excited about having been unable to grasp it to notice it and that's how it goes a lot of the time—but not just with that one word, no, over and over words I had looked for and written down, nailed to a *prominent place*, appear but it doesn't help and in the end I decide to resign myself and simply read over all those unfamiliar words and don't feel bad but take it in stride.

We were hiking, Mother and I, and where we were hiking there was shade and I was shivering and she said, would you prefer to walk in the sun? and I nodded and we took the ways where there was sun, and for my sake she exposed herself to the heat of the sun although it wasn't good for her, and her whole life long she sacrificed herself for Father and me and always held back, and Mother said, when I take out my dentures to clean them I don't look in the mirror in order not to get a fright, isn't that so, and up till the end Father was careful about his appearance, and he kept up appearances until the end, but I was unable to accompany him as he was dying—

when summers out in the country and she wanted to go out and needed a cane to walk well and surely instead of a cane she would take an umbrella and wave to me with it for a long time as I sat on the train back home, and though unable to see me in the window she knew that *I* would be able to see her, and she comforted herself that way, *and now my knee is kaput and I am sitting at the machine and in the background Maria Callas*, and I am sitting with two sources of light : sun and electric lamps, and when it rings : telephone or doorbell my heart skips a beat in EXPECTATION and I promise all kinds of things but then can't put it into effect, *namely, the valley head*.

And Helli *the middle aunt* said to me, you are growing more and more similar to your mother, she said, and when I thought I'd be able to pick up the *objects of desolation* from the office of the hospital where he died someone said to me,

we treat each other so roughly it's as if we were dealing with utterly unfeeling people," he wrote that down and handed it to me, and I was really shaken and thought that sometimes it was indeed that way, and I held back the tears. I eat quickly and I drink quickly and it's utterly deadly because I also make an effort to go to sleep quickly and then sleep through but am unable, I wake up multiple times, most of the time with the temptation to keep on reading my favorite book but then soon asleep again, over my book, and I take notes quickly and my hand trembles and I can no longer decipher the note as soon as I move to make a clean copy and the great connections the great meanings escape me, and once again it's far too sunny a day and the sky seems to be receding and imploring and it's like a spring sky, half past three in the morning when I swallow the insect together with the glass of water it really frightened me, it horrified me, and I wanted to spit it back out, it was my *Geibel service* and Picasso always hoped his youth would return, and I like to read internally not externally, so Gertrude Stein, and when you go for a walk you don't want to come back on the same path you took, etc., and I felt the need to write CANDLESTRAIGHT sentences but now and again there'd have to be an exciting unexpected sentence, a sentence, namely, shot through with electricity and my soul was aflutter because I heard Maria Callas in the next room, namely, I heard her sobbing and I broke into tears while the winter sun its slanted painful arrow against the eyes so that I had to close them and I was ablaze and my blood pressure was up and I dreamed "Ovidian cadences" and I was vexed and then the blood rushes down to my feet and it was as if I were numb, I shook my text and waited for further fruit but the time : the time of day was inappropriate and I had to wait for the writing thrust to come, and I saw the Atlantic covered with huge shimmering icebergs and I rejoiced and in a letter

Peter Pessl writes, I sit in front of the fireplace for half the night and stare into the flames and the whole winter long and I am sad because I do not know whether we knew each other in a past life already and whether we will recognize each other in a later life, but in 20 years I will examine your horoscope and trace you.

Then it's five in the morning I roll out of bed and walk to the machine, two hours later the rush is gone—

for a moment an airplane darkened the sun and I got a fright, yes even a bird's wing, and the storm on that November day blew open windows and doors and EJ asked, if we had never been friends would you have treasured my work just the same, but I don't remember what I answered, and another time he said, do you maintain such a close relationship with Lili because you count on that keeping her away from me : for reasons of friendship, and then he said, without waiting for me to answer, *we're too old to feel jealous*, and it's like a reeling (not a panel) painting, I say to EJ, I don't know which way to turn, that is I turn this way and that but the great connections the great meanings escape me, *I am only a vagrant on this earth*, isn't that so, and it's flying around the apartment, I say to EJ, and I've lost all sense of direction and I ask myself what's going to happen now, and the grapes in the bowl and a pale night butterfly above it, and EJ says, love displays itself in the everyday, and I say to him, I am now only an echo of this world, I am disengaged from everything, and the mind sees itself, says the eye doctor during the exam, and I wake up with the coldest feet, and then this dream flows into another that I've dreamed before, and I take a drink from the rubber bottle, and my nerves were all aflutter—

and to pull out a tip, completely foreign, to pull it out and make of it my own, isn't that so, that is I don't have an

inclination toward the esoteric but at the height of Mother's head a palm branch, and Ely and I exchanged a few letters but that was a long time ago, *and the intention to write collapsed* and whenever I can't write I'm an unbeliever, which means all of a sudden I can no longer believe in the AUTHENTICITY of my texts or I can no longer profess my faith, namely the razor-sharp cut flowers in the meadow, and to drink from the lap and I was bewildered and disturbed, and EJ said, I feel that death is near I think he's crouched real close by, and then the things that now have a place will no longer have a place, that is, they will be stray and everything that still has meaning will abandon us, the world and everything connected to us, everything that seems so important to our daily existence will suddenly lose its importance, isn't that so, the things around us, this empty wine bottle on the table, this bottle opener, this ashtray, this book : none of it will have any meaning, indeed, everything that had to do with us, and we'll become nothing but matted chaos, torn out of our flesh and tossed away, turned into trash, worthless stuff, and everything that surrounds us now, so meaningful so familiar, will be swept away, will be lost, will disappear, will never again come together in the exact same way, isn't that so.

And it was night already when I put the Maria Callas record on again and then Elisabeth von Samsonow called and said, when I gave birth to Gaia she cried bitterly thinking she had to die, landing as she did on dry ground from the water that had surrounded her and that was frightening to her and I was happy I had had *a normal child because I was convinced I could have birthed a lit. monkey*—

and it excited my imagination and it floraed all around me, and there were the objects there were the natural phenomena there were the people's voices merged together and Gertrude Stein says she recognizes the difference between sentences

and paragraphs, namely, that paragraphs are emotional and that sentences are not, and it takes a lot of time to be a genius, so Gertrude Stein, and you have to sit around a lot and do nothing really do nothing, when a bird flies into the room is that good luck or bad, let's say good luck, and I say to EJ, we did indeed want to go to Maria Josefa Park just like a year ago when the wind the leaves to our mouths and foreheads, and you disappeared behind a bunch of hedges, and pastured in the cemetery's cypress groves, bridleway.

In the meantime the piece of honey bread had run over onto the wooden plate, his white glove, the right one, could no longer be found, his all-weather jacket or hunting jacket hung lifeless on the wall, his wovenshoes covered in dust on the shelf, I am mad for walking, I wanted to describe these rags : red flower petals on the tablecloth, I hear the yapping and ringing in the dahlia cove, and then there was a clatter of someone or other's feet but I didn't know, and everything that was but is no longer there comes closer, and in my lap the scraps of paper warbled as I write, as I moved, as I sat, and I took a higher dose. And there is something galloping within me and I can no longer come to a halt, *you know that*, *my cuckoos*, wonder you all dance on the source of the sky, Derrida. A collection : pansy family this pansy I think (helpless) possessed, with its pious faces, in its speed, the gleam of her eyes, like primulas, phantoms, at the end of the pulse, parks, and I often did not understand when EDITH said something to me because she spoke so quickly *rapid or rushing* so that I could barely understand what she said I mean most of the time I grabbed after one or the other word that I had understood and expanded the rest in my mind or I said EXCUSE ME and then she had to say everything again, and sometimes I thought that maybe I had grown hard of hearing, and I decided to visit my ear doctor, and I remembered my

mother's final years she had good ears but *from one day to the next* she had grown hard of hearing and I was really shocked and moved and had a deep sense of sympathy because she often did not dare to say that she had not understood what I had said, and I said to her, BUT WHAT DO YOU MEAN, you've always had good ears, but she just smiled at me and I saw that she was embarrassed, that is, she was suddenly ashamed of her hearing loss and because her eyes no longer worked all that well, and then she said, write with a dark pen, which after that I always did. She had always wanted to enjoy a deep understanding with all the people around her, and a few days before she died she was off in her own world and I think she only had an inner reality and she lay there with her eyes closed, and at the height of Mother's head a palm branch, *the razor-sharp cut flowers at her wound. (In the corner the Labrador with the first lady)* : newspaper excerpt.

At Albertina Platz it smelled of horses, there's a *fiaker* stand there and the horses wait until someone comes to be driven through the center city in a lucid *fiaker* fever, and I really like the smell of horses and sometimes it made it all the way to the front side of the opera house, and I was distracted and placed one foot in front of the other and went to my favorite café and suddenly the sentence EATING IS INTIMACY, and I can identify with everyone and everything, that is, I constantly overflow and am faithful to all and none, isn't that so, *snakes and gold and lice*, I heard that on my way and I winced, namely, the fly had landed on the back of my hand, and I am now writing figuratively, and I let myself be carried by my language as if bucked onto great wings, which is my secret, and it would carry me into the air but I don't see it and it's got to come on its own, and when you read a book everything stands still or when, e.g., I am in Bad Ischl in the summer and take a walk in the woods there

everything is also still, but when you are inattentive for only a moment, that is, distracted, I say to EJ, the hours the whole day passes and all of a sudden it's September and then all at one go and when it's All Souls' Day the whole year is fundamentally over already, but I haven't yet understood how to let time, in fact, stand still, and then you're not so lamentable and that would be *a mind defiance*, etc., and EDITH calls, this year has gotten stuck in the sign of Mars, and it's good that it's coming to an end, for it was a year full of personal confusion and difficulties and struggles, externally and internally, and Max Ernst says, *as if one could dream the gates of the sea opening—* and the young cut flowers razor-sharp cut flowers on the set table and on the stone from Crete the word *tout* and I broke into tears and ceaselessly repeated *tout* and I took the beautiful stone into my hand and pressed it to my cheek and I leaned against the wall and I see the wandering starlight, and I am now reading Gertrude Stein and Jacques Derrida exclusively and I read them over and over and come to parts I know very well already and sometimes have learned by heart, and I can only think visually, and I am no longer used to tenderness at all, and in the meanwhile it appears to me to be an effort, isn't that so, and I almost knew nothing else, that is, what I was aware of had shrunk to a minimum, but someone probably told me or I had looked at a photograph for far too long I looked and then it was as if I had experienced it myself.

Summers I sat in *Zauner's coffeehouse garden* and I sat there the whole afternoon with a book I read for hours and I kept on hoping to get a quiet woman to sit next to me one who wasn't engaged in any conversations but reading a book or a paper, but that only happened rarely, most came in order to talk, that is to have loud discussions, and I was easily distracted and then I had to put my hands over my ears to remain undisturbed, and around the corner was a car and instead of

angels' memoirs, that is, am I of a Passion age, and EJ did not like his meals to be hot, and me on the other hand very hot, especially soup especially coffee especially breakfast and tea, and he complained when I served him his coffee hot, and he had to let it cool down, a breeze, I say, give it a breeze, and it was a flurry of thought, and there was *a fissuring of the forest-asylums*, and I am attached to nature, like Mother, she was always attached to nature to a large degree, and she had a passion for picking large bunches of flowers and then she would hold them pressed to her breast, covering almost all of her softly pale face, and that was a moving image, and there's a beat in the bushes, namely, finches and when I began to write, so Gertrude Stein, I stopped thinking about anything, what good is it thinking about anything, and from then on our familiar life continued, and misfortune is assigned to me, and the flyer boy hurries up the stairs and I wonder about the contour of my book to be and which movements have been displayed, but I don't see it, and I take long walks to see it but I don't and it's got to come on its own, EJ says, following my work, and to pull out a tip, completely foreign, to pull it out and make of it my own, and there were the objects the people the animals that turned into words and sentences and paragraphs, but why did I read so little in my life, that is, why is my reading filled with so many lacunae, is it because I have always read the same books two, three, how many times until I almost know them by heart, and when I went back to the area around Kahlenberg Hill, after 50 or 60 years, and everything looked the same as I remembered : slope and liverwortmeadow and wild cherry tree and the fall of the spring wind, and for a moment an airplane darkened the sun or a dark bird's wings, namely, violet's variety spectacle, I say to EJ, and the structure of everyday life rattles me, and I said to Michael Turnheim, I have been reading Jacques Derrida's

correspondences begin before dissolving and dissipating just as the ones before, and that's how it goes throughout the years, the decades, and suddenly there are mountains of letters and you don't know what to do with them all, *and bury them*—

and the wrinkled hills in the distance and the shrubs in the morning mist have a special smell and the oriental lilies that Ely brought me, back then, opened their buds and gave off an enchanting scent, and we sat next to each other on the side of the bed, back then, and he said, I'm in love with you, and he tapped softly on my naked sole, ach, outermost frame, and nothing and everything happened.

He, EJ, was completely dazzling to be this one thing, namely, he wanted to go back to being a prepubescent, that is, he did not want to have any more problems with what came thereafter, and he said, I was an island as well as a country, and I drank out of the rubber bottle and drank too much Coca-Cola and I had a bout of vertigo, and I did not trust myself to go out of the house so just sprawled about and a matte screen was shoved in front of my eyes as if I had a high fever and my vision was blurry and I slid across the bathroom tiles, feeling shameful, and over and over this geriatric view of things, isn't that so.

And in the '30s my parents had a *Talbot*, and I remember it, or saw it in a photo, I was standing in the car and stretching my arms and Mother was sitting on the running board in a checkered knee-length silk dress, pressing a bouquet of wildflowers to her chest, and my father was standing a few steps in front of his car with a cigar in the corner of his mouth, *sated* and stout though the times were bad, and whistling Father whistling, whistling to himself, and me sitting under Father's desk, me hiding under Father's desk and crouching there for hours, and then Father taking a photo of me, in a white dress, but at the moment Father took the photo I had

turned my head to the side, and one could see it in my hair, which formed a veil across my face, and *everything that was but is no longer there comes closer*, and it is as if you see things in slow motion yet quick at the same time, and the oriental lily in the hall has now opened all its buds and it is giving off a benumbing scent—life's wasted and wild and helpless situations too, and back then as well as now, *Grandmother as a bird at the window, isn't that so*, and then everything made up, and I reject the demand for humor in the fine arts and, ach, how time forces its way into the soul, and the aura in the next room, the tearful song, and it was as if I were numb—

we were both eight and anemic and I was sitting with Lore in the large wicker chair in the hall and Father took a photo of us and Lore pressed up close to me, and I could not get any air and she *lured* me into BORROWING SALT from our neighbor, which we then spread throughout the stairwell, and she already knew a thing or two I had no idea about for I was a sheltered child and could not understand what she was trying to teach me.

Loud Rembrandt on the street, amid April amid clouds of angels (James Joyce), and in the distance the wrinkled birds, and Mia Williams writes, I'm doing well I'm not doing well, and today we were in the Prater at the Lusthaus, the chestnuts were blooming and their scent filled the air, and I am always beyond, and I do not know what the next day will bring, *and I had a powdered mouth, and it floraed all around me and I shook myself out a beloved.* And I say to Ely, your women are all a copy of you, they do everything just like you do, they all walk like you walk, they have all adapted your way of speaking of looking of nodding, it's preposterous—

and the cut flowers *razor-sharp* on the set table, and in a dream I went on a walk with A.O., the poet, beneath a

canopy, and he was supposed to read a text of mine on the radio and I said, but with you it all sounds a bit too humorous, though he was of a fundamentally melancholic nature, which he agreed with, etc., and I waved back multiple times when we said goodbye, but then everything dissolved, I mean, he was no longer there, I mean, in this bloody spray of water, behind the white lamplight *between the Tuileries, and I received the kick the lift the HIGH VOLTAGE* when I wrote "the cut flowers razor-sharp," and I wanted to put on some rouge but I was a bit clumsy and the saleswoman in the perfume section said to me, you didn't apply it well, come back again with a bit of time and I'll do it for you, and A.O. says, just the idea of the presence, although spatially distant, of another (writing) person affects my work, presses oppresses me, causes angina and reduction and you feel like you're being spied upon followed controlled targeted, isn't that so, while the room-grove reared, alfalfa and stock flowers and at the edge of the woods we discussed the title of the new book, and how sweet such lit. attention keeps us alive, so Oskar Pastior, and in the distance the wrinkled birds, and once again there was blood on the dining-room floor and the remote control was swimming in water because one of us had knocked over the glass, and we, Ely and I, exchanged a few letters and it was a long time ago, and I said to him, give me my letters back, so that they wouldn't be in the wrong hands, once, but he did not want to return them, God only knows what he intended to do with them, later, and beneath the folding table *Gertie's First Goat in the Garden, Four Years Old*, and I am now writing figuratively, and I've got cataracts in both eyes, and the sky looks imploring, and for a moment an airplane darkened the sun and I got a fright, and Michael Turnheim said, I see my heart as a ghost, and Daniel Schreber, on whom he was giving a lecture, said, *I've got a Jewishstomach*.

I waved back to him, EJ, as if his shadow had at least been visible, I always waved back one more time, looking at the place where he had been but was no longer, though just a few minutes before he must have been just behind me, I waved to him with an empty plastic bag in which the wind had been caught, the plastic bag, namely, expanded in the heavy wind so that I had to hold on to it, that is with this my empty plastic bag in which the wind had been caught I said goodbye to him who was no longer to be seen ("only from a distance waving / Mexico...").

And I remember he, EJ, had always said, show show yourself show you want to show yourself you want to show what you've done what you've written, I always wanted to show what I'd written, he says, as a kid already, I would run to my mother to show what I had written, ach, the revelations exposures, he says, it's like noisy snow, namely, my writing : has become the disclosure of my self, isn't that so.

And I remove the woolen glove from the windmachine, and on a piece of paper find the words *deep illness, icons, allergy, mimosas, Kanal 25 Arte, the moon's red ring*, and to pull out a tip, completely foreign, pull it out and make of it my own, and I have played the Maria Callas record so often that I can hear the music in my head, I left him a note that said : Schönbrunn : get off where? Dinner ready, and I hoped he would find the note and write his answer for me on it, then a dove on the windowsill, and I thought the dove was him, for the illuminated trash can, and a dog's head in the trash the head of a dog quite clear in the trash the white pointed ears, I think, a German shepherd, and then I put on the Maria Callas record once again and then she spoke sobbing on the record and my nerves were all aflutter but because I liked this sequence toward the end of the record the best I had to play almost everything over again, and that tragic aria would not

leave my mind and I heard it ceaselessly in my head, and then the genius composed of many suns appeared with a melting bouquet of flowers, and the tireless pink of the music drifted over to me and I knew it by heart and it followed me in my sleep and the next morning I awoke with it, and I sang it to myself, and there were wings roses and the rambling longing I felt thereby, *and not a single piece of paper stirred, and when will I see you again, I said to Ely*, and I sink down and my throat is tied and I wiped the blood out of my hair, and ever more often I am anxious that I have unlearned the entire language, lost, forgot, and the most important thing when reading is, I say to EJ, to write down everything that strikes you, *and as if I had been underwater drowned in language, but everything's pounding so vehemently*. I had begun to write this book at the end of August and now it's almost the middle of April and I still don't know how the text should end, and I thought I had done everything wrong and was close to giving up but then decided to keep on writing a little longer, but if I do not find an end what should I do then, I asked myself, and began to tremble with anxiety, and Bodo Hell says, there doesn't have to be an end, Morton Feldman's compositions don't have an end either, isn't that so. Alfalfa, stock flowers, Bashō hangs in the air, and Bodo Hell calls, I just thought about Bashō, *and it's such a catharsis, that is, the effect of a tragedy*, etc.

And I thought about how many anniversaries and holidays and completely normal days I'd seen, how many anniversaries and holidays and completely normal days had already repeated over the course of a year and I'm afraid that it all will not be allowed to repeat much more but that soon, all too soon, an end point will be set, not by me but by my nature, and so I registered all the smallest and most insignificant hand movements and followed everything I did or remembered with the atempt to immediately formulate it all, that is, transform

my kitchen, you see, I once was forced to hear how they scream when you kill them, they scream like lit. children, and it was horrible, and the cut flowers *razor-sharp what a form of magic*, and then there was blood on the dining-room floor again, what edification or catharsis, the cut flowers razor-sharp on the kitchen stool, *and you know that, my cuckoos*, I am mad for walking, and I am now writing figuratively and I have cataracts in both eyes and beneath the folding table *Gertie's First Goat in the Garden, Four Years Old*, in a white dress and with corkscrew curls, and as far as the end of my book to be is concerned, I say to EJ, I have always had difficulties marking the end of my books, isn't that so, but how and when does the end of a book indeed take shape, I ask myself, I say to EJ, I think it was always this way, the end of a book came when my strength was gone, *namely, how sweet such lit. attention keeps us alive, Oskar Pastior*, and for a moment an airplane darkened the sun or it was a large bird.

Exaltation… this dangerous screaming state and EDEN WILDERNESS—ach, reading Bashō!

Is there an option but the umbrella manager the umbrella maker in my dream, and when I woke up I felt a tear on my right cheek and a pressure on my bladder and I was soaked through and I changed my pajamas and I wanted to continue writing for all eternity for if I gave up now what new things would I write, I would not write anything new, I would not risk starting something new, isn't that so, and when Ely came to visit me today there was a new, tough manliness about him and while speaking he kept on closing his eyes and lifting his face, which had something tragic and dramatic about it, and he said, the light in this room is very white and covers the paper like snow, it reflects as if the room were full of snow, do you see it's like loud snow, etc., and he had lost weight

and looked very passionate and when I asked him how he was doing he said, I've got a girlfriend now, and I felt completely removed from him, and he had become a stranger, and he looked devoured, and my blood pressure shot up and I was aflutter and my heart began to race and on the phone he asked, have the oriental lilies found their way into your text? and I could not remember and said, no, but they had, and I rationalized that by the fact that I had said they were TOO beautiful to find a way in though they had in fact found a way, but I did not remember or I did but too late and I dreamed of a stay in the mountains and on the back side of an invoice pad I sketched the area with mountains and an arm rearing out of a mountain and I wrote a pair of lines underneath, which I no longer remembered either, and I cried I felt like crying because everything touched me so, and then I saw a child riding an immense horse and it was a lit. girl and she slowly glided down to the ground, the horse was so tall and she was attractive and she was wearing a suit and riding pants like an adult and then I took another tavern invoice pad and wrote something on it and I had cried myself wet and soaked through and then I woke up, and it was six in the morning and I wondered whether I should go straight to the machine or keep on sleeping, and the room was warm because I had left on the heat and I decided to get up, and two more blooms had opened on the oriental lilies but the others had faded and I quoted Roland Barthes from memory and in my head the melodies continued to sway, namely, the singing on the Maria Callas record and the woods in my dreams looked exactly like I remembered them.

Bashō is purifying, I say to Bodo Hell on the phone, reading Bashō is purifying, he answered, and I said, I just thought of Bashō now too, and I said, Bashō hangs in the air, and I've decided to read Bashō again, and Bodo Hell calls

to say, the season is burning up because everything is full of splinters, everything is full of splinters because people are so agitated and, indeed, everything is agitating and agitated, and one can see splinters lying on the ground everywhere, namely, the streets full of splinters, *Buster Keaton films at the film museum*, a pool of blood on the dining-room floor, and I find a note on the table that says, *buy the complete Bach*, and I remembered having written the note a few days earlier but up till now had not had any time to get all those Bach records—

in my lap, as I sit in front of the machine, in my lap the many notes, with their help, I say to EJ, with their help I hope to continue to write forever, and the requirement for writing a poem is that you are mad and that you start without any aim at all, and I am old today, and the world is like a poorhouse, I say, and it is a completely indifferent world, for most people do not get used to differences anymore, and there's a whirling in my head that is the winged roses' rambling longing, and it drives me away and sometimes I think I am already standing before death's doors and soon I will know if there's an afterlife or not, and what will happen with me, and I brooded over my end, and as he was leaving the young photographer said to me, I often see you walking past my building, and I say, why haven't I seen you when you live so close by, ach, he said, you stand out, you stand out to people when you walk down the street but I don't, I am completely unremarkable, his name is Marko and he is nice and he wears spats, I think, and his girlfriend pumps, and as I was crossing the street a snow-white dove flew in front of me, yoga pants leggings on her red feet, I say to EJ, suddenly in the morning when getting up I had to think of a dead person I had not thought about in years, I'm still tired, I light a candle, swallow my breakfast with a lot of honey, three, four spoons of honey on milk bread / stollen, and in the distance the wrinkled

hills. Early this morning I heard the roaring of the wind in reality organ pipes, and caught myself, the fact that I prefer to live in the future and not the present, on the parquet I saw the AZORES but just a moment, *electrification on top of mountains*, I've got the stuttering sickness, I write on top of a camping table, Ely arrives with wet shoes, I stuff his wet shoes with newspaper, my sleep is unquiet, something rustling in my left ear, fly, an earworm presumably, I imagine my doctor with tweezers, extracting the intruder, oh, my throat is tied my nerves extremely tense, sleep impossible now, I had gotten lost in the woods, then in the silverwareroom, the great connections the great meanings escape me, etc., today I felt the impulse to express the rhythm of the visible world, but my nerves were all aflutter, and once EJ said if he had been able he would have chosen promiscuity as his preferred way of life, and I say to EDITH, this problem, will he solve it, and I woke with the words YOU REALLY ARE A CRY DOG, and EJ gave me a grass pillow and he said, for good dreams, and a strand of hair lay across my notebook, garland perhaps, and my former editor said, I like your new manuscript (*Stilleben*) : it is *unagitated*, and he, EJ, is attached to nature, his face always utterly see through, utterly readable, I could indeed read every emotion from his face, I could read his face, in photos of him I could read just what mood he had been in at the moment the photograph was shot, that is, everything was so transparent, namely, as the foundation of my piety, etc., and after EJ had died Samuel Moser wrote to me, *it pulls one's fingers together the feather becomes fist, this death*, I however always wore a mask so my face was mostly indecipherable, and all of my tears of love. His left leather glove beneath the wardrobe, it is his left hand, and in the bare trees and bushes empty dirty plastic bags from the storm, the bicycle again by the front door and on its saddle a tiny tarp, and I say to

EJ, the steam from the clothes brush and my strands of hair press over my mouth while you kiss me, experience of touch so that my hair strands receive your kisses like veils between our pairs of lips, alfalfa stock flowers, the genius composed of many suns with a melting bouquet of flowers, and in the distance the wrinkled birds... Psychospiritual intercourse as the anthill in the hand (Buñuel) and enraptured or ecstatic I look into the tiny living-room carnations, namely, what's written between my shoulder blades, ach I haven't been able to write in a long time, I say to EJ, then I found a letter dated 27 April '87 from an acquaintance whose name I can no longer decipher, he was one of those people who during the '80s would write me constantly and whose letters I could only answer seldom, and at the beginning of the letter I found Elias Canetti's remark, most of all you'd like—how humble—literary immortality, I liked that, and at the same time I found one of Mia Williams's letters where she writes, the moon comes and goes and I can go mad in any other country as well, and next to it on a note, *we're driving into the southern forests and the ruins of faces are all over the place.*

It had grown late and I fall asleep at the table, I fall asleep in the armchair and am too tired to get up and go to bed, and between the floor tiles the tiny death's-heads in the bathroom, I say, desire for rapture and sometimes the refusal of thought, I left the house without having tied my shoelaces and someone on the street said to me, don't fall! *and she's supposed to say hello to me unconsciously, that's according to Lenchen*, and I broke into tears, and on that misty gloomy day I was getting closer to the center of writing, and I receive the verbal hallucinations, party in the lit. fir tree forest and pulling out a tip, completely foreign, pulling it out and making of it my own, and nothing and everything happened and I was at the end of the pulse (and parks), *namely, the most fiery*

French things, says Gertrude Stein, that is in order to replace lilies of the valley as a decoration, and then I tried to recall EJ's telephone number but I only got to the third number, at the third number I got stuck, and then I stopped thinking about his telephone number and stretched out on my bed and wondered when and how I would continue to write, and it was a cloudy day and as if made for me to continue my work, but I was absentminded and distracted, distracted in various directions and I asked myself, why can't I just concentrate on one thing, and in my head everything hopped about here and there and through one another, namely, the appearance of that déjà-vu, I say to EJ, wouldn't that be an indication of the fact that we have walked this earth innumerable times and in the most various forms, isn't that so, ach, I say, I can't believe it and I am lacking the power of imagination for it, I am only afraid, I more or less am only familiar with fear these days, the fear of death, being afraid of death daily and hourly is a terrible state, I say, nothing to be done, day and night nothing but the fear of death, who can understand that, who can take it, *the cataracts in my eyes*, I took an empty armchair to be a person, I learn from every sentence I read, and in the distance the wrinkled hills—

on occasion, EJ liked to say, that's a practical joke, he said that, but I did not remember what kind of occasions they were, and I did not understand the meaning of the expression, but I did not ask him and it was a game between us, and later I too used the expression without knowing what it meant, from week to week my light sensitivity grew worse, and that was also one of the reasons I rejoiced when the day began to grow cloudy and the whole day remained cloudy, isn't that so, when it was clear there was sun and I was blinded and aggravated by the rays of the sun that shone directly onto the piece of paper fixed to the machine so I took the machine and looked

for a shady place in the apartment in order to keep writing, and I said to myself, *my goodness*, and I said to EJ, *a polished lamb in the window*, and then I said, a maple leaf has drifted through the window, and again I felt feverish with the zeal to keep writing, and some days the time to write shifted from morning to afternoon when it began to grow dark outside, and I received the double glimmer of light, on the one hand from the room's plafond, on the other from the blinding glare of the sun in the corner of the window, but it was all made up, and there was a drawing of Maria Lassnig's, an apple in the middle of a rustic table with a white tablecloth and you could see the bulging grooves where it had been folded after being taken off the laundry basket and then unfolded, and the young cut flowers, namely, the razor-sharp cut flowers on the table's outer edge, but it was all made up and in the morning the fledgling's eye in the mirror, namely, my ugly reflection.

Then we saw the wild roses in bloom, I mean, we talked about them and then we saw them too and to us it was like wandering across wide expanses of snow, then we heard the cuckoo crying and heard the tearing sound of fine silk, namely, the strongest and most unexpected sound and with tradition and freedom one cannot be intimate with any one, says Gertrude Stein, and that's how I see my old doctor, she was not intimate with any one but ready to help at any time, that's all, and I say to EJ, maybe being able to write is a searching with closed eyes, and EJ confirms it, and I found a note with the handwriting of my oldest aunt, and that handwriting is similar to my mother's, and I was surprised, and then his monogram is still on his old handkerchiefs and washcloths and on the edge of the sink a red child's foot so small two red-painted toenails and I could not explain where the lit. child's foot came from, and it reminded me of Antoni Tàpies's foot and in the distance the wrinkled birds, *and then began to pee*,

fish shop, and the area smelled of fish and I could barely take the fact that it smelled so strongly around my grandparents' shop, isn't that so, and out in front of the shop I would jump from cobblestone to cobblestone but I would always avoid their edges, and my grandmother would feed me with lit. rolls of ham, and my childhood was a happy one, two lit. feet moving forward.

My ultimate faltering soul, at some point from somewhere I picked up this heavenly language, but now at my age at times it moves away, appears to me like a foreign language and then I have to put myself into a trance in order to use it, namely, proximity vertigo quick Jesus on his team of roses, and Mother complained that her eyesight was constantly getting worse and she said, it's because I worked so much by hand when I was young, so much embroidery embroidered pictures and handbags, and because I cried so much my whole life long I cried so much, that is, it truly was a life full of tears all my tears of love, on the other hand I always wanted to be a little happy but that rarely happened, just like Gertrude Stein writes, the generation that fought the war can no longer laugh, and maybe the only generations that can are the ones that don't know a thing about war, *they can still laugh*, *isn't that so*. And outside the sky is turning grayer and grayer this afternoon and I say, how beautifully dark the sky, I say that to EJ, the kind of weather for staying at home and writing, isn't that so, or going out and walking through the fog, strange enough, I say to EJ, but remember I've arranged a reading with Marcell Feldberg for 2005 though I cannot predict whether I'll still be alive.

Such a creation of the sky's poets, and I call Heidrun Leoper and say, I see you walking through the woods and leaning against a tree and leaning on the tree for a long time

and then you let go and move into a crouch and then sit down and look into the top of the tree, and how everything is bright green, isn't that so, and then she talks about her grandson Leonhard and says, he's only three but already understands everything and grasps everything quickly and precisely, and the children of this world are born and already have the entire universe within them, but with time everything is taken apart and they lose their sensitivity, that is, the internal fire, the cataracts in my eyes, and in truth I am busy with my writing the whole day long, and it fills my entire day, and over and over I walk to the machine and fly over the most recent pages and then I go take care of other things, but in the middle I walk away and back to the machine and like primulas, phantoms, and everything at heart a puzzle, and then it is a flurry of thought, and in my lap the scraps of paper warbling, as I write, as I move, as I sit, and choosing a title is difficult for me although I've already thought of so many for my book to be, but I've thrown them all away, the listless eye. And on the nail the puffy white apron and on the front page of the paper the photo *Pilgrims from All Over the World Praying in Jerusalem's Church of the Holy Sepulchre*, lying on the church's long white tabletop with piously lost eyes and bowed heads : the chance of meditative immersion to free oneself from the racing of time, outermost depths, namely, the cloths encircling the angels—

nothing but sitting or lying down in a corner is imaginable to me at the moment, utterly wordless, mute, either reading or staring or with my eyes closed, or revealing my true face, and it was as if engraved into my consciousness : a bicycle was leaning against the barrack walls and in a lit. basket on the back a lit. boy constantly closing and opening his eyes and seemingly in the state of falling asleep while his father had sat down on a bench next to him in the restaurant's garden

but without seeing him, that is, without being aware of him, and it was a strange image and I had to keep looking over and I was surprised that the man was not watching the child and did not pick him up out of his lit. basket and take him to himself, *and like a soft tone the fay electricity*, namely, when I took the full plate out of the microwave, that is, touched the plate I did not know whether its edge was burning hot or ice cold, *while the damp meal at my back and it was a pain*, and I had to constantly think about Leo and Erna N. and I presumed to wander about their house in my imagination and to look out into the garden that surrounded it. Three weeks before she died, we, Mother and I, exchanged a few words on the phone without my knowing what she actually heard, what she was thinking about while we talked, but, after I said I was in Rome, she repeated almost in disbelief, ach, you are in Rome, and then for a long time nothing—

and Ely never wanted any ticking clocks to be in the space where we stayed, and before he would come to visit me I had to hide all my clocks, in truth smother them beneath pillows, and it was all made up and Gisela von Wysocki said, we both have this MAIN CURRENT and many lit. branches but the main current is not the same as the main stream, and she laughed, and it was all made up and there was a shift of quicker and slower steps, and I could not hear the dripping of three related sounds when EDITH spoke to me, yes, in truth she had turned away a bit or mumbled with a lowered head, and in the book *Jacques Derrida* by Geoffrey Bennington and Jacques Derrida, Jacques Derrida writes, I remain a Jew, *with sewn-on women*, *e.g.*, and at the moment nothing other than sitting or lying down in a corner is imaginable to me, utterly wordless, mute, either reading or staring or with my eyes closed rather than doing something, saying something, moving, at least my body, only in order not to bother anyone

wake anyone make them uncomfortable, isn't that so, *but no one's there, I live with ghosts.*

Peter Herzog writes, when I saw you for the first time *in natura*, at the Alte Schmiede, reading, you were dressed completely in black, Hélène Cixous once compared Marguerite Duras's characters to a kind of extremely black sun, I do not want to make any kind of comparisons at all but rather allow the indifferent mystery to present itself through things on its own...

but it was as if I were lost in the woods, I say, I write on a camping table and the structure of everyday life rattles me, and ach such a cost : what was that indeed for a constantly repeating job, dressing and undressing and every morning these annoying performances, the listless eye. The leafy forest or in the moonlight I sought out Ely's hand, which he soon pulled away, staring at the window without looking out, namely, without fixing upon anything, no leaf moved, and when will I see you again, I said to Ely, but he did not want to sit higher than me, forced me onto the stool (kitchen stool), sat himself down on the cold floor, then I sat on a pile of pillows, now it is heading for me or what did the old Barbara branch in the window mean, in the art deco vase between the panes, and I'd like to spend the whole day in the country, walking around, looking, being silent, or on a bench or in the shade of a tree, branches, ach, EJ says, that's how I escaped my own blossoming, isn't that so. And it was all made up, and at the next table in the pub laughter like a thundering waterfall, and I would like to know what happened after the home birth in my maternal grandparents' spacious apartment, what all happened there between 1924 and 1927 when my parents relocated to that lit. *provisional* apartment that was supposed to be exchanged for a larger one as soon as possible with room for all three of us but it never went

that far, my parents and I spent all the decades thereafter in those tiny quarters and I would do my homework on an old Bösendorfer piano I received for Christmas one year although no talent for playing piano was ever demonstrated.

Surprised owls and lilac, what an orange-colored hole in the clouds : the sun's attempt to shine through, and, during our early days, whenever I would give EJ a poem I had just written he would begin to laugh, and this was a sign that he liked it, and it was an incentive for me and whenever I showed him a finished poem he would read it and begin to laugh— it was strange, I had to get used to his kind of appreciation, for at the beginning I thought he would make fun of me but that never happened, I am sitting at my camping table, a maple leaf drifts through the window, certainty nowhere, only hope, that is, all, that is, a concentration from isolation, two lit. feet moving forward, I saw into my innermost being into my ceaseless inner being, I was supposed to get an MRI but I walked away, a FLOOD OF FEAR, I am wearing clouds of dust on my hands and feet, I say to EJ, behind the rolling blinds a glowing ball lost in the all, but the great meanings the great connections escaped me, ach, I keep your voice I don't know where (Derrida), yes, when will we burn everything all of our letters these so secretly scribbled texts, I say to EJ, the internal fire, I say, that is the violet's variety spectacle, I say, and I was all aflutter and I watched someone on the tram taking a bite of a large apple, I was unable to gather my thoughts, I say, I was unable to speak, before the MRI I was supposed to indicate what kinds of prostheses I had, I did not know what I was supposed to write, I was seized by a getting-excited : heated, for a long time now I have not been able to invite anyone over because all the tables chairs stools are covered, Dufy's freighter is plunged into a dark color or a dark color is trying to paint over Dufy's freighter

while the viewer intensively perceives the color in their spirit (storm), ach, the fear of DEATH'S SILENCE, which will manifest in every one of my words, namely, the irreplaceable, the unique life : to lose, Peter Herzog writes, the brooding blotting paper in your texts, your most mesmerizing books : these your Platonic books—but full of fire, isn't that so, *is this why you have AZURE, then write it slowly with water.*

I'd thought there was a dog next to me on the street : but it was a fur coat : tip of a fur coat on my legs I'd thought a dog, was frightened it was dusk, I didn't dare speak a word at the conference, didn't dare say a thing, I felt surrounded, I didn't know where to look, grazed upon the faces in the half circle : bored, bad-tempered, sad I begin to tremble I long for the session to end, have verbal hallucinations, I see my heart before me like a ghost, etc., *you know that my cuckoos*, a lit. inattention's enough, I say to EJ, to suddenly feel as if you've been transported from deepest winter into the height of summer, time stands still, namely, it seems to stand still but when we aren't paying attention it moves at furious speed, that is right away from deepest winter into the height of summer with no transition, and the other way round, and no one can say how it happened, isn't that so.

And EJ said, I don't want to write anymore, he said that, and in general, he said, literature doesn't interest me anymore, waste of time, having made literature, he said, I've written enough, he said, now I'm leaving it to others to make literature, he said that, and I was dismayed and I said, but neither one of us ever wanted to give up, we wanted to keep up, ach, EJ said, I've written enough, I don't have anymore interest in making literature, namely, he was bitter and aggressive and he began to stuff his pipe—

I'd barely left, having grown discouraged, my writing place and had begun once again to read through Gertrude

Stein's *Autobiography of Alice B. Toklas* when I was sucked back to the machine and began to write again. There is a visual poem but everyone was unsure as to who wrote and drew it, none of us, neither EJ nor myself, could remember who had done it but it was in EJ's books as well as in my own and it was an EDIFICATION what an EDIFICATION and the black birds sang a quartet and Maria Callas sobbed in the next room, and the cut flowers *razor-sharp* on the kitchen stool, and the fallen linden leaves like green-bottle shards on the sidewalk, and stepping onto the street it smells of sacrament, and I say to my old doctor, that's what makes you so dignified, your discretion, and how sweet such lit. attention keeps us alive, Pastior, *the geniuses make it.*

And in Schladming we walked past the accordions we walked past the button accordions and I had just left the internist, who had not liked the look of things on my EKG, and I was slinking behind EJ and felt sick and EJ said, I'd like to buy a button accordion, and nevertheless I was happy and hooked onto him and we slowly walked to the bus that was supposed to take us to Rohrmoos, where we stayed every summer, and sometimes EJ would get up at night and go into the kitchen to eat something, fruit or chocolate, and we had a wonderful summer and the meadow surged from the valley all the way up to the house, and sometimes we'd take a few steps around the garden, where there were a few spruces, or we would spend the whole afternoon in lounge chairs, in sync, and without saying a word, and once Franz Wurm came to visit and asked EJ what he was working on and EJ said he actually had to prepare four lectures he was to deliver that October in Frankfurt but beyond the title he had no idea what he would write, Franz Wurm liked that and asked what the title was, and EJ said, "The Opening and Closing of the Mouth," which made us all

laugh, and once I drove to Schladming alone and went to the music shop where EJ had marveled at the button accordions and bought him a *Schwegel flute*, he occupied himself with that Schwegel flute the whole summer but one day gave it to Bodo Hell, I have no idea why, and I was a little sad, he probably had just lost interest in his Schwegel flute, and once Hans H. came to visit and right after arriving fell into the meadow and slept for three hours and the cut flowers *razor-sharp* on the garden table, and it was an EDIFICATION what an EDIFICATION and in the lit. spruce grove the birds and it floraed all around me and I shook myself a beloved—*ant almost still a kid, etc.*

When you write a thing, so Gertrude Stein, it is perfectly clear and then you begin to be doubtful about it but then you read it again and you lose yourself in it again as when you wrote it, that means you cannot tell what a book is until you type it or proofread it, it then does something to you that only reading never can do, and when I told my old doctor that she appeared in my book to be she said, how did you portray me? and I said, it's an honor for me, and I sat at the machine with my notes on my knees and I thought, how good that my knees can also serve as my desk, isn't that so, and I wanted to fan out to look for new material, and I thought that I was getting close to the end of the text, and while we, EJ and I, climbed the mountains, clapped, and reading chapter for chapter, reading and barking and always more, and reading and staggering, what do you mean, I say to EJ, and we were surrounded by immense red flower sleeves, plateaus, and there was a horizon of pines in the cut of the window and I thought about all the hikes up the Cobenzl I had taken with EDITH in the Vienna Woods *while the seasons fuchsia red*, it smells of woods and forest animals, I say to EJ, and the bleeding flowerpot, the bleeding dining-

room floor, and there the woods are rippling and to pull out the tip, completely foreign, to pull it out and make of it my own, isn't that so, ach, I have lost my life writing, but on the other hand perhaps it was the best I could do, and while I make a clean copy of some of the pages of my book to be I suddenly see the point, the next sections of my book to be must be distinct and strict and illuminating and yet protective of their secret, *or a wish to the stars*—

over and over these pale iris blossoms in soggy ditches, this pale-yellow waxen-dead yellow, Georg Kierdorf-Traut writes, but then hill-blooming wild roses and elderberry bushes, which in dreary Westphalia allow for hope, hope for a late summer that will purify my rotten thoughts and neurotic mind, so Georg Kierdorf-Traut, late at night in the middle of the rye fields still picking cornflowers, dazed by the pollen sleepless until early morning, and ever more often I saw young women carrying bottles of water and drinking, on the street, on the bus, and tucking their hair behind their ears and carrying lit. backpacks and it was all a fashion, but it was fun to observe, isn't that so, and the storm this morning blew open the windows and the doors, and my eye doctor sent me two faxes where he had written his own poems, and I pawed the ground with my feet, like a horse, and I found a note on which : while we, Ely and I, were sitting close to each other at the marble table in the café, so close that I could only see the gleam of his pupils, and he said, *we are no longer lovers*, and Heinz Schafroth wrote me, THAT WAS MY LAST LOVE, and then one day followed another without life's basic questions having been solved, and my nerves were all aflutter, and once again I had a bundle of notes on my knees and from the topmost one I read what I had dreamed, and it said UNFLOWERED OFFENSE LIKE A FISH IN WATER WITH BENT BACK,

and I looked through the dictionary for the meaning of the word *rhizome*, and I remembered that in one of the letters from the last few days there was the word *rhizome*, and in the morning I wrote on a piece of paper, basically everything is aggravating, and I had problems with my left eye, and when I looked out the window, I noticed a pale butterfly lurching, and then there was a triple rainbow, the last thought before going to bed the first thought in the morning : will I be able to write today, and nothing and everything happened, and today welcoming weather for writing, I say to EJ, and it was a winged craft, and the structure of everyday life rattles me, and I am now writing figuratively, and the sky looks imploring, and a process removed from exterior stuttering yet still a form of stuttering, and it ambushes me when I order at a restaurant, and my tongue balks and I notice the waiter mocking me as he turns away, and my next order will be worse, I will twist the words around in my mouth two times before being able to say them, that is, a rolling around of the language, and I feel ashamed, and everything's pounding so vehemently and I can't do anything about it, maybe it has to do with the state of my teeth, scribbling black teeth on an ad, it is nine o'clock and I'm sitting in my work turban, on the trip to Grado roses in the sea back then roses in the sea, like aspen leaves Esperanto, and while I am visiting Mother at the hospital my thoughts circle around the question of how to tell her I have to get going right away without hurting her feelings so that I can still move around a bit out in the open—which is to say, I was elsewhere with my thoughts.

Now such a rigorous style is breaking through, or voice, I say to EJ, that I am free, strangely free, and when I was supposed to meet Traute F. for the first time she said, I look exotic, that's how you'll recognize me, and I was in such an emotional state that the image of the Rialto Bridge in a paper

made me feel the strong desire to book a trip down there right away, *we are not gods*, someone next to me on the street said, in fact only because we are subjected to the daily act of excretion, that degrades us, turns us into ludicrous creatures : crawling panting and howling, the shadow of a bird flew toward me, '*twas verdigris* : an apparition sinking into green, and Elke Erb writes on the back of a photograph : a grove fades, goes out / branches and never was… roses and red asters in the garden, everywhere his, EJ's, lit. lips—

saw a dog today with its hair brushed away from its forehead, at the supermarket, in fact it was the ears that were brushed back, and it was on a leash, and it looked at me for a long time and it seemed as if it were looking at me with longing, and so I spoke to it, Olga Neuwirth scored her music with long pieces of grass and cryptic flashes of landscape between hanging trees and tall cacti, *and in the middle of April* illuminated bushes and moonshine, *and EJ with his cap of light came toward me*, Bashō hangs in the air, and I played in minor tones and thought about Leo and Erna N., and I imagined being close to them, and it was a completely hidden place, and I remembered having sat with Leo and Erna N. in the Erkerstube many times and it was a great very deep connection and we were always together there, EJ and I, and when EJ was having bouts of depression Leo N. would come and they would talk for hours, and EJ would feel better, and while Erna N. prepared dinner, at the end of the pulse and parks in front of the window : this pansy, I think, helplessly possessed, and now I am always writing really sm. letters to Leo N., and Leo N. writes me back and it was an echo in my breast, and it is a forestroar without debt or phoenix, Jacques Derrida, and it is five in the morning and I roll out of bed and walk to the machine, two hours later the rush is gone, that is I am of a Passion age, I say to EJ, and Leo N.'s

letters are full of secrets and riddles and I read them many times one after the other but I cannot decipher them, they remain hidden to me, and it is a great attraction in his letters and when I show EJ Leo N.'s letters he always says, Leo N. is a poet, and it was a hidden place, and Leo N. once wrote me that Erna had received so many flowers from friends and now he was responsible for taking care of all of them and that was a burden, and I answered that I could come at any time to help and that I would not bring any flowers *and the black birds in the parquet* and I felt my heart skip and the bushes in the garden began to sprout and I wrote Leo N., when it gets warm, when it's spring, perhaps Erna could be brought into the garden, she loved it so much, but it was the unknown form of my self and I saw an electric cloud and there were a few entries from Lili but I could not understand them and it was as if I had been underwater, and sometimes EJ said to me, YOU ARE A FOOL, and he said it with love, and I say to him, I heard your voice and had the feeling *I look like you* at the moment and my glance is like yours, curious over the edge of my glasses into the open book, that is, that thing about taking care of Leo N.'s flowers had imposed itself because Erna loved those flowers and he stuck the flowers after their stems had been PRUNED in all the vases they had and poured fresh water over them, etc., and there was a direct connection between Leo N. and the care of flowers, and I saw him in front of me with a large pair of scissors and rubber gloves and he *was a gardener*, isn't that so, and when after a certain time the flowers begin to droop over the edge of the vase, Leo N. said to Erna, they will wither, and EJ and I felt each other with our eyes and I read him a sequence from a book by Jacques Derrida and it was, you, you are the whole time for me, you give yourself the whole time to me especially when you are not there, and I mourn you, I cry

over you and in you, you are above me and I will never let you go, even when you do not see me, even when you are looking somewhere else, in order to look, one day, *and now I am like the stone there and the raspberry bush over there and don't want to feel myself any longer either.*

Oh dear, he says, oh dear, and I catch myself thinking almost ceaselessly about my book to be, every distraction unwelcome, I am lost to experiences in the world, walk around lost, am completely absent, my head lost, I am totally concentrated on my work, the oriental lily opened its buds and its scent is enchanting, liverworts and primulas and leek, that's how we, EJ and I, trudged through the grove—was it a dark wood was it a grove were they interconnected mountains, ach, I say, they were dark storm clouds, and EJ called me, what are you doing the whole day long, and I say, I am thinking about the form of speech, etc.

She, Gertrude Stein, could listen a long time, *and all of a sudden she could not listen anymore*, and then she said, taste has nothing to do with sentences, isn't that so, but I don't recall anymore, I say to Gertrude Stein, who came and went, whether they were real or whether they were statues : and there were a lot, and the structure of everyday life rattles me, and a USELESS mouth, observing oneself in the mirror, I say, how age marks us.

These secretive letters / ordinances between Leo N. and me, always just a few lines, brief and precise, and it's the same with the letters from Siegfried Höllrigl to whom I write, when one reads your "Prosa III" very slowly and over and over, something quite unfamiliar arises, and I am electrified by it, and I have to read the sentences over and over, savor them while reading and afterward I ask myself : how was that actually formulated, which drives me to read yet again, and afterward I longed to write such long winding sentences

that tried to observe something or to open or to make it visible, and I ceaselessly read Gertrude Stein because I hoped to find a similar kind of sentence and excerpt it, but in the end I was annoyed and distracted because I'd had problems with a medicine of mine, and I was growing more and more tired the longer I sat at home or lay there and eventually I had no desire at all to leave the house and it was an ice-cold day and I asked myself how long it all would continue to go on, not going out, not meeting anyone, not speaking with anyone, and I grew more and more silent, and I just continued to sit at the machine without being able to work : I simply sat there and here and there wrote a letter I already should have written a long time ago and as I didn't know what else to do I just sat at the machine and wrote letters instead of continuing to work on my book to be, but after a few letters I grew horribly tired and stretched out on my bed and fell asleep, and when I woke it was late afternoon and the time I usually go for a walk, but I did not go for a walk because it was too cold and I grew more and more tired and nothing gave me satisfaction and nothing stimulated me *and the Cloud of Unknowing enveloped me.*

And when a bird or birds fly into the room is that good luck or bad luck, let's say good luck, so Gertrude Stein, and that changes quickly, dream and daily reality, I say to Gertrude Stein, so that one can hardly differentiate between the two appearances, the unexpected snowstorm : as a horrible anxiety sprung up inside me as if the world were preparing to be destroyed, an anxiety the likes of which I haven't experienced in a long time—but not only in me : I was standing in the automatic door of a bakery I had just left and as I stood there it opened and closed constantly at my back, the people inside beginning to threaten me with their fists but the niche of the door protected me while I waited on the taxi I had called,

that is the state of alarm not only in me but in everyone and suddenly they all began to run or to curse or gesticulate silently, and everything seemed transparent, I say, I could look into individual destinies from the street as if through an open window, like back then, when Ely and I would walk along the Wienzeile, at night, throwing peanuts into open ground-level windows and laughing—

most of the time I'd wake up around four in the morning and start to write or read through my books of Gertrude Stein and ever more often I found the similarity between my old doctor and Gertrude Stein growing ever more clear, which I liked, and it had to do with the blurry curls, namely, the extreme (justified) self-perception and imagination, THAT'S WHAT SEEMS CHARMING TO ME, IN MY HEART, BUT UNPRECEDENTED and nothing is like it was, I say, standing outside myself, not a single piece of paper stirred and you squint in my direction, a reader of my books gave me a grass pillow so I could fall asleep easier, Mother's flora and fauna, and on the phone Elke Erb said, maybe in this way an increase of life intensity, and later on, referring to EJ, she said, his being was like the purest water, and while I'm on the phone with Elke Erb I keep my eyes shut as if in thought, listening to music and kissing, *ach, to blow time on top*, so Derrida.

I would like to buy myself "The Life and Death of Juan Gris" by Gertrude Stein but it's out of print, everything that was but is no longer there comes closer, and a few months before he died he said, *this will be our most beautiful and last summer*, he said that, and when I complained about being in pain half-joking he said, I DON'T FEEL A THING—

Leo N. writes, it was very sunny and warm. We were dressed lightly on the way back through the village, we froze a bit in the shade and at home we were very tired. It is actually

wonderful, Leo N. writes, to write down such banalities— : what is not recorded did not happen. Leo N. gives me a reason to keep working, from Morocco I heard, Christel Fallenstein writes, that it's cold at night, but Manfred spends the day lying in the sun out in the garden, storks and egrets over the garden a polished lamb between the windows, one could hear Dvořák's *Cypresses*, quite a soft melancholic piece, the pale shrubs in the fog have a specific scent and the structure of everyday life rattles me, in the fictitious *Autobiography of Alice B. Toklas* it says that Gertrude Stein and Jean Cocteau met once or twice and began a friendship that consisted of writing to each other quite often and liking each other immensely and having many young and old friends in common, but not in meeting.

I hear this through tears, the expired dove I had tailwind, on the corner was a lone German shepherd, then my blood rushes down to my feet, and ischemia in my head and I grow dizzy, on the set table, I say, a ginkgo leaf on a plate, some kind of something from daily life all at once rather large and important that happens over and over, how time forces its way into the soul, wild sprouts in the kitchen corner with garbage dirty laundry fever servants misery circumcision dewdrops, slang on a saucer, namely, between two cloudbursts I'd fallen asleep, dreamed of you, I say to EJ, dreamed : lit. Nono monogram, on a summer morning : lit. Nono initials, on a summer morning rain too, EJ on the tram at a spring at a lit. stream smoking his pipe, in his bathing trunks, he looked up and I called out, you're sitting there all alone! I looked for you everywhere *and even if you came back for just a cuckoo long*, and behind the rolling blinds a glowing ball lost in the all.

I write to Leo N., naturally, when reading your newspaper article "Last Days in Vienna," I had to think of the title of the film *Quiet Days in Clichy*, which in any event has nothing to

do with the theme, I liked your "Last Days in Vienna" and I keep reading it over and over and when I take a break I ask myself how this and that bit were formulated and walk to the camping table and check this and that sequence, that is, I am quite touched and start over from the beginning again and it's a pleasure, I know certain passages almost by heart, and I am now writing figuratively, I say, and I see the devotional lamb, but when the doorbell rings or a visitor comes I feel interrupted and already the marquise is streaming against me, the doggish blessing, while the two black pups in the back of the parked car, left alone, pant and squeak—

a mad buzzing is underway, Oskar Pastior, and I grope about, a lot goes through my mind through all my senses and anyway and basically everything is mental, Mother says, you've got to understand that, even those things that are extraordinarily physical, in the end are mental, isn't that so, a pair of skins on top of each other, says Mother, you will outdo everyone, and in the late evening before I fell asleep it was in front of me quite clearly but by the morning it had disappeared, and I've lost something precious, I say to Mother, ach, my whole life long a dilettante, I say, behind the fluttering water a white rose parterre, heartmorning, the structure of daily life rattles me, your ultimate faltering soul, I say to EJ, we wanted heaven on earth for each other, I say, but gravitation won out, that is the glorious foot, namely, when climbing the stairs EJ would not put his whole foot just his forefoot that made him unsure, you see him walking off, shoulder bag on his back, holding it with one hand, you still see him on the back of his last book walking off, so determined and exact as if he knew his way and his end—(my vocabulary has grown small so I borrow words and parts of sentences, whole sentences from before), I mean on the Veronika side, isn't that so, and Isabel says, in Turkish instead of underwear

: innerwear, that is inner clothes the outer clothes, namely, a procedure that is melting overall, and Gertrude Stein says, I like to read internally not externally, and when you go for a walk you don't want to come back on the same path you took.

He took the stairs only with his forefoot, he does not put his whole foot down as it makes him unsure, like Mother in her final years, he did not come back like Adolf Muschg had told me he would, a few weeks after his death he turned up at the jazz club, EDITH says, as a brimstone butterfly, in the middle of the smoky jazz club, above our heads, EDITH says, next to the bartender, next to the stage, between the instruments, disappeared again, I wasn't there, I didn't see it, that is, a butterfly, a few weeks after his death, wobbling over the candlelight, at that club, the jazz basement, where he'd listened, for decades, it was suddenly clear to me that I had no chance left of dealing with people, my only chance was to read and write and move myself, that is, I was no longer capable of anything else, I simply avoided meeting people, meeting up with people sapped my energy and I also didn't know what I was supposed to talk about with them, I could only deal with books and my writing and go on my walks, which I really loved because I could feel my wild thoughts appear, *namely, water-horizon on my face*, enraptured I look into the tiny living room carnations, breakneck felt-tip : deep black cross in the middle of the left palm, and I reject the demand for humor in the fine arts, and beginning to say a sentence but to not continue, to start such a sentence, I mean, EJ had always begun a sentence and then stopped speaking and in so doing tortured me and I said, please finish your sentence, but he always needed a long time to say the sentence and during those pauses he just stared pensively, and I pressured him, why don't you finish your sentence, please finish your sentence, I am dying to hear the end of the sentence, but sometimes he

just did not say the end of the sentence, he just let it stand, a sentence begun, isn't that so, and that angered me and I often waited hours for the end of the sentence, but sometimes there was no end, everything just remained open and it made me suffer, for I was eager to hear the end of the sentence because the beginning was so exciting already, and sometimes he said, now I've forgotten the end of the sentence, and I repeated the beginning to him so that he would remember the end, but he persisted in saying that he had forgotten its ending, that made me sad but you were not allowed, e.g., when he had begun a sentence, to move, when sitting across from him you had to sit real still and not distract him or the end of the sentence would slip into an unreachable distance, isn't that so, but sometimes he'd continue the sentence after a long pause, and to completion, and that fulfilled me and I'd be very happy with him and the fullness of the sentence which always contained some bit of wisdom or insight, and I learned a lot, and I always wrote down everything he said, and he was happy that I wrote down everything and we were happy and sometimes, sitting across from each other, I was even able to manage something like an insight, *that is, an insight plucked out of thin air*, and that made him happy and he seemed contemplative and happy, and behind the rolling blinds a glowing ball lost in the all.

Back then many years ago with Ely, winters in the city park and I slipped out of my moccasins and Ely stripped and said, look at me, and I was overexcited and shocked and said, I know what you look like, and we embraced and did not feel the cold, a boundless affection (Derrida), that is, the water-horizon on my face.

And then I was always somehow *infatuated*, namely, even with things and a fire in my breast and I was carried away by a person a thing a dog thing, etc., and then somehow

MISSED, that is, that something had come into my eye, above all into my left eye especially into my left but in the meantime my right one too, and when something came into my left eye some kind of dust mote mascara hair a bushel of delirium how unusually it had come into my eye and I didn't know how and it confused me and I had to go to the eye doctor and he said, I will rinse it out, and he turned my eyelid inside out and I imagined how awful that had to look, namely, my left eyelid, and I grew dizzy while I sat on the examination stool *and he cleared out my eye*, and the strangest things were in there and he put it all on a piece of gauze and I was amazed and disgusted and I said to myself, I've got to be more careful, that is, the Sphinx, for Linde Waber drove to Cairo and drew the Sphinx, but it began to rain quite heavily and it was a storm and the picture was ruined and, once she was back home, she had to draw the whole thing again from memory, but she said there was an illuminating connection between me and the Sphinx and I said, yes, it's symptomatic, and everything that was but is no longer there comes closer, and Mia Williams wrote me, I ate a heart and drove to Venice, and that was a long time ago for she is long dead, deep black cross in the middle of the left palm, barbed-wire lip—as the anthill in my hand, Buñuel, and enraptured I look into the tiny living room carnations and the dining-room floor full of blood, at some point from somewhere I picked up this heavenly language but now at my age it moves away ever more often and sometimes it appears to me like a foreign language and then I have to put myself into a trance in order to use it, *I see the brilliant divan, Pastior / Petrarch*, and suddenly I found myself *in the handicraft room, amoeba-like*, and we were in the university garden, we were walking straight through the university garden and he hobbled and hobbled but did not say a word he did not complain just

looked toward the ground balanced on his cane hobbling
and this was the only way of moving forward and we went
straight through the garden and Hans Hollein far ahead, he'd
rushed on ahead and the two of us slowly bringing up the
rear, hobbling, and I the tears and in this garden the tall trees
and blooming bushes and individual palms and everything
orange-yellow and then it was a tearful day and he slipped
ever deeper into himself and closed off locked off and I was
in doubt because I could see that the end would soon come
and I in a horrible bodily and mental state, namely, at the end
of the pulse and parks, and took a higher dose and everything
at heart a puzzle, isn't that so.

I mean, I remember a photograph my father had made
back then but I do not remember the real scene : the cap was
too big for me because it was a cap of my father's, and then I
got onto the bus and it smelled of disinfectant ("Karbol") and
I wondered why, but there weren't any people with bandaged
heads and I was alone, and I considered a title for my book
to be, e.g., DELIRIUM or DELIRIA like a waltz by Josef
Strauss, namely, every day, especially in cold weather, I went
for a walk through the supermarket, I took a shopping cart
and rolled through the aisles and sections and then bought
myself something to provide a reason for having gone to the
supermarket in the first place, that is, I had such dark thoughts
and memories while waiting for the tram and it was bitterly
cold and at the stop I walked back and forth with quick steps
and did not hold back my tears, they ran down my cheeks and
I thought, the wound does not want to close, I thought that,
and then I thought how bitterly I missed him and it fit the
bitter cold that was cutting my cheeks and I had wet cheeks a
powdered mouth and I felt skinned by pain and the cold was
crawling through my clothes it was like I was not wearing
any clothes at all the cold was so cutting it took the clothes

off my body and there was my *Hercules aunt* but she was no longer alive and sometimes I imagined similarities between us two, and it bothered me, especially in the morning, namely, the power of imagination, and I found myself in a horrible bodily state just like one always fears, in the morning, before you've looked in the mirror, the fear that your own face has utterly transformed into that of a demon but then relieved to see it's still the same puffy old face looking back, a dressing gown "lapsus" polished lamb, that is, from my supply coat I pull out a bunch of notes that I hope I will be able to use for this, my book to be, so now I pull a pack of notes out of my supply coat and put them under the magnifying glass but I constantly mistype because my hands are trembling with excitement, and I'm perched at my machine, completely sunk into myself, that is, only twilight thousand impressions : thousand lonelinesses and if something falls out of my hand, I mean, a note, and falls to the floor which is completely covered with paper so that I can barely tell which are the latest ones, that is, the new material, *that is, voices*. And I am an island as well as a country, a lapsus (dressing gown) the arms always turned inside out, namely, slipped inside out and to put it on first you've got to shake the arms back, she, Mother, was always very gutsy but when Father died she suddenly turned skittish, loud sounds made her wince or begin to cry and then she'd say, there's something in the air announcing change, and that made me so tender and tearful that I left the house and inhaled the scent of freshly cut grass and Carmen Tartarotti called and said that the lit. film she'd made had turned out well, and she said, your eyes so flowing (fine) and the hall chair overgrown with grass, and then I met Heinz Schafroth and he said, slowness is an art, and I was so close to my burial mound, and Gerlinde Creutzburg writes, we really do have the most various hearts at multiple

points throughout our bodies, isn't that so, and I've brought
most of my wills, namely, one or two every year, up to date,
(perpetual) wills, so that it just bled that way, that is, with one
foot in the grave, the underhood the underhand or the privet
sky's blinding blue the light-blue secretion of an early June
sky that itches chases or drives you out, and Mother says, I
understand you completely, and I always thought that I had
a lot of friends but then when holidays arrive or something
unexpected and burdensome or an accident "a wood accident
/ wood scene" no one is there, Mother says, and you lie there
and begin to cry because you've been left behind by everyone,
etc., namely, I say, *a snow-covered fanny or wandering starlight*.

And as I stepped inside I saw his umbrella in the umbrella
stand, a bit deep, and hanging my coat in the closet I could
smell the smoke it had soaked up at the café and I was happy
to be back home and I began to make a clean copy of what
I had noted on the way, and I always said, concrete poetry
doesn't excite me, I say to EJ, and as my eyes had become sick,
I say to EJ, namely, seeing as they'd installed a sun filter, as
my eye doctor explained, it was not bright enough anywhere,
but the sun was too harsh, especially the winter sun, and ran
from it, and it makes a huge difference who when and where
and in what kind of mood you meet, my old doctor says, and
I say, nearly all the people I run into on the street on which
I live say hello to me or speak to me or try to involve me
in some kind of conversation, which makes me happy, and
Renate Kühn, who I'd had to assume had put me *ad acta*
because she had not gotten in contact in months, wrote me
a wonderful letter and I wrote back and told her how things
are *but the sunrust seeped through my bandages like blood*, and
Schlegel says, the lightning flash of eternal life ignites itself
only in the midst of death.

And Georg Kierdorf-Traut writes, this spring cheered me up at first, but now it is just making me tired, it seems to be an old-age spring, and death-spring, bees and brimstone butterflies on the burial mound's flowers, the marriage songs of the common chaffinch and warblers, at night then the owl and its silent shadow above the grave.

Variety of pansy, I say to EJ, and I was all aflutter and I watched someone on the tram taking a bite of an apple, and it seemed that I always got distressed as soon as I left the house and a tragicomic role played in a constantly running film, and he walked away before my eyes and I had to laugh at myself and cry in the same way, and when I take a walk my glance is always turned toward the ground as if to make sure I don't stumble over anything and fall, in reality everything affects me and nothing at all, I say to EJ, and the truth is something I still cannot reach, but EJ says, what are big words like *truth* and *reality* supposed to mean, I'm a bit skeptical, he liked to say and whenever possible one should manage without messing about with such terms, he said that, and he said to EDITH and Andi, take the two old fish with you to Crete, and another time he said to them, I still want to take a few lit. LEAPS, isn't that so, and EDITH says, ach, the sign with his name still hanging on his house, nostalgia, etc.

In this book to be I have used a *nonstyle*, that is, a kind of literary self-exposure, isn't that so, that is scribbling / soiling : the scribble on my naked upper thigh or writing on my palm and drawing a black cross that can no longer be removed, my hands are different temperatures, left cold right warm, *completely stopping to mumble, I've got hands of melancholy, and ran into the machine so that I died inside—*

that is, I didn't know what he meant I didn't understand what he was saying and I said to him, as I saw one of my white tennis shoes sticking out from behind the trash can,

for a second I thought I myself was standing in my white shoes, and on 1/04/78 he wrote on a note : memory as sense organ to perceive the temporally distant, namely, party in the lit. pine forest, the powdered mouth, back in '55, at the Winterbach teachers' home I tasted Coca-Cola for the first time, which EJ had taken with him on a hike, but I didn't like the taste, it tasted strange, to EJ it was great and bit by bit, after we drank it all the time, it began to taste good to me as well and it became our favorite drink and we walked through the woods and there was a polished lamb in the clouds, but the great connections the great meanings escaped me, and behind the rolling blinds a glowing ball lost in the all. And I am now writing figuratively, I say to EJ, and I feel cold and hot flashes rippling down my back and I like it when it carries me away and I am listening to Maria Callas's madness aria *and between two cloudbursts the figure of a person or ink.*

And back when I was seven or eight and we came back from Deinzendorf and school began again my worried mother asked our relatives, *does the child look rested*, and everyone said, yes, yes indeed, *her eyes are brighter*, everyone was satisfied with that but I didn't know and I could not find my place in the world at all, and I had a nemesis in my class and she would compete with me and make fun of me because my clothes were old and had been calculated for me to grow into and she had well-groomed chestnut-brown hair and new clothes every day, and I felt inhibited, etc., that is, in my heart however unparalleled, Pastior / Petrarch, *and plants racing through the garden*, namely, the handwork or inner apron, till, slog away, plow, Bodo Hell says, that's the procedure with writing, and there's a stream of consciousness, and the interior images confuse me but it's a sweet confusion, isn't that so, and while I was reading Gertrude Stein's *Everybody's Autobiography* at my favorite café I thought about a lot of

other things, really, why was I so inattentive and distracted, while reading I thought about Kurt Neumann and Oswald Wiener and Juan Gris and about Dalí and my old doctor, and Gertrude Stein says, you can read a book over and over again until you remember everything, and even then you can read it over again if you begin at the beginning, that is very important about reading a book over again you must really begin at the beginning : in that way you can read it over and over, in any event I am reading Gertrude Stein's books for the third or fourth time, I say to EJ, and it remains an immense pleasure, I like to read internally not externally, so Gertrude Stein, a bird as prophet as seen by Max Ernst, that always gives me the shock of joy, most people are afraid of poems, I say to EJ, that's why they don't read any, before my window mimosa-wind, Mia Williams writes, before my window the lit. animals *and plants racing through the garden*, how time forces its way into the soul, I have already lived the day after tomorrow too : that's how quick how comprehensive time is now, from a dream this morning I remember "*a pair of points and pussies*," from the bottom of a car sprouting trees : saw them from the window (aromatic writing work), painted a portrait with strawberryblood, and the structure of everyday life rattles me, you know that my cuckoos, Bashō hangs in the air, and the sky looks imploring, I begin to blubber, to curse, I curse the entire world, a sinister kitchen smell from somewhere or other.

"Because they are inseparable from the weather," everything dream, totally crumpled soaked through woke up with the phrase "the cleaning boxes past me," had Fredy K. called? ever more expansive more casual the once erotic : brotherly sisterly Ely there too, vanished, slipped off in my head, recently only exists in name, I have CATARACTS in both eyes, we exchanged a few letters and it was a long time

ago, with the pack of music under my arm, departure from
normal narrative style, everything stream of consciousness,
thousands of interior images, discussions, movements,
ceaseless, but bit by bit Gertrude Stein's casual style tires
me, I'm already withdrawn, and that rubs off when I read
her books for too long, black fingertips, that is the outermost
version, namely, my dream had modeled itself on reality
and madness, I wanted to go away, I was already dressed, I
sat down at the machine in my fur coat, *suddenly ambushed* :
fur coat fur hat cigarette in the corner of the mouth, subtly
brilliant, EJ would describe it, *well all the same*, the eternal
blubbering and increasingly scattered, isn't that so, earlier I
did everything properly but I didn't know how I did it, maybe
ecstasy back then in that castle-like building by Lake Attersee
where you had to ask for everything : glasses and breakfast
containers circulations bowls and decorations cutlery and
the telephone lines didn't work, onward the adorable yellow
roses in the garden and pattered down the dock to the lake
and EJ gripping my arm, that much was still okay going
down to the lake was still okay but in the afternoon we had
walk back up, walk back up the slope, and the hawthorn and
mallow bushes thick copses and where real cautiously we
step by step and over and over raced and why that potter's
workshop this memory of a potter's workshop I don't know
the view over the reflecting lake glimmering sunlight *maybe
ecstasy* and while taking a shower I remember walking with
Michael Hamburger through a huge and sparse forest in
Berlin and he says, I can never take breakfast I can never eat
or drink anything in the morning, and I see him before me,
his somewhat bent form and his well-chosen steady step, and
it was a game between us, EJ and I, and we said to each other,
laughing, *Litvinov Finkelstein* and we repeated it countless
times, and someone says, anytime is a good time to write a

poem, but who, in any event I object and say, no, you need a holy time, and back then Mother imagined : a long way to the pastry shop, but I said, it's not long, just a few steps, isn't that so, but in her imagination it was long, and sometimes it's long to me now too, etc.

And so always make a new start for its own sake, paws on the machine, jump into the text as into bathwater as into the lake last summer and then I realized with horror that I'd forgotten how to swim that I was going under : point bush and hair Maria had pulled me out saved me and I was quite despondent, isn't that so, and asked the old doctor, can one forget how to swim but I don't know how she responded, and so always a new start for its own sake and ask again can one forget how to swim and my old doctor says, no, one doesn't, just like one doesn't forget how to ride a bike ride a horse if you've learned a number of languages you can forget them, just the language you learned first you can't that is one forgets all languages but one's mother tongue, it disappears last, isn't that so, but one can, e.g., forget how to pray— one simply forgets the words of the prayer even when one tries to say them often, one gets stuck somewhere and has to start over again, and I say to EJ, *just nothing accommodating in literature*, and I say to him, if you write a poem every day then you always remain at the same temperature and then it's understandable that you start to repeat, then I felt elevated by my hallucinatory language and was eager to see how it would continue, that is. in forestroar forestbluster, everything rushed into the landscape, *namely, into the forest-tide*. What's puzzling, so Gertrude Stein, is that nothing is really very frightening, anything scares me anything scares anyone but really after all considering how dangerous everything is nothing is really very frightening, I was astonished, I dreamed, it had to do with the blurry curls that is Gertrude Stein's self-perception

and imagination, I say to EJ, that's what made an impression, she painted the air, I say to EJ, *a snow-covered fanny*.

I won't go to Spain as a tourist, EJ says, we either get invited as poets or NOTHING AT ALL, the view is constantly getting deeper, I say to EJ, the snowballs on the windows dissolved and rolled into the room, just nothing accommodating, I say, an author who writes for an audience in reality does not write a thing, says Maurice Blanchot, ach, I say to EDITH, his handwriting is still lying around everywhere, his cane's against the door I grab the cane and think I can feel the warmth of his hand, my therapist slips out of her shoes by the door, steps barefoot into the room, THEN STRIKE HIM FROM YOUR PATIENT LIST, while the curtain I mean the curtain the scene wiped away, *unflashed* world, I am of a Passion age, lapsus, dressing gown, one arm inside out, the head of the lamb, torn, remained outside, I'm in danger of self-negligence, farewell, I expel the crying region, ach, this rampant death, I say to EDITH, and I sink down and my throat is tied, and I wiped the blood out of my hair, ach, his *glorious foot*, I say, where can man still find refuge, in madness in silence in death in cynicism?

Valéry often reminded us that his best works arose thanks to random commissions and not personal need, Maurice Blanchot says, in the grass a piece of silver-white cardboard like the cap of a poisonous mushroom, anomaly or stone how poisonous (dream) your favorite dish o' lit. hunter girl (dream), and Mia Williams writes, you are like an Austrian landscape, are they gods is it a young swallow, something chirping in the bushes in the clouds of ether, we went walking it was sunny and hot, he placed a green leaf on the bridge of his nose against sunburn *while a powdered lamb in the window*, what's written between your shoulder blades, I say, the acoustic is my stepchild : *I'm*

an eye-person, which EJ doesn't like me to say, we strolled along
the avenue, a hand from the heavens reached for us, roaring
blotting paper and more, Karawank eyes, heart valves. Party
in the lit. fir tree forest, slowness is an art, Heinz Schafroth
says, or the light-green interwoven branches in the window,
I remember a tree on a hill, at the supermarket a woman who
speaks to me pulls out a photograph showing her with a huge
snake around her throat and she says, you don't need to be
afraid of them you just need to pet their heads then they don't
do anything—she loves animals, etc.

What all rolled into the room I ask myself was rolled in
from the window, the snowballs the Our Father, standing
on tiptoe behind the window and hear the dove's cry, you've
completely gone under in this line, EDITH says, *I'm shifting
the flowerpots*, EJ says, I like to read these crime novels the
most, you feel secure you forget all the hardship and grind,
back then, Ely, *he grabbed my left breast* it was in the empty
station hall we were going to the mountains, I felt unconscious
we both saw it in the window opposite as he did it, and I
was ashamed. It's monstrous making it so difficult for the
reader, I say to myself, to suggest one had eliminated a figure,
as I did with Ely, and suddenly there they are again, and a
lit. inattention's enough to suddenly feel as if you've been
transported from deepest winter into the height of summer
and the other way round, and so when we aren't paying
attention time moves at furious speed and no one can say
how it happened, and I hear a paper-like crackling and notice
I had buried Jacques Derrida's *THE POST CARD* beneath
a pile of manuscripts, which frightened me, and I thought
about the title of my book to be and I asked EJ, and he thought
about it then said : BLUES—and I liked that and I wrote the
title of the book down on a new piece of paper, BLUES—

experience of touch (heartwonder), the body is an object

of divine wonder, the allocation of madness and reason and then my blood rushes down to my feet, and nothing and everything happened, and years afterward people still asked me, I mean, after I had once again lived in Vienna for a long time whether I still lived in Berlin and I had to announce that I had not lived in Berlin for a long time already but the rumor that I was still in Berlin persisted and the rumor would not go away and it aggravated me because I had to correct people everywhere and all the time and my nerves were all aflutter and I took a higher dose and announced that I had been living in Vienna again for years already and that I could not be in Berlin, that I had left Berlin more than two years before, but people persisted in thinking that I lived in Berlin and that made me feel impotent and in the end I just let it go, and nothing and everything happened, and my pen WALKED over the paper and dragged a strand of hair : bushel of hair and why had it fallen out while I was writing, and late at night the sequence of sentences was in front of me quite clearly but by the morning everything had disappeared and I had not written it down because I had been too tired, and then his monogram is on the handkerchiefs hand towels and washcloths and his aftershave in the cupboard, namely, the dark engraved birds in the sky.

"*Pishing*," my old doctor says and looks at me, surprised, wide-open questioning eyes as if she had just discovered the indecent word, *is this something spiritual*, I ask her, that sometimes I feel a pain in my spine and sometimes I don't, otherwise I would have to feel it all the time or never, no? which makes her laugh, a laugh in my feet a tear in my eyes around my neck a tire, quite a cast, winter clothes in the dream, *I see the brilliant divan*, *Pastior / Petrarch*

and in any event it's a boulevard, when I, e.g., act as if I would ignore you, I say to Ely, and speak to others a lit. like

I speak to you, then because I ignored myself, and with your other darlings you do the exact same things you used to do with me, the same caresses the same words the same glances you let them, the other darlings, e.g., stand on your naked feet with their naked feet and then you go toddling about, you carry them around the room on your paws, etc. Ach these realities shot through with lovely madness, I say to EJ, my literary development, I say to EJ, goes from associative stammering : rubblebeing to aspired-to longing-goal of a discursive word-sentence-connection along with the odd hallucinatory intrusion, that means the aspired-to classicism is once again destroyed from behind, or the aspired-to classicism sabotaged by means of surreal countercurrents, light poultice blaring in the eye and Nina Retti says, Fatima is ensouled by prayers and is it perhaps a bit like kitsch.

How can someone change, Gertrude Stein says, one has to be as one is and it is exciting it is confusing that all are as they are. I am constantly getting heavier, I say to my old doctor, I walk more slowly, I always love myself a lit. less, I only pay attention to my health inasmuch as it allows me to keep on writing, *I mean, that's overkill*, my old doctor says, when you take so many kinds of medicine with similar effects, that is unnecessary that is too much, *and I was mixed up and I was lonely and I bought myself a new perfume and it was a comfort*, and I called Erika Tunner and I said, my spirit is fluttering, in a few days I'm coming to see you in Paris, and in the corner of my eye a flash a garment in the corner, what was it, I go back to the place where I had seen it flash, in the hall all of a sudden but it did not flash again, and I walked back to the machine and a few sentences dripped, drizzled onto the paper and I stuck my feet into hot water and said to myself, now all I've got to do is wait for my own death, my next goal, like shots you hear avalanches thundering down from the rooftops—

the body has memories, EDITH says, in my need I called upon all the dead, force the travel-cap on, a man on the street says, excuse me for speaking to you : you look like my deceased wife, multiple times while writing I have changed perspective, I say to EJ, I have an almost religious trust in my language, that is, my texts arise out of a self-propagating eye experience, Gertrude Stein says, Bérard's pictures are almost something and then they are just not, to have a reason to leave the house, I say to EJ, I write a letter to T.S. and hurry to the next mailbox, I swallow some medicine, the aura of Winterbach before me, namely, on the tongue, suddenly, four in the morning, it began to storm, and the sky will wither like a dried-out meadow, whenever someone tells me about an accident, I say to EJ, I get anxious and my blood pressure goes up, the clean dove of the universe is spinning about my skull, in a tyrannical way : not a single day without sun, I will conjure myself up a free Wednesday, I write to Elisabeth von Samsonow, as I'd like to hear your Wednesday lectures, my slotted habitus, large fish bones on the sidewalk, the impression of a wet dog's paws, a man with a watermelon in his hand smiles at me, it is so cold here, I say to EJ, *my breath a cloud in my room*, Peter Pessl writes to me, I saw you at the Alte Schmiede for the first time dressed completely in white, your aura was very different and I could barely speak to you because you make my words fall silent, I do not want, nor can I say, a thing and saying anything is superfluous, which can indeed be a beautiful state. While doing the laundry it smells like chocolate, and I bolted into the machine so that I died inside, and watched the tiny Japanese ankle socks that had grown so small because they had been washed in hot water, various hump-like movements, a snowed-covered fanny, and we saw a lot of bushes most of the time blue, etc., and we saw the flat land, so Gertrude Stein, and it was a lovely spring

and I always wanted everything I wrote to be ordinary and simple, so Gertrude Stein, and then I worry whether I failed, whether it's too ordinary and simple, so much so that it is nothing, everyone says it is not that way, it is not too ordinary and not too simple but do they know…

from a distance we cast a glance toward the leaning Tower of Pisa, but we went in a different direction, and I really would have liked to see the Tower of Pisa from up close, I say to EJ, and felt sad and lost myself within it, and the tears came to my eyes and it floraed all around me and I shook myself a beloved, then one day followed another without life's basic questions having been solved, and then it flashed like in "Hansel and Gretel," and you have to wait for that moment, everything else is craft, I say to EJ, and my throat is tied and I sink down and I washed the blood out of my hair, *namely, the crooked handwork the inner apron.*

I have cataracts in both eyes, in the way that people who live on the coast or by waterfalls speak more loudly, Jean Paul. Crawling down out of bed, bad cough, EJ bent over a steaming meal, meditating, praying, dream, me crawling, in the afternoon, feathers fluttering out of pillows, last night I saw saintly people lots of caps, a man going through the restaurant from table to table and handing out lit. cards I AM DEAF-MUTE PLEASE HELP, then he re-collected the lit. cards and the change (not much), clouds with sparrows, that is, the sloping meadows : verses, a moth tumbles onto my black front (sweater), I kill it, answer a letter from Leo N., write at the end, I embrace you with Erna with lots of flowers, namely, I imagine your room full of flowers and palms and a very strong feeling. At the door the GP's sign pasted over with Leukoplast, shimmering pool of blood on the dining-room floor, I've become a slave to the idea of frenzy : to throw myself in front of an oncoming U-Bahn train, I have to step

away from the edge of the platform because I am unsure, getting on once again happy to NOT have thrown myself in front of the train, Franz Koglmann speaks of the *precision of melancholy*, EJ always used to say, my whole heart is yours, he came with a bush of strawberry leaves against phlegm, and ash trees, and no flowers at all not a single one, and I asked him, is Gerhard Rühm's property next door, and Lili swayed and said she'd had too much to drink, and at the doors of the bar it did not say "*ziehen*" but "pull" and not "*stoszen*" but "push" and we were both sad that this LANGUAGE LOSS had begun to assert itself ever more forcefully, and I was mixed up and in tears and I found a note written *Service Ca*t and while swallowing the medicine the aura of Winterbach before me again, and whenever he was in the hospital I would visit him every afternoon, but before entering his room I would drink a cup of coffee at the buffet and then I was happy to see him again, *the most glowing things*, at night I wrote down what a dream had dictated : "fire a fire breaking out in a branch of the store in truth filiation then an excessive tip, the waitress gave me ivory gloves, but in the end it does not help in the end does not scrape off…" Like a broom the large fir branch losing its needles upside down in a trash can in the kitchen, and though she gave birth Mary remained untarnished, I read, the savior had left her body like a ray of light and Joseph said, "Then I, Joseph, wandered but did not wander. And I looked up to the peak of the sky and saw it standing still and I looked up into the air. With utter astonishment I saw it, even the birds of the sky were not moving. And I looked at the ground and saw a bowl lying there and workers reclining. And their hands were in the bowl. And chewing, they were not chewing. And picking food up, they were not picking it up. And putting food in their mouths, they were not putting it in their mouths. Rather, all their faces were looking up.